A
years ago I would have never imagined
how influential women/grils and their phones
could be...
What will be next??
looking forward smart
gurl,
mom

DIGIT@L
GIRLS

FASHION'S NEW TRIBE RISK TAKERS, RULE BREAKERS, AND DISRUPTERS

Design by Shawn Dahl, dahlimama inc

Edited by Nicole Phelps

Text by Steff Yotka and Emily Siegel

DIGIT@L GIRLS

GIRLS

MARKO MACPHERSON

RIZZOLI
NEW YORK

New York · Paris · London · Milan

Foreword

■ BY MISHA NONOO

WHEN I DEBUTED my fashion line in 2011, the system was already broken. The industry clung to an outdated timeline and set of rules that were rapidly becoming irrelevant. Twice a year, designers presented their collections to long-lead editors with elaborate pomp and circumstance, hoping the buzz would linger long enough to drive sales when the items became available for purchase six months later. When social media, blogs, and Style.com emerged, fashion fans around the world were offered front-row seats to shows in all the major cities. We didn't have to wait for the season's trends to be broken down, analyzed, and repurposed through a media outlet's filter. These new methods of sharing content were raw and instant. Now, by the time the clothes were displayed in magazines and department store racks, they seemed stale to both insiders and spectators. The old model was no longer effective.

I knew if my business was going to succeed I had to deviate from outdated traditions. In 2015 I broke the rules. I left the conventional runway behind and pioneered the Insta-show—revealing my Spring/Summer 2016 collection solely on Instagram. Images were uploaded to a custom account, @mishanonoo_show, and also shared on key social media darling's feeds. The Internet's virality did the rest.

The new strategy was a success, but the concept had to be pushed further. It wasn't enough to present an upcoming collection directly to consumers. They wanted to take immediate action. They wanted to shop. In response,

I restructured my business model for Fall/Winter 2016 to a direct-to-consumer, buy-now, wear-now format. Through the power of technology I'm now able to interact with customers directly, and boldly step out with fellow Digital Girls to propel the industry into the future.

But who are these other Digital Girls? They're known to the world as influencers. I call them risk takers, rule breakers, and disrupters. They're a generation of women who determined to be true to their individuality, and in the process reshaped the landscape of an entire industry. For decades, faceless experts who urged society to look and act a certain way ruled the fashion and beauty worlds. What editors declared as truth was perceived as law—end of conversation. In fact, there was no conversation. There was only a monologue, with no avenue for feedback. Bowing to the words of a print media editrix seemed to be the only way to stay versed in style news and trends, until an unprecedented force tore through the barrier between the content creators and the consumers.

Smart phones, blogs, and video platforms gave voice to an innovative class of new creatives. They found empowerment through technology and discovered fresh ways to produce content. With each upload they ushered in an age of originality and authenticity, sharing pictures and writing posts that remained true to their personal points of view. Now, fashion fans have more than Chanel and Prada runway looks to be inspired by. Bloggers mix and match pieces in unconventional ways, integrating both designer and mass market price points. They represent all sides of the style spectrum, from bohemian to preppy and romantic to punk rock. Differences are no longer considered imperfections, unworthy of magazine real estate. Curvy, freckled, and ethnically diverse are now widely celebrated as beautiful qualities. Women around the world can find role models who exemplify the type of lifestyle and personal style they can identify with and aspire to be like.

Not only did bloggers create new sources of inspiration, they also invented community. Comment functions allow for real-time dialogue between

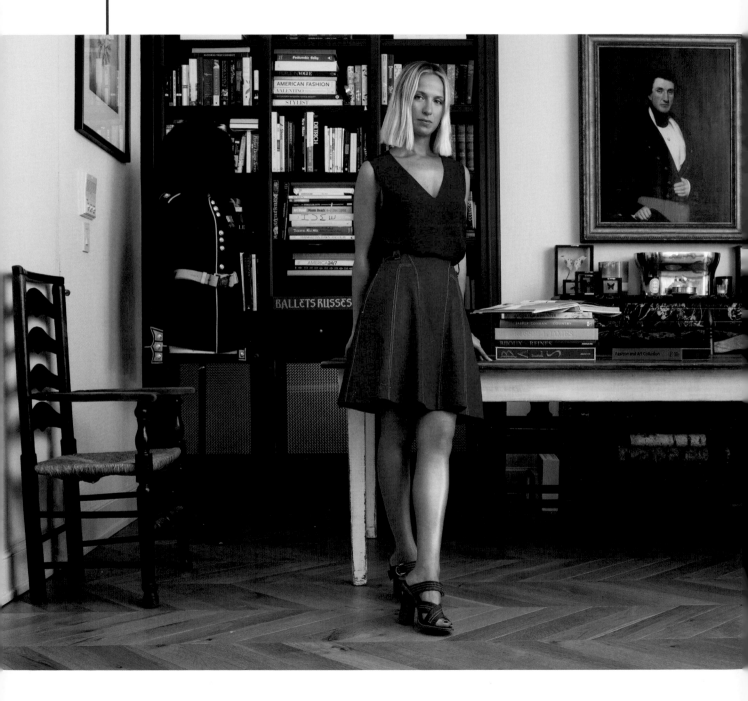

Misha Nonoo in her studio,
New York City, July 2016

the story's author and the audience. The feedback given here can instantly be absorbed and applied to produce a more effective and relatable narrative that will better serve the user. This is also an unpretentious and convenient way for like-minded women from around the globe to connect, support, and be completely transparent with each other. Digital Girls full of personality, like Leandra Medine, managed to humanize a field that seemed one-sided and exclusive for so long.

But there is a downside to being vulnerable. The same channels that allow for positive input are also opportunities for criticism. By being accessible, Digital Girls are open to negative and often personal attacks. When their candor is met with backlash, the stakes become clear. There's a level of independence in this business that can be terrifying. It's also admirable. These women are pioneers. They've paved the way for others to believe in themselves and find their voice. They've also got each other's backs. Instead of throwing elbows while shoving and pushing their way to success, Digital Girls band together. They recognize that women need one another, and have formed a squad that is empowering and supportive.

The old gatekeepers, who used to ignore these once-voiceless trailblazers, have now lost their influence and are clamoring to collaborate and replicate this new generation's methods. Digital Girls have blasted through the iron doors, forever altering the fashion and beauty industries. With technology rapidly progressing and the fuel of newfound courage leading the way, we are living in a moment where anything is possible.

What comes next is for us to decide ourselves.

Brave New World

■ BY MARKO MACPHERSON

DIGITAL: "Involving or relating to the use of computer technology."

GIRLS: "Women who mix socially or belong to a particular group, team, or profession."

I BEGAN USING THE TERM "Digital Girls" as shorthand for "top influencers across multiple platforms with high numbers of dedicated followers" because it seemed the most potent and succinct way to describe the leaders of what has become a new and highly impactful profession. These women produce a steady stream of content—selfies, blog posts, video clips, etc.—to connect global audiences to their unique points of view. They successfully navigate the complex algorithms of social media, while inspiring and encouraging followers with their originality, innovative thinking, and best-in-class style.

I first noticed the Digital Girls movement in 2010 after creating a (now much imitated) series for Vogue.com titled "Five Days, Five Looks, One Girl." I photographed my subjects in street-style format, documenting *Vogue* editors

Four of the Vogue.com "Five Days, Five Looks, One Girl" series that led to *DIGIT@L GIRLS*
From top row: Valerie Boster, Chioma Nnadi, Simone Tetteh, Stella Greenspan

with busy jobs in an authentic, reportage style. The greatest challenge—and my favorite part—of shooting the "One Girl" stories was creating elevated fashion portfolios on the move, without lights or special equipment, starring real, working women with a strong sense of who they are and how they like to communicate their individual style. It was a tall task to continually bring out the best qualities in the most demanding women in the industry (who were not at all coy about voicing their feelings, pro or con, for a photograph). Nonetheless, it was a dream come true to work with these *Vogue* editors; my appreciation for fashion lies at the intersection of brains well-used and beauty well-defined.

It was while following *Vogue* editors at New York Fashion Week—where I captured them arriving in town cars, meeting backstage with designers, or sitting in the front row—that I discovered there was a parallel universe with another set of girls doing virtually the same things as we were: using the glamour and grit of the fashion world as a backdrop for creating images that exhibit a lifestyle worthy of imitation. The Digital Girls seemed to come from everywhere—and be everywhere: Man Repeller's Leandra Medine surrounded by flashing cameras in the front row; the Norwegian model-turned-blogger Hanneli Mustaparta negotiating the street-style scrum outside Lincoln Center; Gary Pepper Girl's Nicole Warne locked in conversation with Ralph Lauren post-show. I recognized in these women the same qualities that I loved in the editors. They were beautiful and smart, amazing yet effortless. It was a potent combination for me, and I knew I needed to find a way, a reason to photograph them. *DIGIT@L GIRLS* is my attempt to document the women of this tribe, to track their rise from outsiders to insiders, and from the digital realm where they mainly reside, into the physical (and maybe old-fashioned) world of paper and ink. No matter what the future holds, they're captured now in this book, reflecting an important part of our time.

These women are brave. It's scary to put your true self out there, bare all, and open yourself up to criticism. How wonderful, then, to learn in these interviews that the more honest these young women are, the more successful they become. This book happily showcases and celebrates the diversity found within the Digital Girls world. Indeed, these young women have helped upturn fashion's old ways of thinking by refusing to heed the traditional and limiting definitions of size, gender, color, and more.

The art form of the Digital Girls is self-expression in every sense of the word, because whether the content is about work, play, family, design, social justice, gender equality, wellness, body image, or all of the above, once a platform and audience are established, a brand is born. The Digital Girls have *big* audiences, not just members of the industry, who support their ideas and views. This is when I realized the Digital Girls have democratized fashion, beauty, lifestyle—you name it—and transformed media and its consumption forever. All of the old boundaries have fallen, or are falling. This transformation, in turn, has caused a sea change in the way I view my subjects and the world at large. As someone whose early career evolved around conventional fashion and traditional formats, the Digital Girls have enlightened and motivated me to find new ways to approach my art and work, and made me freer and more confident in showing beauty in all its forms.

Perhaps most surprising about the Digital Girls, for me, was how universally warm and open they were in welcoming me into their private spaces, studios, and sanctuaries, how unguarded and accessible they made themselves, so that we could create beautiful, intimate, and honest portraits and interviews. They didn't have to be this way; they are, after all, veritable celebrities to their millions of followers. And they could have acted as such, keeping me and my crew at arm's length. But they didn't, because communication is the point of being a Digital Girl. And for that, I will be forever grateful.

Digit@l Girls

■ BY NICOLE PHELPS

IN 2017, it's hard to remember a time before Snapchat, Instagram, and YouTube. Now, of course, they're inescapable, and their self-made stars are as well known as movie actresses and pop icons. These days "very followed" very often trumps "very famous."

This book showcases and celebrates those self-made stars, the pioneering Digital Girls who began colonizing the Web in the mid-to-late aughts, launching personal style blogs and publishing YouTube beauty tutorials. When the social apps we're all addicted to came around a little more recently, these women and their digital heirs embraced the new platforms, and, capitalizing on our insatiable appetite for images, fast-tracked their careers and turned themselves into mini brands. In the process, they've fundamentally changed the fashion and beauty worlds.

Consider this book a snapshot of a once fledgling industry at the ten-year mark, and a manual of sorts for how to get in on the action. In 2017, the Digital Girls' formerly do-it-yourself blogs are professional, expensively made websites with advertisements from the biggest and best labels in the business. Those ads have led to brand ambassadorships, which in turn have bred collaborative gigs with companies from Chanel and Estée Lauder to Diesel and Re/Done jeans. In some cases, your favorite blogger has morphed into your favorite designer,

à la Elin Kling with her minimalist line Totême. Or she might've become a beauty impresario like Emily Weiss, who used her site, Into the Gloss, as a platform from which to launch a skincare line. Your go-to eBay seller Sophia Amoruso is now a #GirlBoss with a $100 million-plus online retailer Nasty Gal and a *New York Times* best seller to her credit, which has inspired an upcoming Netflix series.

You recognize the women entrepreneurs in this book by their handles: the Man Repeller, the Blonde Salad, Gary Pepper Girl—Leandra Medine, Chiara Ferragni, and Nicole Warne, as they're known offline. Each has well over a million followers on Instagram; Ferragni now counts over six million. If you've picked up this book, you may well be one of those millions, eager to reproduce Danielle Bernstein of We Wore What's outfit, or to learn "how to take the perfect selfie" from YouTuber Michelle Phan. You know why these Digital Girls are popular, why they connect: with their pictures and videos and with their words, they're speaking directly to you.

As a millennial herself, Phan remembers her first time on YouTube. "I got chills. I just knew that if people made quality content it could become the global television for [my generation] and Generation Z." How right she was: she posted her first YouTube tutorial, "Natural Looking Makeup," in May 2007. Since then, Phan has garnered more than one billion views for her YouTube clips, success that's led to a lucrative cosmetic line deal with L'Oréal and the founding of her own makeup subscription company, ipsy. Her latest accomplishment? Voicing the character Jessica Jones on the mobile game Marvel Avengers Academy.

The Digital Girls' unstoppable rise came as more of a surprise to old media editors—even as they were being displaced by them in the front rows at fashion shows, and otherwise witnessing their own influence shrink as the

Digital Girls' impact grew. Revolutions do tend to catch people unaware, but this one shouldn't have. We all witnessed the birth and boom time of reality TV, many of us got hooked on the unscripted back-and-forth of the Real House-wives and the Kardashians (even if they weren't unscripted at all in the end). Admit it, ladies, you keep up with Kim and Kendall! DIY-style blogs and YouTube tutorials are very much the online equivalent of reality television: aspirational, yet authentic in a way that magazines were no longer perceived to be.

To extend the reality TV metaphor, just as Kim Kardashian causes a bigger splash than an Academy Award–winning actress (recall, if you will, her Inter-net-breaking *Paper* magazine cover of 2014), so too can Digital Girls generate more publicity and bigger click through rates than old media types. By 2015, Digital Girls had become such a phenomenon that *Lucky* magazine editor in chief Eva Chen (no slouch herself in the digital department, she's now the head of fashion partnerships at Instagram) put Ferragni, Warne, and Zanita Whittington of Zanita Studio on the cover of her February 2015 issue.

Speaking of cover girls, consider Gwyneth Paltrow. She may be an Oscar winner, but she's as well known for her lifestyle brand Goop as she is for acting these days. Paltrow collaborated with the Valentino designers on a capsule col-lection sold in a Goop pop-up shop in New York City and she launched a Goop skincare line that's sold on her website. She's Hollywood's ultimate Digital Girl, but in the years since she launched Goop as an online newsletter—way back in 2008!—many stars have followed her lead. Think of Jessica Alba's Honest Company or Reese Witherspoon's Draper James.

If Gwyneth was onto it, you knew it was going to be big. Just how big the Digital Girls could become was made clear when Ferragni and her site, The Blonde Salad, became a case study at Harvard Business School in 2015. The report is a must-read for anybody who's trying to make it online today, and/or eager to bring home the $8 to $10 million a year (depending on who you ask) Ferragni is currently collecting. It's a steal at just $14 from the *Harvard Business Review,* if you're interested.

Now let's backtrack; 2009 was a tipping point for Digital Girls. It was in September of that year that Domenico Dolce and Stefano Gabbana put bloggers Garance Doré, Bryan Grey "Bryanboy" Yambao, Tommy Ton, and The Sartorialist's Scott Schuman in the front row at their Milan women's fashion show. Street style photography—images of the fashion show outside the fashion shows—had begun to catch on, and the designers were eager to capitalize on it. (Marc Jacobs did it his own way, christening a handbag the "Bryanboy" the same year.) The presence of Doré and her fellow bloggers at Dolce & Gabbana sent ripples through the fashion crowd. Of course, the walls had started coming down years earlier in 2000, when Style.com made runway shows accessible to anybody with a computer and an Internet connection. But there they were in the front row, outsiders invited into the inner sanctum—self-appointed, yes, but every bit the arbiters that the old media types were thanks to advances in technology and the new attitudes of readers.

If you ask Schuman or Doré these days about that game-changing show, they'll insist that they weren't trying to steal front-row seats (they had been invited in the past without the fanfare, by the way); they simply wanted to share their unique points of view with their growing numbers of followers. That's democracy in action! And it's remembered as a real moment within the industry. Coincidentally, or more likely not, there was a flowering of personal style blogs around 2008–2009. Hanneli Mustaparta, Rumi Neely of Fashion Toast, Ferragni, and Warne, who are all profiled in the book, launched their sites in those years.

Their early popularity was aided and abetted by the fact that they were beloved subjects of the Tommy Tons and Scott Schumans of the world. The street style photographers didn't distinguish between old media editors and new ones. If they liked a girl's look, they would often shoot her on a daily basis as the fashion shows moved from New York to London, Milan, and Paris,

tracking her wardrobe, and, indeed, encouraging a culture of multiple outfit changes a day.

In turn, street style photography became a kind of template for the personal style bloggers. They launched their sites with a DIY spirit—blogging software and hosting platforms were free online, and therefore within reach of almost everyone—but they most definitely aren't taking selfies anymore. To visit their sites now, going on a decade later, is to see how the game has remained the same and how it's changed. Their feeds are more or less still lined with photos of themselves in stylish outfits, but the production values have gone way, way up. There are professional hair and makeup artists behind the scenes and professional lensmen behind the camera. It wouldn't be a surprise if these personal style bloggers have personal stylists of their own at this point.

Who could blame them? Their image is their livelihood. Neely and Ferragni have parlayed theirs into clothing lines that they cross-promote on each other's sites. There's a real culture of collaboration between Digital Girls. Jewelers Jodie Snyder Morel and Danielle Snyder of Dannijo have enlisted Leandra Medine in the past to build interest in and help sell their collections.

Leandra Medine's Man Repeller—so named, she's explained, for trends that women love and men hate—came along in 2010, and it's a contemporary exception to the personal photo stream site. Don't get it wrong, she's got fashion bonafides to spare—Lisa Marie Fernandez named one of her fabulous ruffled bikinis "the Leandra," after all—but perhaps because Medine's life goal was to become a journalist, "more specifically, a *New York* magazine profile writer," you'll see her byline on her site more often than you'll see her picture these days. She's a little more inclined to post photos of herself on Instagram.

Medine was the blogger who took a stand when the *International Herald Tribune*'s Suzy Menkes penned a now-infamous 2013 takedown of what she called the street style "circus." Menkes, a well-respected veteran critic, lamented "the cattle market of showoff people waiting to be chosen or rejected by the photographers" outside the shows and semi-seriously suggested that show organizers,

"let the public preening go on out front, while the show moves, stealthily, to a different and secret venue, with the audience just a group of dedicated pros." Writing on Man Repeller in a post she ironically titled "Blog Is a Dirty Word," Medine defended herself and her Generation Y peers Tavi Gevinson and Susie Bubble, who, when faced with a lack of editorial jobs as young people, she argued, created their own, and proceeded to do "astounding work."

She was right about Gevinson, who was barely a teenager when she began her eponymous blog and soon became a darling of designers like Miuccia Prada and Rodarte's Kate and Laura Mulleavy. When it blocked the view of people in the rows behind her at the Spring 2010 Christian Dior couture show, little Tavi's large chapeau became an online meme of its own. But fashion wound up being just a launching pad. She started *Rookie,* an online magazine that publishes work by and for teenagers in 2011, and she's acted on Broadway and in a film alongside the likes of Julia Louis-Dreyfus and the late James Gandolfini. Susie Bubble, meanwhile, is now better known by her real name, Susie Lau, and she's a constant presence in the front rows at fashion shows from which she files posts for her well-respected site Style Bubble.

While addressing Menkes's points, Medine also turned a critical eye to the culture of gift-taking, chastening bloggers who praised products they received for free without acknowledging the transactional nature of the exchange. "It

"Consider this book a snapshot of a once fledgling industry at the ten-year mark, and a manual of sorts for how to get in on the action. In 2017, the Digital Girls' formerly do-it-yourself blogs are professional, expensively made websites."

is at the point where readers can smell the sponsorship that integrity gets lost," she wrote, alluding to an issue that continues to dog personal style bloggers today. "In everything else, Darwinism will always prevail," Medine continued. "The strong will continue to survive and the weak will eventually begin to wean off." The post received nearly three hundred comments, suggesting that, if nothing else, Medine had an audience that rivaled Menkes's in size. Even a far less serious article still garners plenty of feedback from her followers; four years later, Medine is doing quite nicely.

About Instagram… "Blogger" is no longer a dirty word, but it doesn't quite cut it in a multi-platform world. Instagram is the Digital Girls' current killer app because it's right there in the palm of your hand. Everybody's hands, and it's just so dang addictive. Followers may visit an online site once or maybe twice a day, but they'll swipe through their Instagram feeds ten times, twenty times, countless more. For the Digital Girls who have mastered it, like Ferragni, that's potent stuff. As she puts it, "The best thing about it is that people can instantly see the power of a single post. My site has always had crazy views, but there was no way for brands to know that without seeing analytics. Now people get that information right away from Instagram. They instantly see how many followers and likes you have—and you can't get much more powerful than that."

Powerful and how. It's no overstatement to say that Instagram has minted the most popular models of the last few years. Hello Kendall Jenner! Hiya Gigi Hadid! As a primarily visual medium, Instagram is an ideal platform for catwalkers. The Korean-American model Irene Kim, profiled in this book, dyed her dark-brown hair blue on a whim a couple of years ago, and watched the jobs

start rolling in. Now she keeps track of her ever-changing color on Instagram, capturing not just her freshly dyed rainbow-hued locks, but also the times when it's fading or in need of a touchup. They're all #HairGoals to her some seven hundred thousand followers.

Model or makeup junkie, as Marianna Hewitt, the lifestyle blogger behind Life With Me, describes herself, the thing to remember about Instagram is to post frequently, "Sixty-four percent of Instagram traffic comes from outside the U.S.," Hewitt says, "You need to post at all hours of the day, not just when you're awake." So how is a Digital Girl supposed to get her beauty sleep with multiple channels to manage? "It's really challenging," admits The Haute Pursuit's Vanessa Hong, "the effort is constant." Hong is betting on Instagram for the moment, but she sees how Snapchat could overtake it. "The Snapchat moments are real. You can't edit. You can't do any post-production. What you Snap is what you get—and people crave reality. We're all just voyeurs at heart."

Or, to borrow a phrase from our friends at *The Cut,* "We want that bitch's life." That right there spells out why personal style blogs took off in the first place. There was no better format for getting a window in on these women's lives and envy-inducing closets. Other apps will no doubt come up in Instagram and Snapchat's wakes, and more after that. These Digital Girls, the strong ones, as Medine would say, will adapt, just like they've been adapting since the beginning. "The important thing," says Phan, "is to keep your eye on the prize, which is content." "Too often," she says, "people are so focused on the next trendy platform that they forget to make content that's good. But quality content will last regardless of the platform. Just look at *Snow White,* that movie was released in 1937 and it's still popular today. You can find it on the cloud, on demand. Quality content will survive on any platform."

Wise words from an online original. You'll find plenty more of them on the pages to come. ■

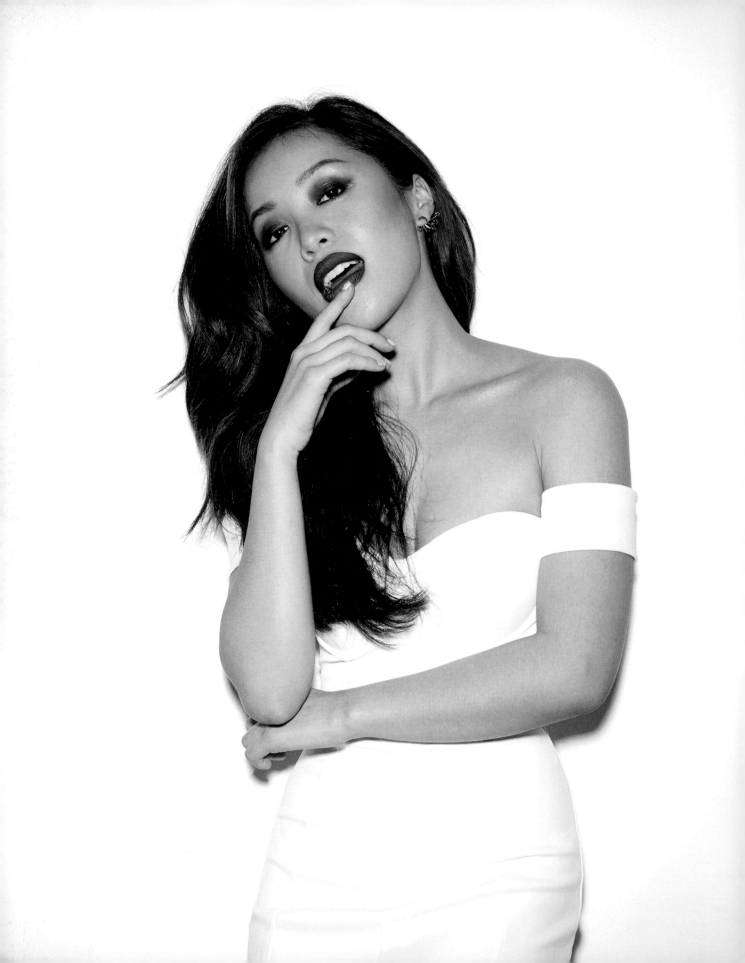

Michelle Phan

MichellePhan.com
YouTube.com/MichellePhan
EmCosmetics.com
@michellephan

"Teaching and inspiring everyone to become their own best makeup artist :) So sit back, enjoy, and let's play with makeup! I live, I love, I teach, but most importantly, I learn."

MICHELLE PHAN LITERALLY BRIMS WITH POSITIVITY. THE twenty-eight-year-old entrepreneur happily engages our crew in conversations about their hopes and dreams, not giving a thought to herself, the star of today's shoot. It's her selflessness that makes Phan so endearing—a quality that has earned her more than eight million YouTube subscribers.

Ipsy Open Studios,
Santa Monica, October 2015

"I remember the very first time I went online," Phan says. "I was twelve, maybe thirteen years old, and I was over at a friend's house. From the moment I saw it, I knew the Internet was the final frontier."

Phan is sitting in Ipsy Open Studios, the Santa Monica venture she opened in 2015 to provide space, tools, and support to burgeoning content creators like herself. As she looks around the bustling studio, she remembers her childhood as a bookworm. Phan worked her way through every book in her home—and that included the encyclopedias.

"I wanted to read more, to *learn* more," she explains. "And the thing about print encyclopedias is that they're not updated all that often. But the Internet? It was just this expansive horizon of information that was updating all the time. I couldn't get enough."

At the age of sixteen, Phan undertook her first online project. The platform? Xanga, the long-gone blogging platform of the early 2000s.

"A lot of people think I found fame and fortune on YouTube," Phan recalls. "But it was actually Xanga—that was the platform that launched me. When Xanga was at the height of its popularity, my account, Ricebunny, had more subscribers than anyone else on the site." Phan traded in Xanga for YouTube once she sensed the Internet tides were turning.

"I got chills the first time I saw YouTube," she says. "I just *knew* that if people made quality content, it could become the global television for millennials and Generation Z. For about a year, I experimented with posting private videos. And when I posted my first makeup tutorial in the spring of 2007, I didn't think anyone was going to watch it....until it got forty thousand views in the first week."

Recognizing the immense opportunity for informal beauty tutorials that lived online, Phan

"Michelle Phan may have got a humble start on YouTube, but she is well on her way to helming a billion-dollar unicorn: her subscription beauty sampling business, Ipsy, last month raised $100 million to value the company at over $500 million." —FORBES

- Her YouTube channel has over 1.1 billion views.

- Can't live without concealer.

- Directs and edits all her YouTube videos herself.

- Her "Poker Face" Lady Gaga tutorial was one of her first to get over one million views.

threw herself into creating a digital lifestyle destination. She didn't, however, quit her job *or* her studies at Ringling College of Art and Design—a decision that Phan says left her, "without any sense of a social life."

"Success doesn't come without sacrifice," Phan makes clear. "It's the great misconception of blogging. People assume that because it *looks* effortless, it must *be* effortless. Let me just say: it's harder than it looks."

In 2008—with the advent of the YouTube Partner Program—she started making money. In traditional Phan fashion, she used her earnings for only three things: student loans, helping her mom, and reinvesting in the vlog. She left school and became an online ambassador for Lancôme in 2009.

"I'm an incredible introvert," she says. "So it didn't bother me much to give up the traditional 'college' experience. I made the right decision for me. Ask anyone who knew me in middle school or high school—I never spoke. I barely had any friends."

So how did a self-proclaimed introvert find herself hosting one of the most popular YouTube channels in the world, with over one billion views?

"In a way, you have to train yourself to be the opposite of who you are in real life," Phan explains. "But if you're truly passionate about the topic—if you're doing what you love—then it comes naturally. That's my best piece of advice: find a topic or genre that feels authentic to you, and try not to become too focused on the master plan. Have goals, not expectations."

And once you've found the right topic—what comes after that?

"Focus on the content, not the platform," she says. "Too often, people are so focused on the next trendy platform—Periscope, Google Cardboard, you name it—that they forget to make content that's *good*. But quality content will last regardless of the platform. Just look at *Snow White*: that movie was released in 1937, and it's still popular today. You can find on it on the cloud, on demand. Quality content will survive on any platform."

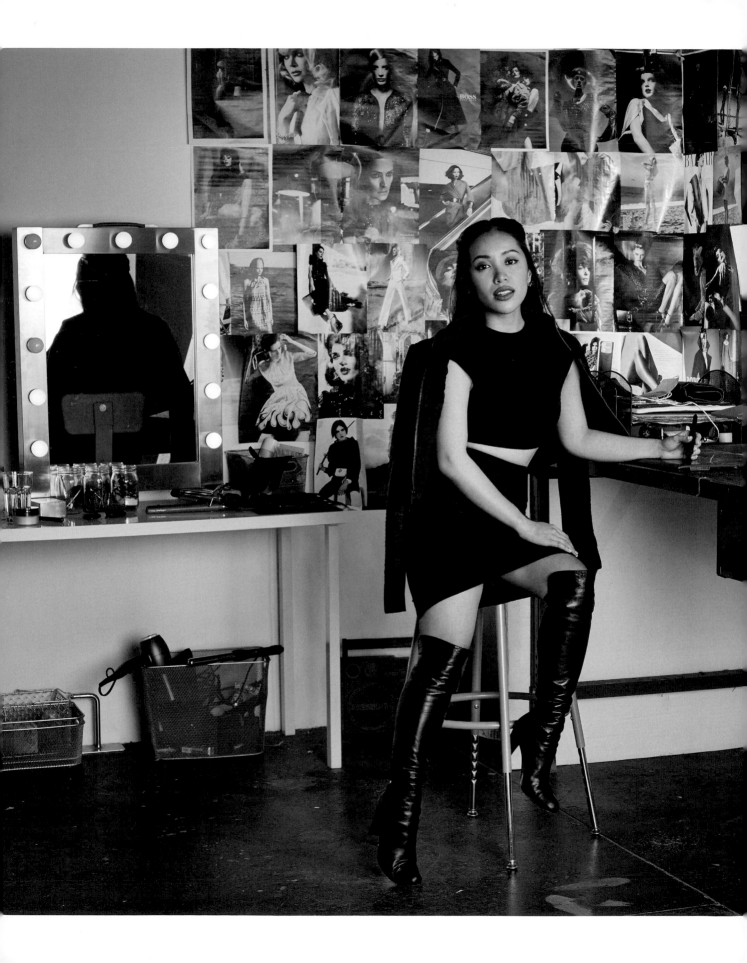

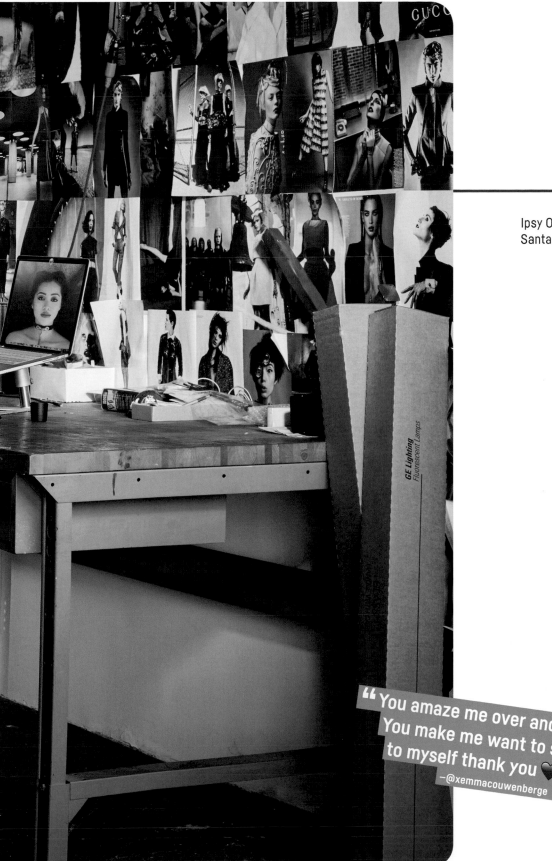

Ipsy Open Studios,
Santa Monica, October 2015

"You amaze me over and over again.
You make me want to stay true
to myself thank you 🖤 ✦ ."
—@xemmacouwenberge

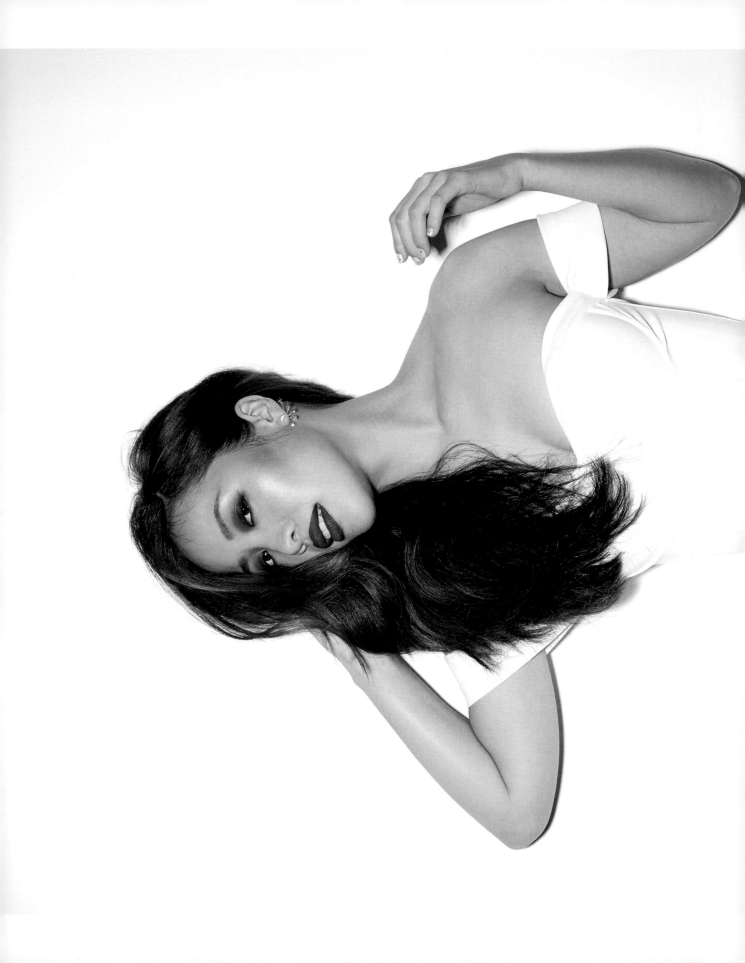

"I love how you're utilizing your strength as a dreamer to bring these beautiful ideas from your imagination into a reality! You're incredible! Keep inspiring us 🌻💖🌻 Love You Michelle 🙂😊😍🙏🙏💖💪.

—@ablindhero

MichellePhan.com

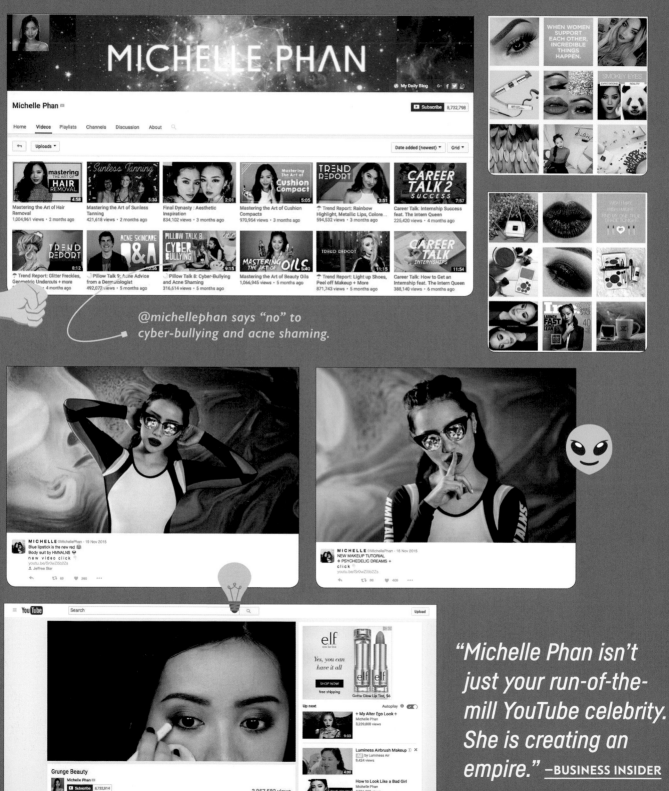

@michellephan says "no" to
cyber-bullying and acne shaming.

"Michelle Phan isn't just your run-of-the-mill YouTube celebrity. She is creating an empire." —BUSINESS INSIDER

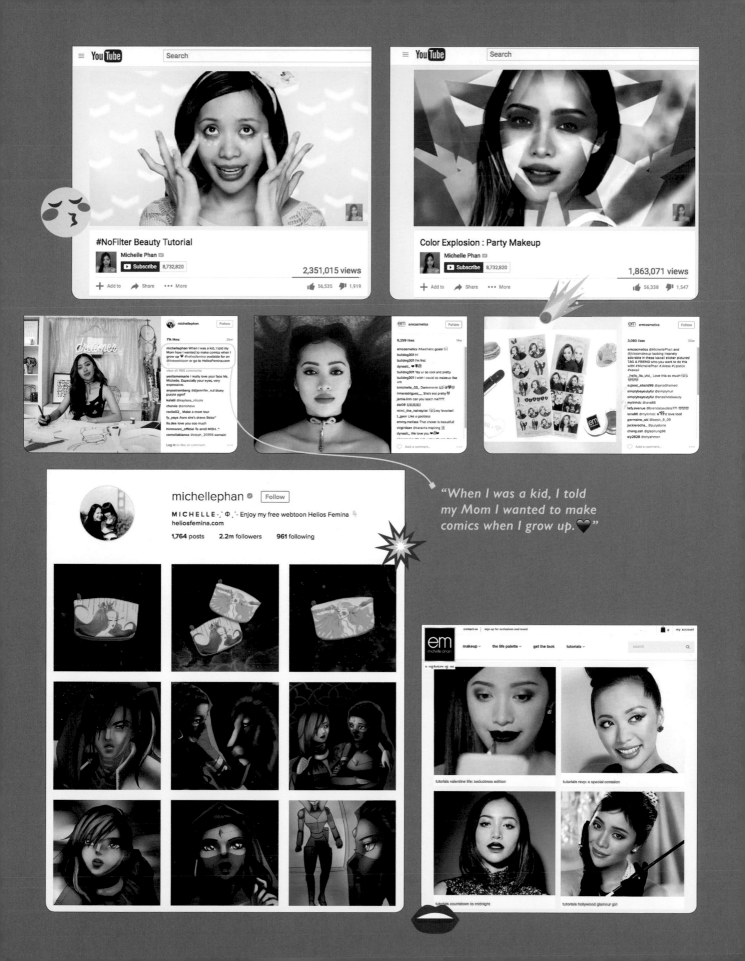

"When I was a kid, I told my Mom I wanted to make comics when I grow up. 🖤"

Chiara Ferragni

TheBlondeSalad.com
@chiaraferragni

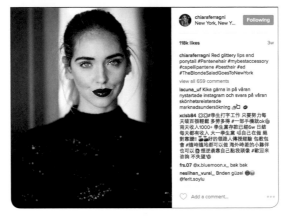

*"Love fiercely (and don't forget to stop along
the way to take photos). #NeverStop 💪
Made in Italy, living in Los Angeles."*

THE MOMENT CHIARA FERRAGNI OPENS THE DOOR TO HER
bungalow home in Beverly Hills, you can feel her energy like a tidal wave. She
smiles broadly and waves from an elevated porch, her towering presence only
heightened by her platform shoes.

To call the twenty-nine-year-old Italian behind The Blonde Salad (or TBS
for short) a "blogger" would be an injustice. She's a brand. She
has 6.1 million followers and counting. Her four-year-old shoe line,
Chiara Ferragni Collection, is available on three continents. And, as
if all that weren't enough, she's also a case study at the Harvard Business School.

"I don't like the term 'blogger,'" Ferragni says. "It's not terrible, but my
site is so much more than that. The Blonde Salad was a blog when I started. It
was my personal diary—a place where I could post pictures and share myself

At home, Silverlake,
Los Angeles, August 2015

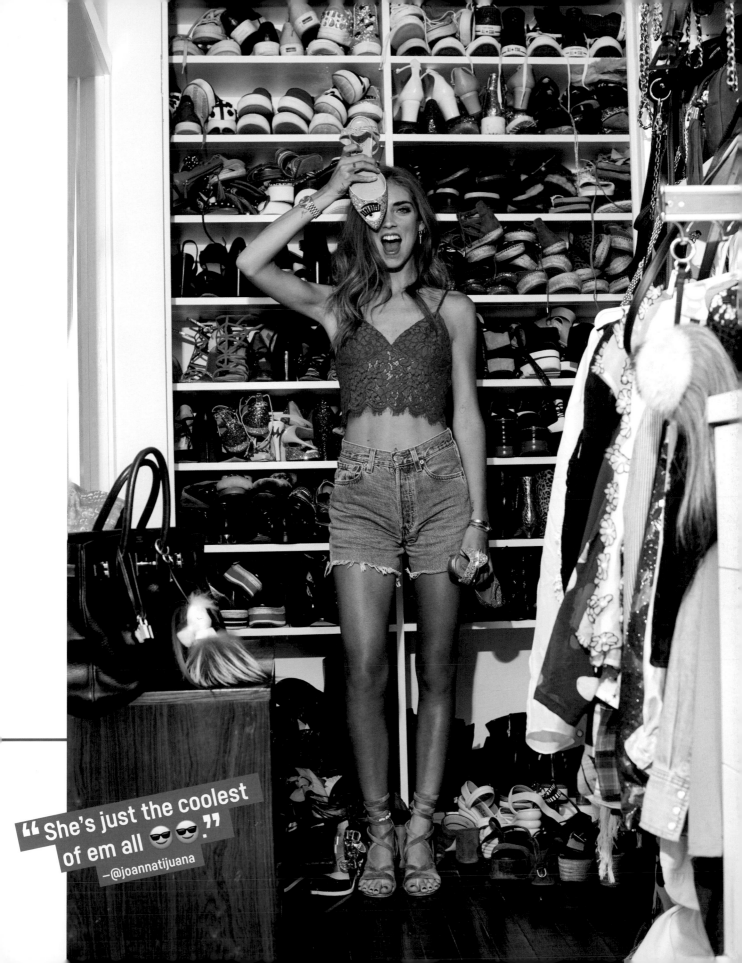

"She's just the coolest of em all 😎😎"
—@joannatijuana

with the world. But now, it's so much more than that. It's more like a magazine, more inspirational. Social media has replaced that need for a 'diary.'"

It's true that Ferragni's initial success came from a selfie-style approach to photography. Early versions of her site appeared on photo-hosting platforms such as Flickr, where she posted personal moments, creating a digital catalog of her life and style.

"I grew up in Cremona, Italy, one hour outside of Milan," she says. "My mother works in the industry, so I always loved fashion. She taught me that clothing was a way to experiment and dress up as different characters, and at the age of sixteen I started posting photos of those different characters online."

Within months, Ferragni's Flickr page boasted more than thirty thousand hits per day, but she remained focused on sharing the photos taken by her then-boyfriend, Riccardo Pozzoli—not on creating an editorial site. The text that accompanied the pictures merely aimed to inform fans on how they could replicate a particular outfit.

"By 2009, everyone was talking about fashion bloggers," she remembers. "That's when I was starting to get invited to shows and receiving offers to collaborate with brands. Based on that demand, I founded TBS with Ricky in October of that year."

Pozzoli continues to be an influential partner in the Blonde Salad business, and, despite the couple's split in 2013, he still serves as Ferragni's manager. Together, the pair has built a thriving team of young talent—called the TBS Crew—that has helped the company to grow.

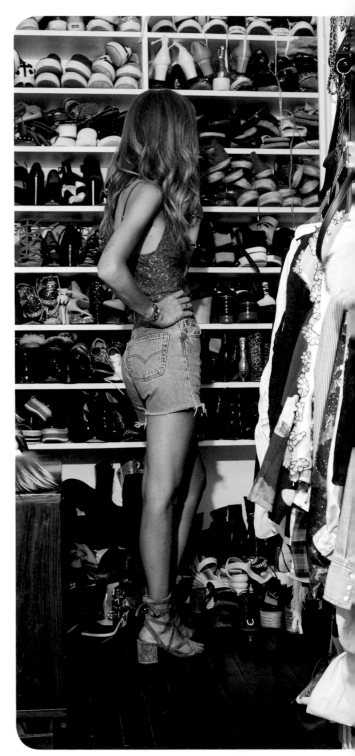

"Ricky and I always knew TBS could be something powerful," she says. "But it still amazes us that we have eighteen full-time employees. I'm so grateful for the success."

Ferragni relocated from Milan to Los Angeles in the fall of 2014—a move inspired by her new boyfriend, and made possible by much of the same technology that helped put Ferragni's site on the map.

"My team is still based in Milan because it's important to me that TBS still feel very Italian," she says. "I have people from my team travel with me whenever I'm abroad, and we use digital media to stay in contact otherwise. We constantly Skype and have conference calls. We have a 'TBS Crew' chat on WhatsApp that we use every day. The only reason I *can* have my team in Milan is because we're all so versed in digital platforms."

So with all these platforms and apps, what's the one Ferragni can't live without? "Instagram," she says.

"I'm so inspired by Instagram. It's where I look for new places to visit, or new brands to try. But the best thing about it is that people can instantly see the power of a single post. My site has always had crazy views, but there was no way for brands to know that without seeing analytics. Now people get that information right away with Instagram. They instantly see how many followers and likes you have—and you can't get much more powerful than that."

Still, Ferragni recommends that those looking for similar levels of success start in a more organic place. Leave fame out of the game.

"People see how many bloggers became famous, and they start blogging just to have what someone else has," she says. "But you can't start a business for the fame or the money—it won't work. You need to start it for the fun."

At home, Silverlake,
Los Angeles, August 2015

"You and your crew's success with TBS is very inspiring. Keep up the good work!"
—@lydia from RavenMaiden.blogspot.com

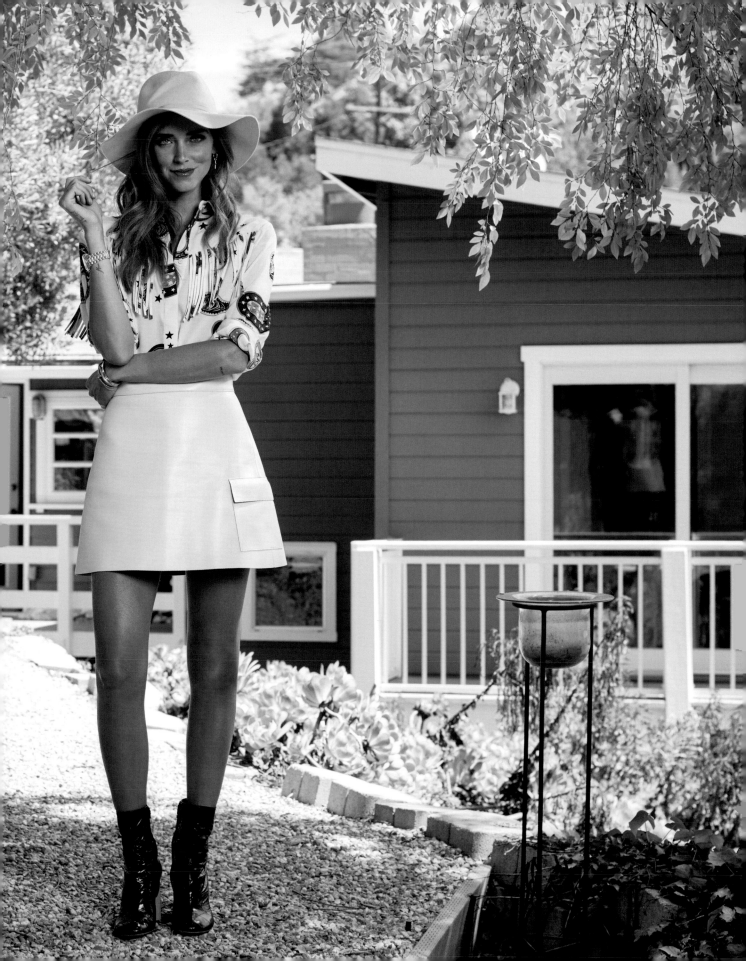

At home,
Silverlake,
Los Angeles,
August 2015

"For someone like Chiara to have three million-plus Instagram followers is incredible. I mean today, your followers is your currency. She was really there at the very beginning, and when you are sort of a trailblazer in a new medium, you really grow your fans fast, quickly, and really with a lot of loyalty." JOE ZEE, EDITOR IN CHIEF OF YAHOO STYLE

@chiaraferragni

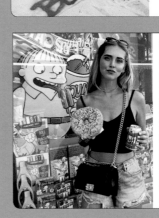

The Blonde Salad

fashion beauty people travel talents 🛍 shop

chiara ferragni

Chiara Ferragni inherited from her mother the passion for fashion and photography. When she was a teenager, she already became popular on the first online communities, where she shared photos she took with her friends. In 2009, when blogs were not yet the phenomenon of today,

chiaraferragni
Milan, Italy **Follow**

93.1k likes 3w

chiaraferragni Rule #05 #forsuccessfulliving Love Openly #ChiaraFerragniFeaturingDiesel @diesel
view all 487 comments
l052455 lovely
federicapastore_ Giacca stupenda 😍😍
fj_jessica the top look good
milkwoodnyc The teddy is incredible!
onlymyfashionstyle 💕
andreamagalhaescendon @gabymagalhaess
vnsashn Deine Jacke 😍@annadnkr
naturalbornraider Heart warming
annadnkr Ja hab Chiara direkt geschrieben und gesagt sie muss die einfach haben! Top Passform 😍@vnsashn
kseniyaromanova_ 💕

Log in to like or comment.

thebiondesalad **Follow**

3,364 likes 3w

thebiondesalad Did you see our new site? Go check it and also check the Beach vibes! Video + backstage pics from the photoshoot #shopthebiondesalad #livetbs 💕🎀
gforgabriel Love the new site!! @thebiondesalad
elysiumworld23 Ciao chiaraess 😍😍 Ragazze per voi sconti su tutte le BORSE 👜👜👜 PASSATE 💕💕💕
hate.you.so #super
writer_ns
spinnaker_boutique Always so beautiful
soma_jaff_ 😍😍😍💕💕💕
misakisophia ❤
hayleyappleford Yayyyyyy
torinoelamiacitta ❤

Add a comment…

chiaraferragni
Ladurée Soho **Follow**

75.6k likes 2w

chiaraferragni When Barbie shows up at your #ChiaraFerragniLovesLaduree event for your special macaron and customized box (with your own Chiara Barbie) you know all your childhood dreams have been fulfilled #MagicBaby #Nyfw #TheBlondeSaladGoesToNewYork
view all 511 comments
lenazhan one is u, another is who?
vogure.insta Stunner
mabel.luo OMG haha too cool
uuiiio8 🌸🌟學生打字工作 只要努力每天破百很輕鬆 多勞多得 #一部手機就ok@兩天收入1000+ 學生黨存款已經6w 日結 每天都有收入 大一學生黨 💰絕對靠譜!!👍好的領路人傳授經驗 包teo包會 #隨時隨地都可以做 海外時差的小夥伴也可以 💰想üä襄靠自己點我頭像 #歡迎來咨詢 不失誤
diankinil @rennyrahayu94 barbie 😄
Log in to like or comment.

chiaraferragni
Universal Studios H... **Follow**

152k likes 5w

chiaraferragni True Simpsons' fan at @unistudios 🍩 #AmericanDays @discoveria
view all 1,339 comments
cesariduma Jajajajaj neta que si se ve bien @pamtapiar
marisagm16 Ve esa donaaa @montsenava7
mariaalfaro_97 El bolsito 😍@alpevs
giuliabardelli I want that donut @drainoldi
drainoldi Omg I saw it in her snapchat and I couldn't believe it @giuliabardelli
jfranciscaas Ahí esta la cartera @ourlifee.e iovan muestrasela a la fernanda
mariklevgaard @mereteklevgaard donut goals
magalirodriguez89 Hinchada todavia @pachibustos
xclsb110 🌸🌟學生打字工作 只要努力每天
Log in to like or comment.

The Blonde Salad

fashion beauty people travel talents 🛍 shop ♡ 0 🛍 0

@chiaraferragni on the cover of Glamour Turkey.

"...This is just the sort of whimsical post one needs to start the day off right. Thank you! 🖤"

"If anyone's qualified to be the subject of a Harvard case study on the business of blogging, it's twenty-seven-year-old fashion star Chiara Ferragni." —STYLECASTER.COM

Irene Kim

YouTube.com/IreneIsGood
@ireneisgood

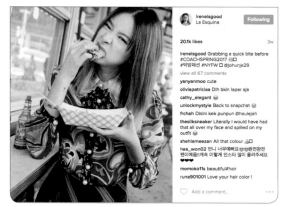

"Model with a huge heart and cramped closet."

"I THINK THE BEST THINGS ARE UNPLANNED," SAYS IRENE KIM.
Over the years, the saying has served as an unofficial motto for the twenty-nine-year-old model and social media star.

The best example of her mantra at work might be when she decided to dye her hair blue on a whim several years ago—without telling her modeling agent. "I'm just the type of person that if I want something, I have to do it in the moment. At that moment, I wanted blue hair," she remembers. "I walked into my agency and they just stared at me like I was an alien and were like, 'You know, you're not going to book any more jobs.' That season I was the model that walked the most shows during Seoul Fashion Week." Today, her rainbow-hued locks are her calling card, and just one of the many features that sets her apart from other models and Instagirls.

Kim's intuition has served her elsewhere, too. Way back in 2010, she was quick to join Instagram after a friend of a friend introduced her to the platform.

SoHo, New York, February 2015

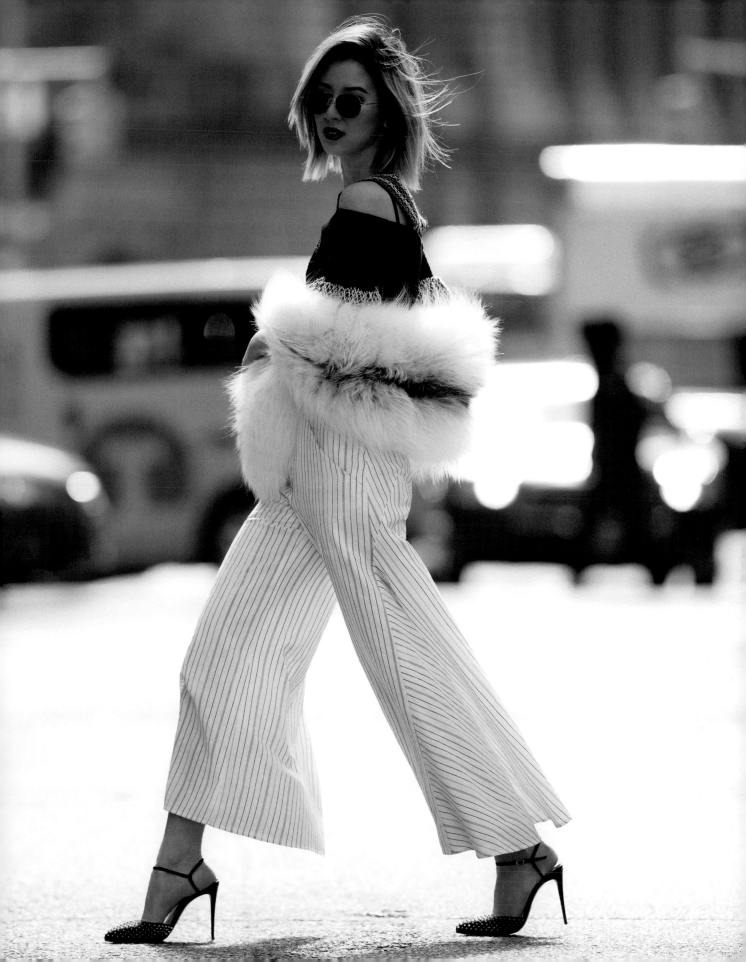

La Esquina restaurant,
SoHo, New York,
February 2015

"It's hard to miss Irene Kim. The covetably tressed street style star [with hair that is either neon pink or seafoam green—or both] has become a global phenomenon." —VOGUE

"Yaaaassss no one has the power to dull your shine ♥".
—@vickyk

She now counts more than 777,000 followers on her account. "When I first moved to Korea five years ago, nobody had Instagram in Korea. All of a sudden, it boomed. Now, every celebrity in Korea, every restaurant, blogger, and person has an Instagram."

She was early to Snapchat, too, creating an account after her teenage cousin recommended the app to her over three years ago. "Then, I got my celebrity friends in Korea to join Snapchat and it made the Korean news!" Kim exclaims.

But for all her social media savvy, the model still approaches her accounts with an organic ease. "I just want to share what I really love," Kim says. "Especially with so many branded posts and sponsored posts out there, I try to keep my accounts as real as possible, as authentic as I had them before." Scroll through her Instagram or tap through her Snapchat and you'll feel like you're living life alongside the model, trying on outfits, going to the gym, or just hanging out with friends. Oh, and there's a couple of snaps you'll want to live vicariously through, too, like selfies with Victoria Beckham and Balmain's Olivier Rousteing.

Like most Digital Girls, Kim's love of fashion started early. As a child, she remembers she used to change outfits five or six times a day. "I would change for lunch, to go to the playground," she says. "And that's my job now, to put on clothes for a living." In middle school, Kim's family moved from Seattle to Seoul, with Kim returning to the United States to attend college at New York's Fashion Institute of Technology. While in New York, she interned for stylists and at an online magazine, becoming a model when she returned to Seoul in her early twenties.

Aside from walking the runways of Seoul Fashion Week, Kim's career highs include a slew of magazine covers and the title of Global Beauty Contributor at Estée Lauder, a gig that allows her to experiment with beauty in new ways. "I love working with Estée Lauder because it's really about what I want to say," Kim explains. As an Estée Lauder girl, Kim joins the ranks of fellow models and social sensations Kendall Jenner, Joan Smalls, and Liu Wen.

But modeling isn't the only industry Kim sees herself in. With a creative team in Korea, she's just launched a digital content site called The FIA Space. "That stands for Fashion is Art," Kim explains. "It's more fashion editorial–based, more artistic. We have an Instagram account we just launched, and our most recent editorial we shot with Chanel." She has even bigger plans for the future. "I think eventually I want to launch my own brand or line of clothing one day." Stay tuned.

La Esquina restaurant, SoHo, New York, February 2015

★ HIT LIST ★

- Uses ten or more hair dyes to get her signature rainbow hair.

- Acts as a beauty ambassador for Estée Lauder.

- Has a cross tattoo on her wrist.

- Practices aerial yoga.

- Frequents Unistella Nail Salon in Seoul.

@ireneisgood

Irene Kim's Crazy Fashion Show Show Fittings Ep. 2
Irene Kim
5,775 views

SFW with IRENE
Irene Takes Over Seoul Fashion Week
Irene Kim
9,194 views

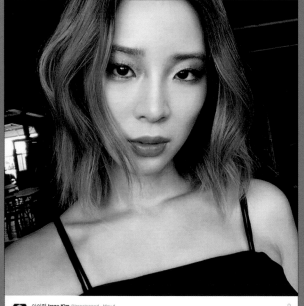

ireneisgood
Follow

19.6k likes

ireneisgood #hairalwaysintheface #vogue20
view all 159 comments
edaesavas @bellastinka degisilk
kqyoo Love your hair 😍😍😍
sarsoura19 @ouarda547 je veux pareil 😍
ouarda547 @sarsoura19 trop stylé !!!
ouarda547 @sarsoura19 moi j'aimerais bien comme guy tang avait fait à Michelle phan
sarsoura19 @ouarda547 c'est vrai que c'était beau comme œuvre
c_i_n_d_y_86 @nashita.tomlinson
nashita.tomlinson @c_i_n_d_y_86 what?
c_i_n_d_y_86 @nashita.tomlinson hair is so nice
nashita.tomlinson @c_i_n_d_y_86 i like her nails lol
Log in to like or comment.

아이린 Irene Kim @ireneisgood · May 4
Hi Vegas! Takin over the @Sephora snapchat for the @thesteeedit today! Add 'Sephora' on snapchat 😊
#beautyattitudes

ireneisgood
New York, New York
Follow

22.5k likes
2w

ireneisgood #hairalwaysintheface & happy 800k! Thank you guys 🙏📷□ @thestyleograph
view all 91 comments
cuchan86 Love the hair
xiansgirl Your hair is iconic 👏👏👏
catherine_cy Boots from Gigi!!
ashkynard @mzmirpanda hair❤
truthisimfromthecircus Does anyone know where she got her phone case from? It's so cute!
doratung Love the hair!!
chonapk 💜💜💜
comet_choi 😍😍😍💜💜💜
na.di.a.j HAIR 💜💜
wkdalth12 @minwoojoy 예쁘구만
nana_imti Congratulations for making it to 800k 😍
Add a comment...

ireneisgood
SEA - Seattle-Tacom...
Follow

21.6k likes
2w

ireneisgood Still sad that my family time is over😭 Hopefully #NYFW will make me feel better! See you soon #ireneisnewyork ✈✈✈
view all 59 comments
rebecca.theodora Wow
.pjj what brand suitcases are those?
niminox 언니... 🖤🙏
olemasonjar 👌
manuellapribeiro cutie
katechan9 wow
ljaneillustration Check out my fashion drawings 🎨 always looking for fashion bloggers to draw ✏

ireneisgood
Whitney Museum of ...
Follow

15.2k likes
2w

ireneisgood Flowery fresh for @toryburch this morning 🌸🌿🌷💐🌺 #꽃단장 #ireneisnewyork □ @johunje29
view all 51 comments
zion0425 SO KOOL❤PANTS STYLE 🌸🌿❤❤❤🌸
hollykkkkk 😍
kroger99 Face looks weird
pechy_p 😍
banillastreet Doll💜
jnyin1 beauty❤
bnid How gorgeous!! 😍
chilenofnj galaxy of flowers with you in the middle
reyanagarcia Slaayyyyyy
143vv 😍
amandabaptista1 ❤

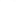
Add a comment...

IRENE × PLAYNOMORE

It's ME

아이린 **Irene Kim** @ireneisgood · 8 Apr 2015
The many faces of #IRENExPLAYNOMORE pre-order at playnomore.co.kr

78 90

Hey

ireneisgood Follow

27.1k likes 6d

ireneisgood #Nomakeupmakeup is my fav

janee.kim lol yeaaa @chanhee.kim
ivanacheia_hrspny Pretty
crazy4nia_fx You always look pretty
magsmia @ysl.in what if I dyed my hair like this
amy_daniels Stunning
kaarenntan @raphaelkcr #itscallednudemakeup
duncanburn You look amazing
raphaelkcr @kaarenntan of course you know nude fashion best
kaarenntan @raphaelkcr you too free isit dtg komen make up
elliemarbur Beautiful as always

Add a comment...

"Does anyone know where she got her phone case? It's so cute!"

"#NoMakeupMakeup is my fav. 💋"

"In short, she's the 'It girl' you'll actually want to follow on Instagram… and Snapchat…and Twitter." —INSTYLE

아이린 **Irene Kim** @ireneisgood · Feb 5
Blue brows vibes

117 193

아이린 **Irene Kim**

117 193

"Dream Woman 🖤"
@maryam_nassir_zadeh

Leandra Medine

ManRepeller.com
@manrepeller
@leandramedine

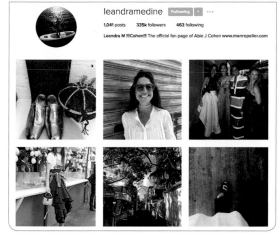

"I'm the founder of a nudist colony called Man Repeller."

■

LEANDRA MEDINE MIGHT HAVE STARTED OUT LIKE MANY
other Digital Girls, posting pictures of her outfits online and doling out style
tips, but the twenty-eight-year-old Man Repeller (a.k.a. MR) has spent the last
six years growing her onetime personal blog into a burgeoning media com-
pany. ManRepeller.com boasts more than ten million page views per month,
and is considered by many—including Karlie Kloss—to be the most influential
force in digital fashion. "I started blogging in Paris while spending a semester
abroad from the New School," says Medine. "Because I was a journalism stu-
dent—because I was so accustomed to the editing process—I found it incred-
ibly cathartic to write whatever I wanted, whenever I wanted. It was my first
sense of 'self-service' publishing."

Spring/Summer 2017 NYFW, September 2016

We're chatting with the Man Repeller herself, doing our best not to be distracted by the Karl Lagerfeld doll on her end table. Medine's Manhattan apartment—which she shares with husband, Abie Cohen—is a Digital Girl's dream, full of eccentric artwork and drool-worthy clothes. (They even converted a second bedroom into one mega-closet.)

"Back in college," she continues. "My goal was to become a journalist—more specifically, a *New York* magazine profile writer. That is, of course, a job that doesn't really exist…at least not full-time. But I thought that having a blog might help me get there."

Back in her native New York, the then-twenty-one-year-old Medine spent months searching for a topic as comprehensive and inspiring as the City of Light. And it was—as with most things in life—in the most banal of moments when lightning struck.

"I was at Topshop one day, complaining about the affairs of my love life," she recalls. "When a friend mentioned the reason I was still single was probably because of the way that I dressed. That's how the idea of a 'man repeller' came to be."

And so ManRepeller.com was born, a site dedicated to the fashion women love and men hate. It's important to note, though, that Medine didn't found a company. She founded a hobby—something to put on her post-grad résumé.

"I didn't envision MR as a business," she remembers. "I started a blogger page without a strategy in place, but I think my mind must be wired to work that way, because I subconsciously acted in ways that were always supporting the brand."

The Man Repeller one finds today is notably different from earlier versions of the site. So, what's changed? The addition of a full-time writing staff, and a shift away from fashion-only content.

"In 2013, I sat down and asked myself, 'Is this something I would feel comfortable doing five years from now? Is this something I could consider selling ten years from now?' And the answer to both of those questions was 'yes,'" she says.

" Up late last night and I read your post about not wearing makeup. I think it's awesome. You are beautiful. Not just on the inside. Keep killing it. "
—@candalangy

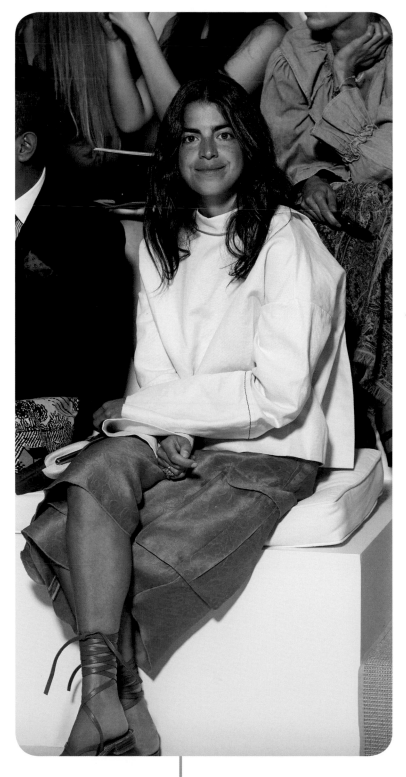

That internal dialogue was the trigger for Man Repeller's evolution. With twelve employees, Medine has transformed the site from a personal blog into a full-blown media company.

"The site has changed so much," she says. "When it started, MR was this very literal site. Now, it's become a nod to female individuality, a treehouse where women can come to feel understood."

"When I started MR, we operated predominantly on desktop," she explains. "Social media outlets were just these prongs to support us; they could hypothetically bend and snap without harming the site. Now, social media operates like a micro-business in and of itself. If MR is the nucleus of the family, our social media accounts are the children who are growing up and going off to start families of their own."

When asked for her best piece of advice, Medine turns to a simple message: "Be wary of letting others permeate your ideas," she says. "If I told people I was going to start a blog called Man Repeller about trends that women love and men hate—and that it was going to become a big deal in fashion—no one would have believed me. You must listen to yourself."

Ralph Lauren Spring/Summer 2016 NYFW, September 2015

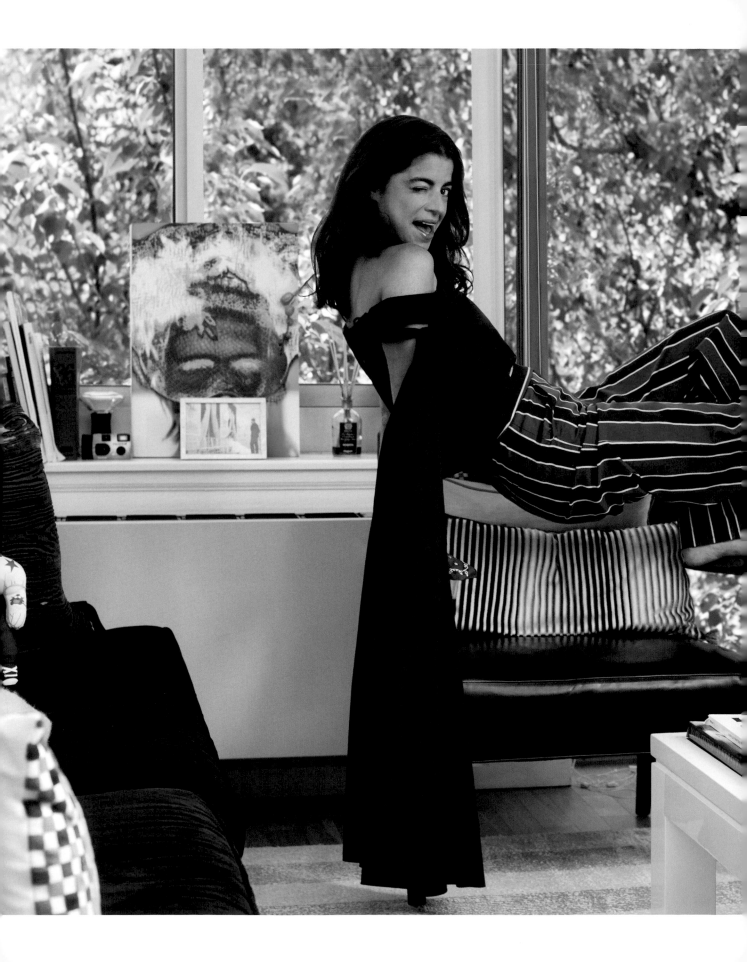

"What sets Medine apart from her peers is, and has always been, her particular breed of intelligence and wit."

—BOND STREET MARKETPLACE

At home, East Village, New York, July 2015

ManRepeller.com

PERSONAL STYLE

Get to Know Team MR: Meet Leandra

SHOP MR PICKS GET THEM ALL

1 / 12

Be your own teacher's pet.

Hi I'm Leandra and if I don't hold onto my arms they'll fall off which is why I'm doing this!

leandramedine Following
1,041 posts 335k followers 463 following
Leandra M !!!Cohen!!! The official fan page of Abie J Cohen www.manrepeller.com

manrepeller · 2 months ago ✓ Following

I got nothing but love for you (me singing to my rolls)

11.6k likes 174 comments Instagram

"She's toooo funny. 😂😂"

leandramedine Following
1,565 likes 100w
leandramedine @camargue01 spoils
frannyella @juliableznak shit
eclecticedit @leandramedine - shoe cred?
patrickstudiolosangeles @leandramedine ...love the sneaker..what is the brand golden goose??
lil_escava Omg @renee_chera mine r high top
ez_cash_method Like it!
sarah_jemai @lilaoj
steffemoreno @jennbunnybreakfast I think I found the golden goose I want!!!
lil_escava @sarah_mansour I no reen @ed meisl
alliefez Trill
sarlasakka @m_sekka @deniasekka
Add a comment...

leandramedine Following
5,119 likes 2w
leandramedine I really have to get my moles checked
view all 42 comments
mariolavaldivie El mejor @collegevintage2
melaniaparra Perfect
beckjewels Love the color combo
totalslizzmove @_pipstagrams
ariana_kate I was thinking the same thing when I saw this
drizlinha
kelicita_lifestyle Me encantan los accesorios
dddorlita
kinvietnameserestaurant Very nice
newyorkcityjenny You can get them removed @flashlabblaser !
Add a comment...

leandramedine Following
6,411 likes 28w
leandramedine Emoji hand is the new foam finger
view all 68 comments
mirandascott @kellym942 tell me bout it
claravear16 Que pazaaaa @claraesg
leandramedine @bwoori_ and the rest of the stuff is tap-for-credited
echo.co.o @amberlog 你的親子
nav1955 She's tooooo funnny
sofiapampin @anasaanchezz_ sortida
bwoori_ @leandramedine @garrettleight ooh I didn't check that far Thank you!
idaskalevik @anniemie
taliluo
cathblast @kaciecarter
jessicaluxe Picture perfect
Add a comment...

leandramedine Following
4,618 likes 9w
leandramedine Perfect night for bathing suit as underwear, huh?
view all 72 comments
greisalano @eve_alano ganahan ko sa shape noh? Dili luod or something. Igo ra
holl.jack buy this @_maha_khan buy that top thing to wear over your new suit
holl.jack @_maha_khan I should buy a dress shirt and then cut it in half and sew it and give it to you
aeyakeya the suit
araksofficial @leandramedine
sanelag jewelry???
paintersdaughter @saradharary @sanelag jewelry = @aureliebidermann
_maha_khan @holl.jack omg please do that
Add a comment...

"Perfect night for bathing suit as underwear, huh?"

"Ever since she exploded onto the fashion-blog scene in May 2010 with The Man Repeller—a seamless blend of style reporting, personal reflections, and social commentary, all infused with the writer's idiosyncratic wit—Leandra Medine has made a name for herself as the quirkiest critic on the front row." –VANITYFAIR.COM

Paloma Elsesser
@palomija

"Lady ✍."

VINTAGE NAOMI CAMPBELL PICTURES, NIKE AIR MAX 95S, AND photos of the coolest girls in the world are among the things you'll find on Paloma Elsesser's Instagram account, alongside thousands of photos of Elsesser's own unbeatable personal style, which is a mashup of streetwear and girlie influences that she pulls together in an unfussy, exciting way. "I would say my style is an adventurous balance between masculine and feminine," says Elsesser, whose résumé includes modeling jobs for ASOS and runway appearances for Tyler, the Creator's fashion line Golf Wang.

"I don't dress for my body, I dress as I feel," she continues. "I think in the plus market, I have carved out a space for myself that isn't about being sexy or having to confirm my confidence all the time. I do have male followers, but it's mostly girls from the ages of sixteen to twenty-two who are my major demographic. Generally, my comments are mostly girls saying, 'I'm into how she dresses.'"

Elsesser first began to share her inherent sense of style with the world through her LiveJournal and MySpace pages, transitioning to Instagram when it became the app to have. "In the beginning I didn't really think about it much,"

SoHo, New York, May 2016

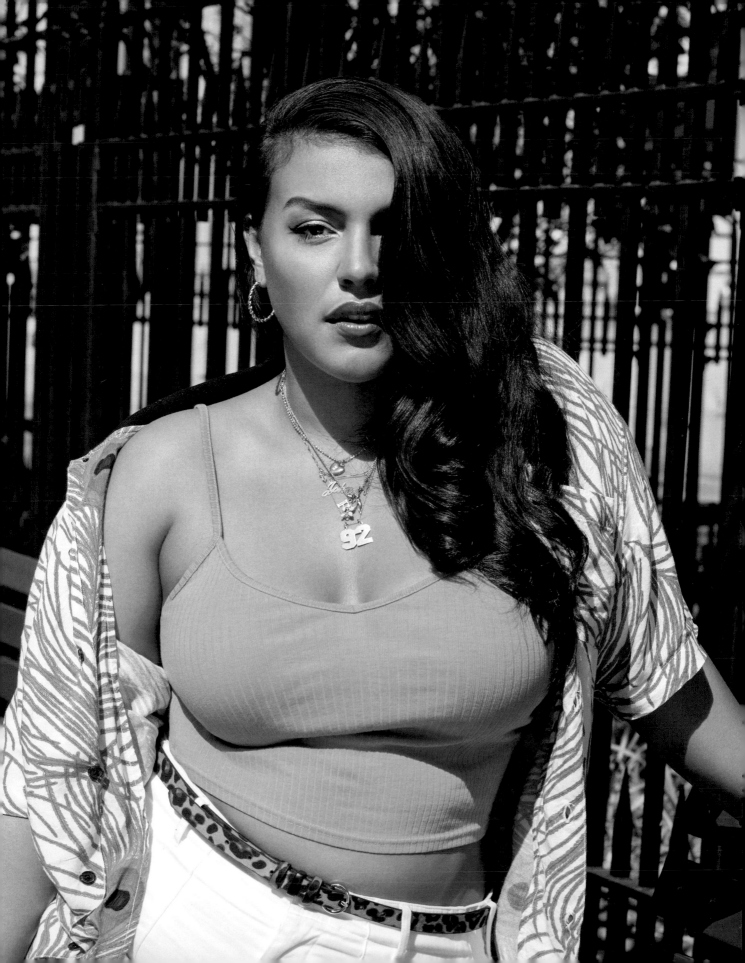

she admits. "I just posted a refined version of my interests." As she continued posting, her following grew; today she has over forty-seven thousand followers.

As her social media following swelled, so did the fashion world's interest in Elsesser. Through a friend, she was introduced to the legendary makeup artist Pat McGrath, who was about to launch her own line of beauty products. Elsesser quickly became one of McGrath's muses and campaign stars, photographed by the likes of Patrick Demarchelier. "She didn't want the archetypal model type. It is just an inclusive amazing project," Elsesser explains. "The first shoot I did with her for Gold 001 was the best shoot I've ever done to this day. There was so much love and so much support. I was just in awe of her artistry, but at the same time she's so down to earth and she makes everyone feel so special. I felt really accepted and welcome, and we've been on the same trajectory since then."

Through her work for McGrath, the Los Angeles native began to garner press, appearing on Vogue.com, Into the Gloss, and The Coveteur. She's also signed with Muse models and has a special Instagram account with ASOS where she shares even more of her #OOTDs.

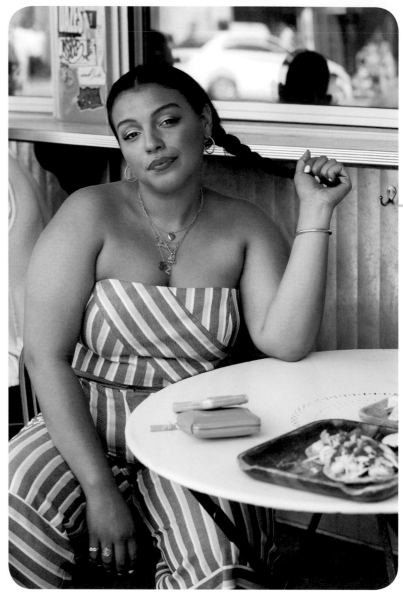

★ HIT LIST ★

- Is makeup artist Pat McGrath's muse.
- Modeled for Tyler, the Creator's Golf Wang fashion show.
- Swears by MAC Ruby Woo lipstick.
- Wears a nameplate necklace of the name "Johnny."

"Paloma Elsesser is a writer, model, and all-round megababe based in New York City." —OYSTER

La Esquina restaurant,
SoHo, New York, May 2016

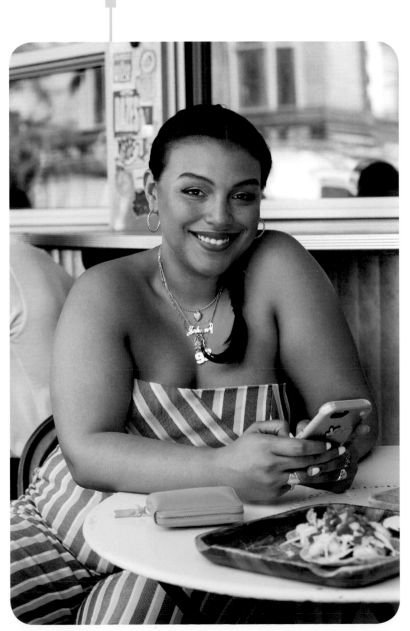

"Being a plus girl of color who's interested in a variety of topics, I think I am relatable to a large group of girls. There's a lot of girls out there who are just like me," she says. And many of those girls look up to Elesser as a success story for making it on your own terms. "Honestly, in no way did I ever think I'd be on a platform inspiring people. It's definitely shown me that I have power in ways that I didn't really think I did before. I'm super grateful for that. It's given me confidence in ways that I never thought I would have. I never thought this would be how I financed my life."

Reflecting on her self-made success, Elsesser continues, "It feels more earned. I wasn't picked up in a mall when I was fifteen. I was myself, and now at twenty-four years old, I'm rewarded in these incredible, beautiful ways for being myself and not streamlined to be what somebody else wants me to be."

Elsesser hopes to bring her brand of awesomeness to even more girls through new mediums. "I would like to do more video stuff. It's a passion of mine to talk to people—if you haven't noticed, I can never stop talking!" she exclaims. "I would like to be able to connect with more women and continue to talk about real things."

" Just saw your H&M ad and immediately felt such inspiration and relief—finally a beautiful woman with a RELATABLE body type that I could look up to. Thank you for making me feel so much better. You're amazing! "
—@marisaseligman

62-63

La Esquina restaurant,
SoHo, New York, May 2016

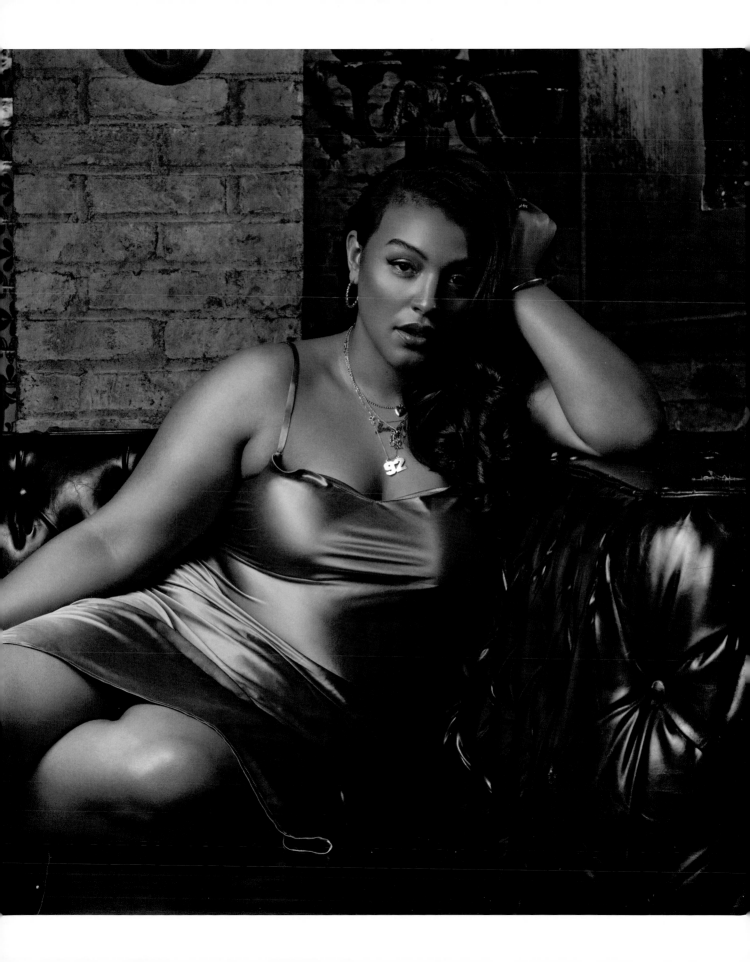

@palomija

palomija — Follow

3,816 likes 22w

@patmcgrathreal~ ✴
view all 94 comments

pantyhoez Omggggg

starcrossedcroqueta Completely refreshed by your style @palomija - Anyone can be painted up to be beautiful, and you def are, but your STYLE is giving me life. Slay, Queen. ♡ You have one more fan today.

yourgirlvic 😍😍😍😍😍

mybestfriendjen Love how you can see your freckles through the makeup. H.O.T!

siancathleenmc Gurlllll 👀👀

pirenge Stunning

becca_grib @_saunds_ can you do this on meh pls

saunds @becca_grib yes!! My camera comes next week we can practisss 😂😂😂

marionalloreta So lovely!

Log in to like or comment.

palomija — Follow

3,025 likes 34w

palomija spoke to vogue.com today about ghosts of beanies past and how to stay fashionably afloat in the winter~ you're the best @voguemagazine @marjon_carlos @bardiazeinali @emrophoto @trexmcneill @goldandrew @staskomarovski 🎀🌟

smellayehros @must_love_hummus

oscar_1992 go awwf boo

a_mi_la Paloma you are a rare beauty 🌹

sazncidious Role model 🖤

nektarine 🌹🖤

marjon_carlos 👏🏽🌹

bluebandanaspantana Wooowwwsaaaa aaa

futurprimitif 😍

penfieldusa 🙌

thehairartiste 🔥

Add a comment...

palomija — Follow

1,223 likes 74w

palomija ~💟TO THE END💟~

1800holly 😍😍

mandaknowsbutts OMG!!!

preston.dupree 🖤

itseyerls So good 🖤

girls_girls_ig You the bomb boo

nikhilmis Steven powers yo

immortalhenry ^

cloudipi ♥

immigranteOvisitante @kaley_isabella

Add a comment...

palomija — Follow

1,879 likes 59w

palomija right hand 🤚🏽 taken by the best @daniyellowden 🤳

carlysophia How long are you here for?

delaurerare 👯‍♀️👯‍♀️👯‍♀️

biofeelia Breathtaking

minyaquirk Princess of Babetown ♥

aphrakf_ @Otamir0 ♥

daniyellowden 🤳🤳

nicolchves this is amazing! 🖤♥🖤

marykfarinas goalzzzz

hannahbackward Wowwww goddess

kelsey__ohara Ommmmmgggggggg Paloma ♥

larrieeee 🖤

larrieeee UR MY GO TO

connyfranko 👯

itstalvah FML

Add a comment...

#1 mija
@palemuh
hi tho
NYC
choppechepoadowh.tumblr.com
Joined May 2009

Tweet to #1 mija

TWEETS 10.8K | FOLLOWING 493 | FOLLOWERS 3,838 | LIKES 419

Tweets | Tweets & replies | Media

#1 mija @palemuh · Jun 27
I partnered with @Target to help debut their redesigned sports bras. peep tgr.bit/palomija - #ClkatTarget #sponsored

#1 mija @palemuh · Jun 24
The beauty of the sport - #ClkatTarget @Target #sponsored

Who to follow · Refresh · View all
burbie @lowellbarbara — Follow
Bag Snob? @BagSnob — Follow
Vasil Kallman @vasilkallman — Follow
Find friends

Trends · Change
#NationalCoffeeDay
Coffee addicts unite around National Coffee Day
Hoboken
One dead, dozens injured after a commuter train crash in NJ
#Bathsday'sContemporary
#TAP2016
#ThursdayThoughts
43.8K Tweets
#Brigitslymalae
#WeirdOneLetterOffbrands
13.3K Tweets
American Honey
1,350 Tweets

2 Followers you know

1,053 Photos and videos

palomija — Follow

3,631 likes 4w

palomija yesterday with @davidchiche 👌🏽

biofeelia 😍😍😍

marinaelyse 🖤🖤✴

mbeka97 Luv

dippedinsalt Wowwwww

elikasepulveda Soooooooooo beautiful 😍

asap_melo 😍😍😍

lili__peper Angel 👼

loumenais ♥

longboardlads ✨

becca_grib @priminahirst

yungslice Your skin!!! 😭 I wish

jour_ne 😍

kalluchis angel face

n4ta5h4 Nice

Add a comment...

palomija — Follow

2,264 likes 23w

palomija talking sweating at the club and literally never wearing heels ever in life on @intothegloss with my lurvley ladies! Link pon mi bio~

elizabethsmart Heaven

danaveraldi 👯‍♀️👯‍♀️👯‍♀️

n.en.o 😍

thisismayan 🖤🖤🖤

blackgrimes @isadoralurana

Add a comment...

palomija Follow

Paloma Elsesser lady ✿palomakai@gmail.com ☞ muse nyc
danielle@musenyc.com ☞

1,710 posts 56.1k followers 832 following

*"Bein a sparkly lil donut for @patmcgrathreal &
@voguemagazine by my angel @thisismayan. 🌹"*

*"Completely refreshed by your style @
palomija—anyone can be painted up to
be beautiful, and you def are, but your
STYLE is giving me life."*

palomija Follow

14k views 2w

palomija bein a sparkly lil donut for
@patmcgrathreal & @voguemagazine by
my angel @thisismayan

view all 67 comments

meggiemmakeup Eugh love her, such a
babe @blvkangel

y_hx1 Luv the lippy...I want 😍

jujyfruitx ✨😖☕🐍

isabelleisliger Want this @kylaelisabeth

sunshine_boy__odc Your super cool and
sexy @palomija

youngkundalini Gorgeous! 🍱

jango88fett 😍😍😍😍🚔

amaelsesser hi you just killed everything
in my existance

arigara_ 🌸🌸🌸

daniella.est Mine just came in and I
bought it bcs of you

♡ Add a comment...

palomija Follow

2,188 likes 15w

palomija posey, choosey ☞
edca50 THOSE VANS DUDE
basedgirl so precious
tha_ming Jeeeeezzz
jazzmynejay @palomija UM YES.
uhhunnudd
visionsnvoices Steez 👌
cleararmorwoe I love you
260two How to rock your uniform
@giin_and_juice
whitechineseman @ninamhach nice
pyjamas
mexicanamericanbaby 🔸🔸🔸
8ffku1_463_ 🌀Ого, классное фото 🌀
Самые низкие 🌀цены ❗Только
оригинальная обувь, реально
смешные цены, примерка, доставка,
самовывоз э 🌀 Ликвидация склада 🌀

♡ Add a comment...

asos_paloma Follow

601 likes 10w

asos_paloma 💅🏽
qasim181 You are sexy
john1wilson Back it down @qasim181
biancajaggerwannabe In Those Jeans -
Ginuwine (2003)
danikadiamond YOU have made me 100%
okay with wearing my belly tops this
summer despite my weight gain. accounts
like yours are gold.
goodvibe_girl luv this
goodvibe_girl link for jeans plzzzzzzzzzzz
morayo.k.t Never been so inspired to rock
my own style more. 💜
_cf23 Link for top for favor
ghosttownbri 💜🙌
tugbstagram Su karideki ozguven bende
olsa @syma19

♡ Add a comment...

*"Elsesser's success is
proof that social media
is democratizing the
industry, and she's just
getting started."* —ALLURE

Christene Barberich
Refinery29.com
@christenebarberich

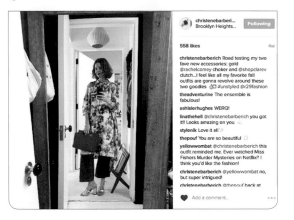

*"Global editor in chief and cofounder of @refinery29…
coauthor of* Style Stalking, *vintage in nature, I gram,
therefore I am…"*

◼

CHRISTENE BARBERICH'S BROOKLYN HOME IS DELICIOUSLY
eclectic, with bold colors, lush plants, and a three-legged cat named Phoebe.
She credits her architect husband, Kevin, for the stark lines and design. Kevin
and, well, Pinterest.

"[Kevin] sees space and light before decorating," Barberich says. "He turned
that funny loft above the living room into our office, even
though we can't really stand up in there. While we were
finishing up the renovation, he was always in the alcove, and
I was always looking for ideas on Pinterest."

At home, Brooklyn Heights,
New York, August 2015

Like Barberich's apartment, every bit of this editor-cum-entrepreneur's
life has been a series of conscious decisions. Her first job? Assisting Steven T.
Florio, then president of the *The New Yorker*. When Florio became chief execu-
tive officer of Condé Nast, Barberich went along for the ride. She then became

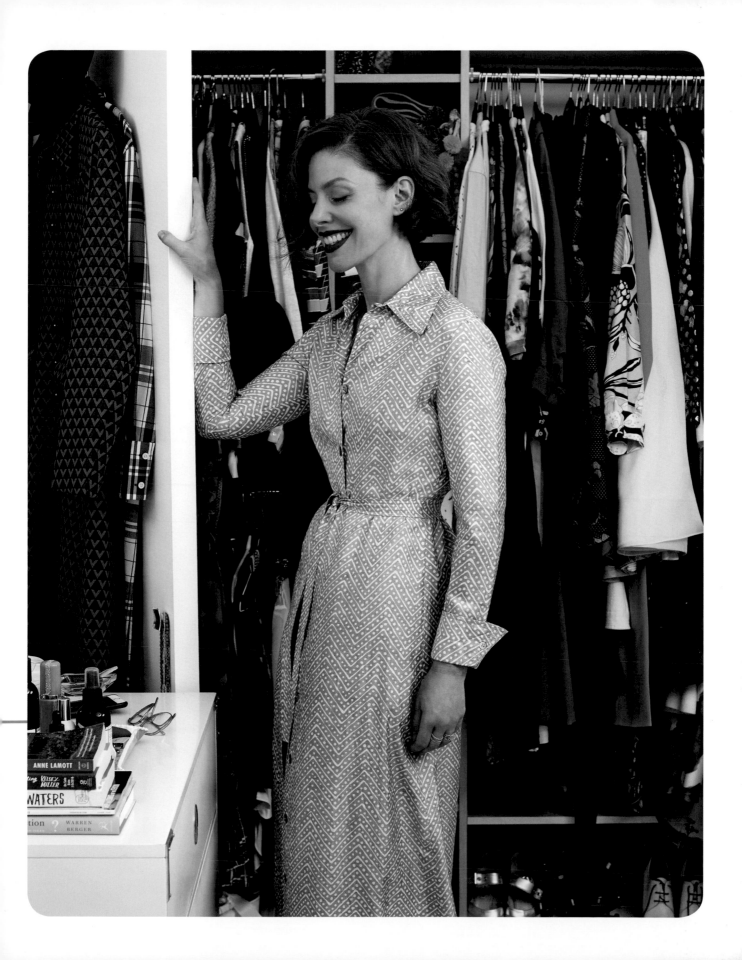

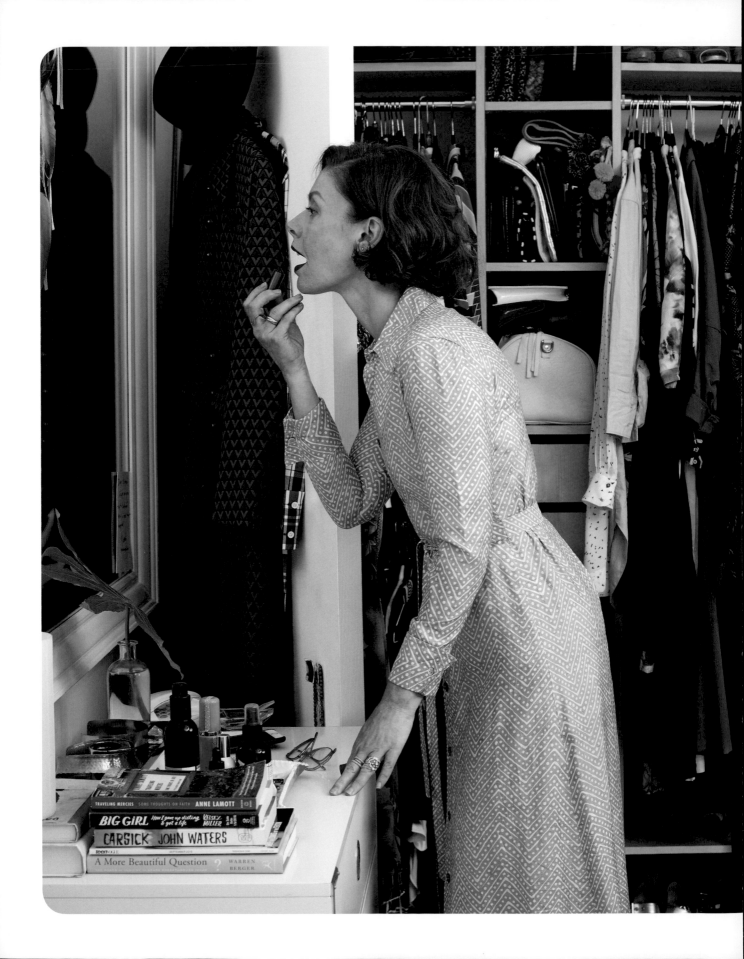

"Perfection!!!!! You have a talent for finding the perfect pieces!!!!"
—@julianatalie63

At home with Phoebe,
Brooklyn Heights, New York,
August 2015

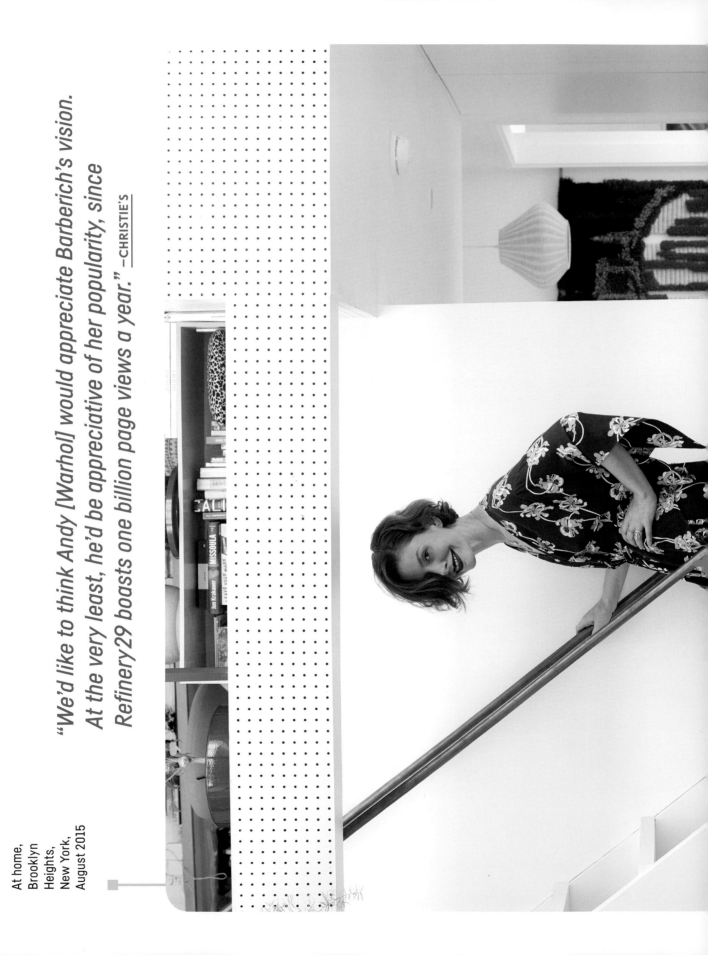

"We'd like to think Andy [Warhol] would appreciate Barberich's vision. At the very least, he'd be appreciative of her popularity, since Refinery29 boasts one billion page views a year." —CHRISTIE'S

At home,
Brooklyn
Heights,
New York,
August 2015

style director of *Gourmet* magazine in 1995, a role she held for four years before launching an indie fashion and design magazine called *CITY* above a bar in SoHo.

"Over the years, I became good friends with [Refinery29 founders] Philippe von Borries and Justin Stefano," Barberich explains. "They asked to meet for drinks one day, explaining they'd come up with a digital style platform for boutiques in New York and Los Angeles. They wanted me to provide a consultative, female perspective—they never thought they'd be stuck with me for twelve years!"

Refinery29 has changed significantly since its 2005 inception, blossoming from a city-focused style guide into a full-blown multimedia enterprise. Their Web traffic is staggering—twenty-five million unique visits each month—making Refinery29 an undeniable leader in the space. As the current editor in chief, Barberich describes the content mecca as, "connecting with readers *wherever* they are, whether that's mobile, desktop, Snapchat, or any other emerging platform designed for our user."

Barberich and her team are focused on readers. Where do they read content? What stories will they share? How long do they engage with each article? It's the

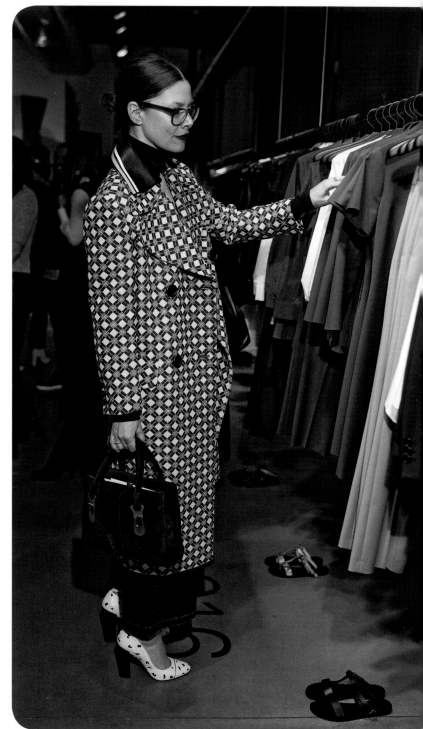

great fortune of digitally-rooted companies to have this wealth of information—something many print publications learned too late in the game.

"We have immediate access to reactions, behaviors, and trends that emerge," she continues. "It's the task of any great storyteller today: to see what resonates, and to grow and change your medium and approach accordingly. That's how a great brand endures, too, by listening and adapting, without losing sight of your center. When I look at Leandra Medine's early writing, for example, it's nothing like it is now. And that's a good thing. It means she was willing to listen."

Barberich truly believes that everything you need to know lies in audience data. Your readers are your best critics. "If you listen, you can create an incredibly powerful experience," she asserts. "People *tell* you what they want to read. It just isn't in the comments anymore."

So does Barberich ever miss the simplicity of print publishing? When all that mattered was circulation, and "click-through rate" had yet to enter the lexicon?

"I grew up with print magazines, and I'll always love them," she says. "You can probably find a crumpled-up *New Yorker* in my bag as we speak, but I've learned to express myself digitally. It's how I consume and engage with everything I know. Just don't expect me to give up my handwritten journal! I've been keeping one since I was twenty-two years old."

Fortunately for readers of this book, Barberich's advice for burgeoning Digital Girls extends beyond keeping a journal.

"Be a great reader," Barberich says. "It's the best thing you can do for yourself—and that applies to whether you're working on digital content, print content, or whatever is next. You must be able to recognize and appreciate what makes a voice special. What makes it connect. It doesn't matter if you're a blog, or a billion-dollar company—you won't succeed until you know how to read, and how to understand what gives a voice value."

★ HIT LIST ★

- Is the founding editor in chief of Refinery29.

- Cowrote a book, *Style Stalking*, in 2014.

- Traveled over 100,000 miles in 2015—and wrote about it on R29.

- Lives in Brooklyn.

- Appears in the digital comic book *Heroine Chic*.

Theory Fall/Winter 2016–17 NYFW, February 2016

@christenebarberich

christenebarberich
Brooklyn Heights Hi... Follow

540 likes 2w

christenebarberich After almost TWO YEARS documenting the transformation of #thebaxterproject , the before and after is finally live today on @refinery29 !!! Thank you to @careinthecity for helping me and @baxterprojects tell our story and to the wonderful @winniewow who documented this process so elegantly and effectively...we are SO PSYCHED! You can read the whole experience at the link in my bio....thank you to ALL OF YOU for your support and house blessings...means so much!! #houseparty #spaceinvaders #roomsaroundmyworld

roxiedarling Beauty!!!

theamericanedit Ah! Christene, it is so beautiful and special and I love reading about all the thought and energy and intention you put into your home! 😎🖤

jessie_loeffler_randall Love that girl!

velenagitlinneshit

Log in to like or comment.

christenebarberich
2016 Democratic Na... Fo

560 likes 8w

christenebarberich Awesome panel discussion hosted by @refinery29 and @theatlantic at the #dnc2016 tonite sharing how millennial women are gonna rule the election...and thanks to @tanyataylor for providing me with just the right top for the occasion #imwithher @hillaryclinton

shopmiamivintage 🖤🖤🖤🖤

lenadecasparis 🖤

joycemarg This is really awesome 🖤🖤🖤

shopmiamivintage @kampretzel

shopmiamivintage @dafonteart Sally needs this...

dancebody_maddie That makes two of us 💯

kerrybombe 🖤

lauraneilson 🖤🖤🖤

thechangingfactor Nice!!!

Log in to like or comment.

christenebarberich ✓ Follow

Christene Barberich Global editor-in-chief and co-founder of @Refinery29 ...co-author of Style Stalking...I gram, therefore I am...
www.refinery29.com/2016/09/103360/christene-barberich-home-tour/#slide-29

2,015 posts 45.3k followers 919 following

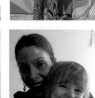

"An editor at heart, Christene shares some of the best advice I've heard for both burgeoning editors and ambitious young folks at large." —MANREPELLER.COM

STYLE STALKING ABOUT THE AUTHORS THE MUSES REFINERY29 VIDEO BUY IT NOW

THE FASHION-GIRL BOOK OF THE YEAR

BUY THE BOOK

STYLE STALKING ABOUT THE AUTHORS THE MUSES REFINERY29 VIDEO BUY IT NOW

TO ALL THE FASHION FREAKS OUT THERE

BUY THE BOOK

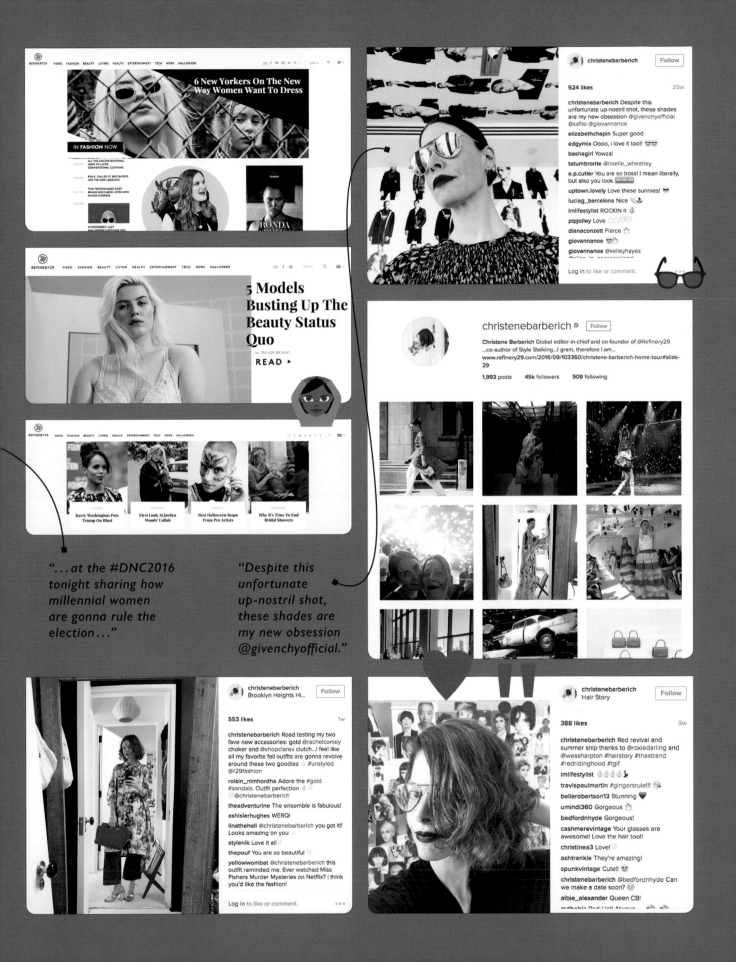

"...at the #DNC2016 tonight sharing how millennial women are gonna rule the election..."

"Despite this unfortunate up-nostril shot, these shades are my new obsession @givenchyofficial."

Nicole Warne
GaryPepperGirl.com
@garypeppergirl

"To infinity...☄ *"*

ATOP A SOARING PENTHOUSE AT NEW YORK'S QUIN HOTEL,
Nicole Warne is battling jetlag. The twenty-six-year-old founder of Gary Pepper Girl has a passport that bears witness to the fact that "Fashion Week" could be more aptly described as "Fashion Month."

"There are times when I don't see Sydney for months,'" Warne says. "It's tiring, but so worth it; I get to be my most creative self every day."

When the Australian style star founded Gary Pepper Girl (GPG) in 2009, she did not anticipate such global success. GPG was launched as a simple vintage store—an eBay venture similar to that of fellow Digital Girl Rumi Neely.

The Quin hotel,
New York City,
September 2015

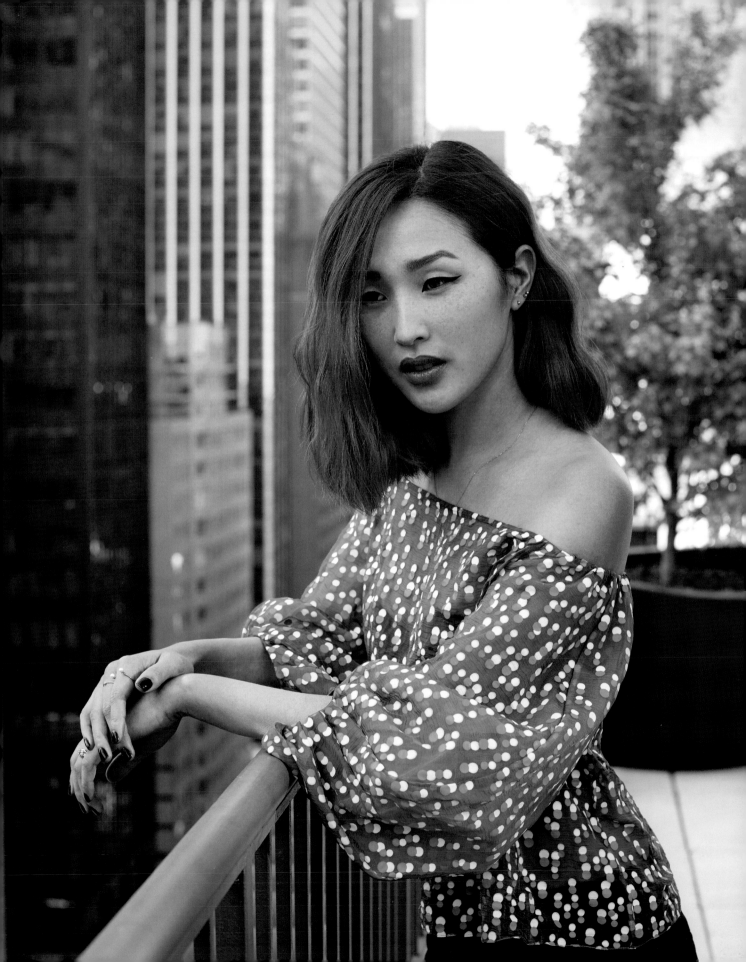

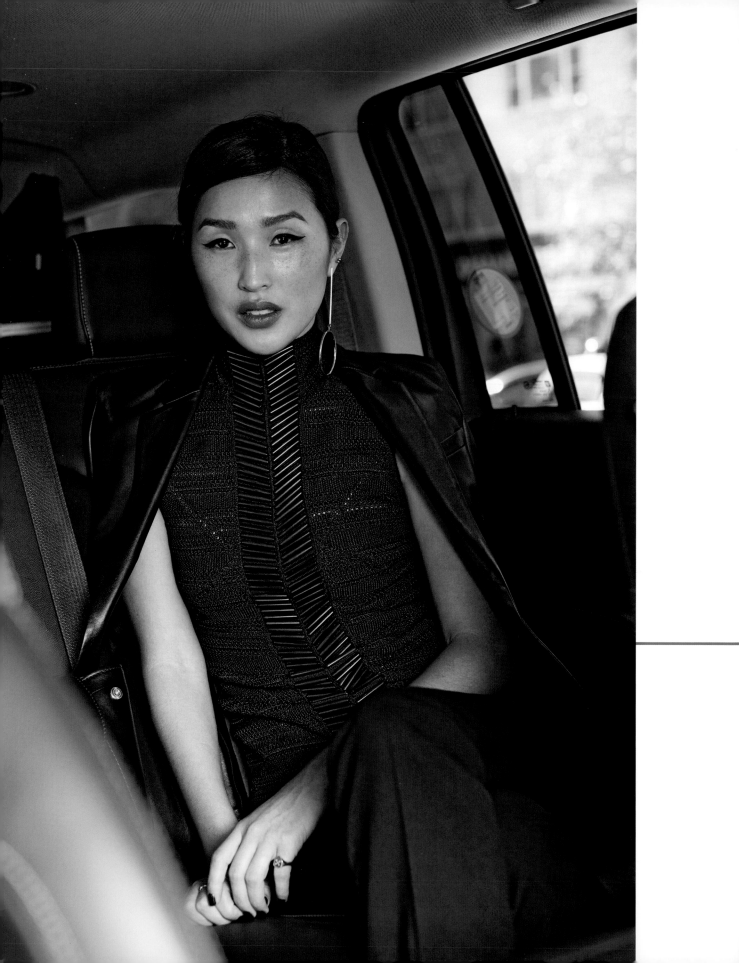

★ HIT LIST ★

- Her go-to eyeliner is Make Up Forever in Aqua Black Cream.

- Grew up on a farm in Western Australia.

- Interned at *Grazia* and *Harper's Bazaar* Australia.

"After selling two-thirds of my inventory on the first day, I realized I was onto something," Warne remembers. "GPG was so instantly successful, in fact, that I left fashion school and quit internships at both *Grazia* and *Harper's Bazaar*. Some might call that blind confidence, but I call it doing what needs to be done."

Warne hired three full-time staff members, and started selling approximately two hundred items every ten days. Inspired by sites that blended commerce with content—think Sophia Amoruso's Nasty Gal and Suzanne Ford Carafano's Spanish Moss—Warne opted to supplement her store with a blog.

"To be commercially successful today, you need to have a personality," Warne explains. "It feels cold to buy from a massive corporation—people want a connection. That's why I founded GaryPepperGirl.com: to have a blog that enabled GPG customers to connect with my personality."

One should note that the GPG blog was never meant to overtake the store. Its sole purpose was to connect shoppers with Warne as an individual—not to become a full-time occupation.

"I was able to divide my time between the blog and store for about two and a half years," she remembers. "But I couldn't keep up with demand. Over time, it became clear that the amount of time invested in selling one vintage piece simply wasn't worth the overhead."

New York City, September 2015

Warne shuttered the GPG store in 2012 in order to focus on her editorial site full-time. It was Facebook that helped put Warne's blog on the map.

"Facebook may have more competition now," Warne says. "But for GPG, that platform was our greatest success. For a long time, we didn't even have Instagram, although we did have sixty thousand fans on Facebook within our first year."

"Love how you're always supporting causes you believe in ♥."
—@velveteencockroach

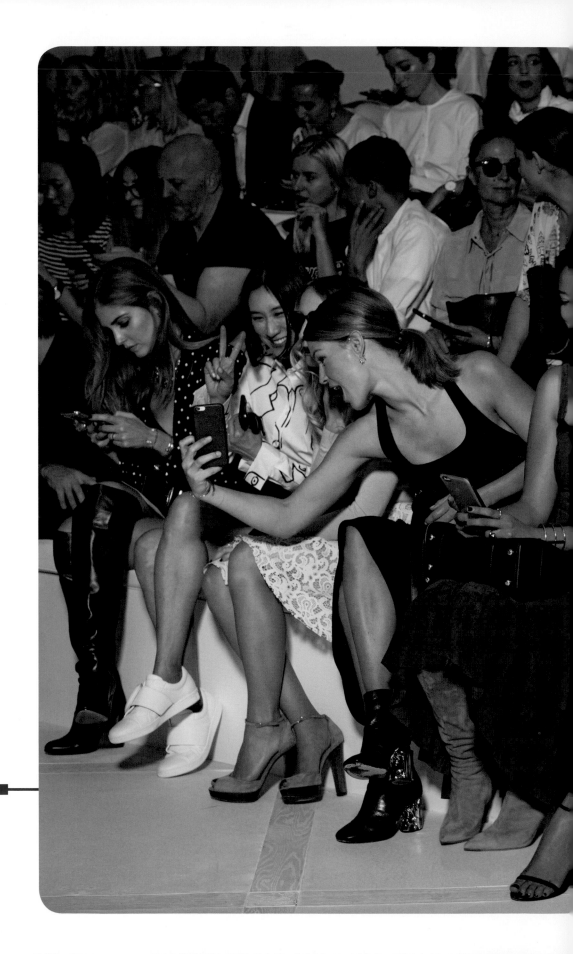

Ralph Lauren
Spring/Summer
2016 NYFW,
September 2015

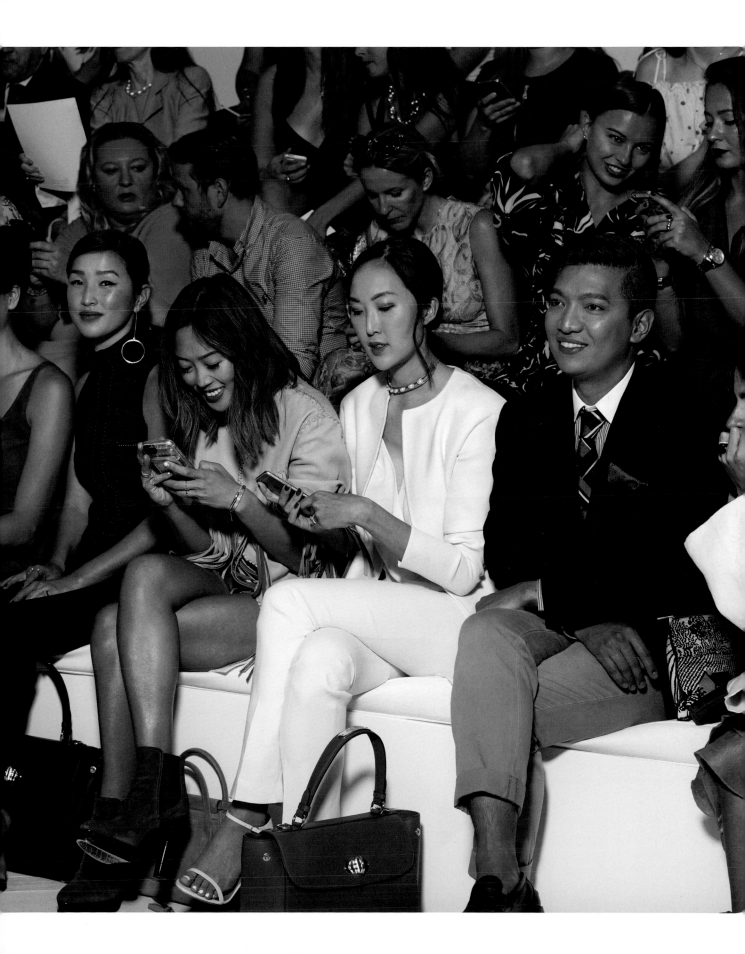

"I love what a paradox you are @garypeppergirl, in Paris one week glammed up, the next on the central coast cleaning your house! You're so genuine & real 🖤🤍 ."

—@rl_246

Warne continues to use caution when expanding GPG to new platforms: "It's better to do something well than to do something first," she asserts. "Ideally, of course, you do both. But if I had to pick, I would rather be thorough."

A primary example of Warne's methodical approach is the way she denotes sponsored content. "One-off sponsored posts never sat well with me," Warne explains. "Readers need to know when something's been paid for. That's why I'm always transparent when I've partnered with a brand. I really feel audiences appreciate not being deceived."

Warne approaches brands with the same level of attention as she approaches her fans. "In the beginning, I didn't take on a lot of sponsored work," she remembers. "I wanted to be very exclusive with collaborations—to build long-term partnerships that were beneficial to both me and the brand. I won't work with a brand partner's competitor, for example. And while that may mean less money, it also means I'm loyal."

Warne views part of her business as a full-service agency, bringing leading brands to GPG readers in ways that feel organic, authentic, and true to her aesthetic. She's so successful, in fact, that some brands have tasked Warne with developing entire campaigns.

"I've signed on as a digital consultant for Qantas Air," she explains. "They recently asked me to come up with the concept for an entire campaign. I handled everything from talent outreach, to production, to implementation."

So as Warne transforms herself into a full-blown, digital agency, where is she focused now?

"I'm most interested to see what happens with Facebook," she says. "They've acquired all these platforms—Instagram, WhatsApp, Oculus—and the rumor is that they'll combine them all in one application. That's what I'll be watching."

"We've long been fans of Warne not only because we covet her laid-back chic style, but we also can't help but love a woman who has managed to find success in the fields of fashion, digital and social media, and e-commerce, creating a completely self-made empire." —GLAMOUR

GaryPepperGirl.com

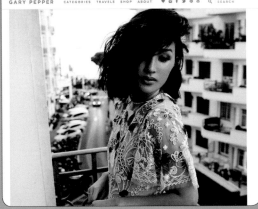

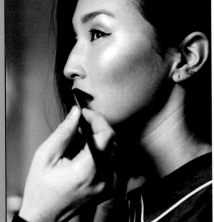

garypeppergirl

11.3k likes 24w

garypeppergirl Getting ready for the Chanel show w/ @victoriabaron for @chanelofficial on garypeppergirl.com now 🌸 It's pure love when I get to work with VB - wish I could take her everywhere I go.

view all 78 comments

pip.dickson @azfifteen

kaitroseh @hannah__noellee HIGHLIGHT

michele_wz Nice color

qliz520 好像曼玉

stylegardenmom Gorgeous!

danainthedetails @dupeityourself I have that color it's gorj

amandabaptista1 Beautiful ♥

cathy_yangchenchen 气质呀

laurenfonda Flawless skin

fauxtinger Cool!

Log in to like or comment.

Nicole Warne on the cover of ELLE Australia.

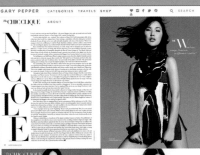

THE FOUNDER, NICOLE WARNE

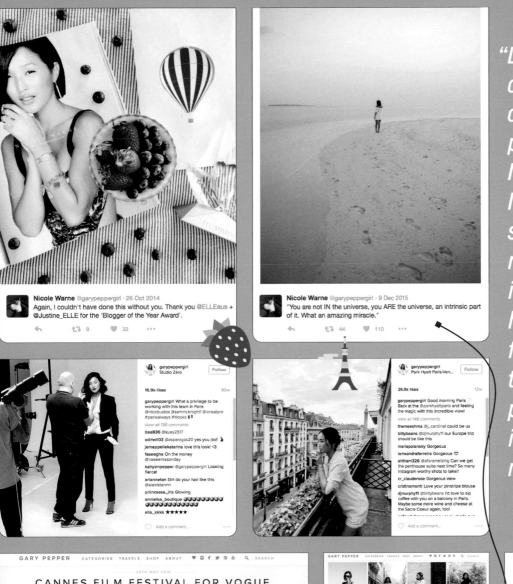

Nicole Warne @garypeppergirl · 26 Oct 2014
Again, I couldn't have done this without you. Thank you @ELLEaus + @Justine_ELLE for the 'Blogger of the Year Award'.
9 32

Nicole Warne @garypeppergirl · 9 Dec 2015
"You are not IN the universe, you ARE the universe, an intrinsic part of it. What an amazing miracle."
44 110

garypeppergirl
Studio Zéro Follow
16.9k likes 80w
garypeppergirl What a privilege to be
working with this team in Paris
@nicobustos @sammcknight1 @loreaipro
#parisalways #itlooks
view all 136 comments
bea836 @suey2517
adriwil03 @asparagas20 yes you do!
jemappellekatarina love this look! <3
faseegha On the money
@naseemasonday
kahyenpepper @garypeppergirl Looking
fierce!
ariannetan Girl do your hair like this
@alexistannn
prllncesse_iris Glowing
annielka_boutique
ella_kkkk ★★★★★
Add a comment...

garypeppergirl
Park Hyatt Paris-Ven... Follow
26.9k likes 12w
garypeppergirl Good morning Paris
Back at the @parkhyattparis and feeling
the magic with this incredible view!
view all 148 comments
themeeshma @j_cardinal could be us
bittybeans @djmurphy11 our Europe trip
should be like this
marlapolansky Gorgeous
lamsandraferreira Gorgeous 😍
ahtham326 @aforameizing Can we get
the penthouse suite next time? So many
Instagram worthy shots to take!!
cr_clauderose Gorgeous view
cristinamonti Love your pinstripe blouse
djmurphy11 @bittybeans I'd love to sip
coffee with you on a balcony in Paris.
Maybe some more wine and cheese at
the Sacre Coeur again, too!
Add a comment...

GARY PEPPER CATEGORIES TRAVELS SHOP ABOUT ♥ ⬚ f ♥ ⓟ ⓐ Q SEARCH

28TH MAY 2016
CANNES FILM FESTIVAL FOR VOGUE
EDITORIAL

"Living the definition of a life worth posting about, Nicole takes to Instagram daily, showing the rest of us what it looks like to have your dream future come true, with each post even more inspiring than the next." —BUZZFEED

"You are not IN the universe, you ARE the universe, an intrinsic part of it. What an amazing miracle."

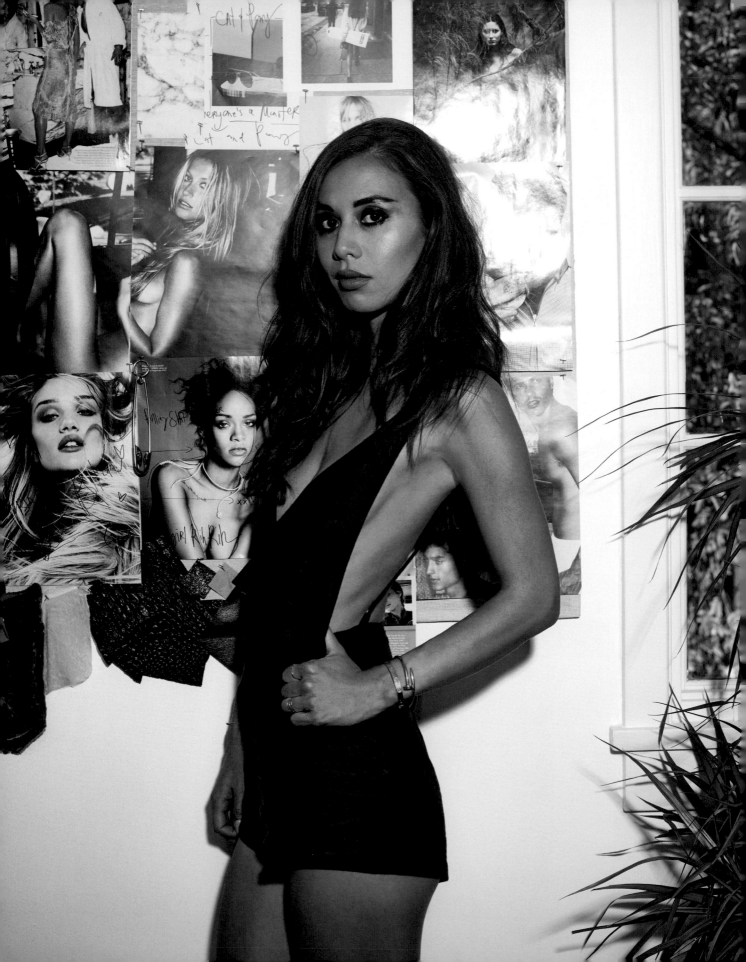

Rumi Neely
FashionToast.com
@rumineely
@areyouami

"Creative director and owner @areyouami."

■

ANYONE YOU ASK WILL NAME RUMI NEELY AMONG THE
OG class of fashion bloggers. This Japanese-American style star grew up in the
Bay Area, selling vintage clothes and learning to pose long before we all knew
the difference between Kelvin and Ludwig filters.

"I've been reading fashion magazines since I was twelve," she says, sitting
cross-legged at her wooden dining room table. "I literally begged my mom to
buy *Vogue* whenever we went to the grocery store. Neither my parents nor
my friends cared about fashion, so those magazines were my only outlet. I still
have all the cutouts."

The Los Angeles–based blogger has come a long way from grocery store
magazine stands. Her Instagram boasts over 680,000
followers, leading to frequent collaborations with brands
like Dannijo and Revolve.

At home,
Hollywood Hills,
August 2015

"I started Fashion Toast with the goal of becoming
a magazine editor," she explains. "And it's funny to think how far I've come in
the past nine years. Back then, I was on BlogSpot. I didn't know how to handle

large amounts of e-mail. I had no idea how to talk to brands. Now I'm the founder of a company."

The most obvious reason for her success? Her style, of course. It's what she put to use when launching her vintage e-store—an early version of Fashion Toast—back in 2008. Neely's look then was not unlike what it is now. An archived post from seven years ago, for example, showcases much of the same clothing Rumi wears today. "I'm instinctual almost to a fault," Neely explains. "More than other bloggers, I don't take other people's opinions into account. I don't wear the latest trend. I want to look like me."

In 2015, looking like Neely became a whole lot easier with the launch of her fashion line, Are You Am I, which brings wispy dresses and daring rompers to Fashion Toast fans. (Fellow Digital Girl Chiara Ferragni is an avid customer.)

"Are You Am I was born from my desire to find the perfect slip dress," Neely says. "I just couldn't find one that I loved, so I bought vintage versions and modified them in really elementary ways—chopping them with scissors, leaving hems raw. I couldn't believe that something as simple as a slip dress didn't exist. I wanted to make those perfect staples that everyone needs."

Are You Am I quickly took off. The e-commerce site now rivals Neely's Fashion Toast in terms of traffic, and her pieces appear frequently in fashion magazines and on the Instagram accounts of her fellow bloggers.

"Everyone is so into Instagram right now," she says. "Because it's quick to satisfy. That in-the-moment gratification is the best thing. But I'll use Pinterest or Tumblr sometimes to find inspiration from places like *Vogue* Paris; they're really inspiring to me."

When discussing ways to break into the industry, Neely preaches the importance of finding your own voice: "Post what you love," she says. "Create your own normal. Exist on your own plane. Try not to worry about what other bloggers are posting or wearing, and build something of your own. The most important thing is to stand out with your content."

Great advice by any standards, but what's Neely's number-one rule? "Don't be afraid to spoil yourself with fashion," she says. "It's better to buy one amazing piece that lasts forever, than four pieces that'll end up in the bin next month."

At home with Kumo, Hollywood Hills, August 2015

★ HIT LIST ★

- Founded Fashion Toast alongside a vintage store on eBay called "Treasure Chest Vintage."

- Is close friends with Chiara Ferragni.

- Kendall Jenner and Bella Hadid are fans of her clothing line.

- Does all her own makeup for her blog.

- Dressed up as Natalie Portman in *Léon: The Professional* for Halloween.

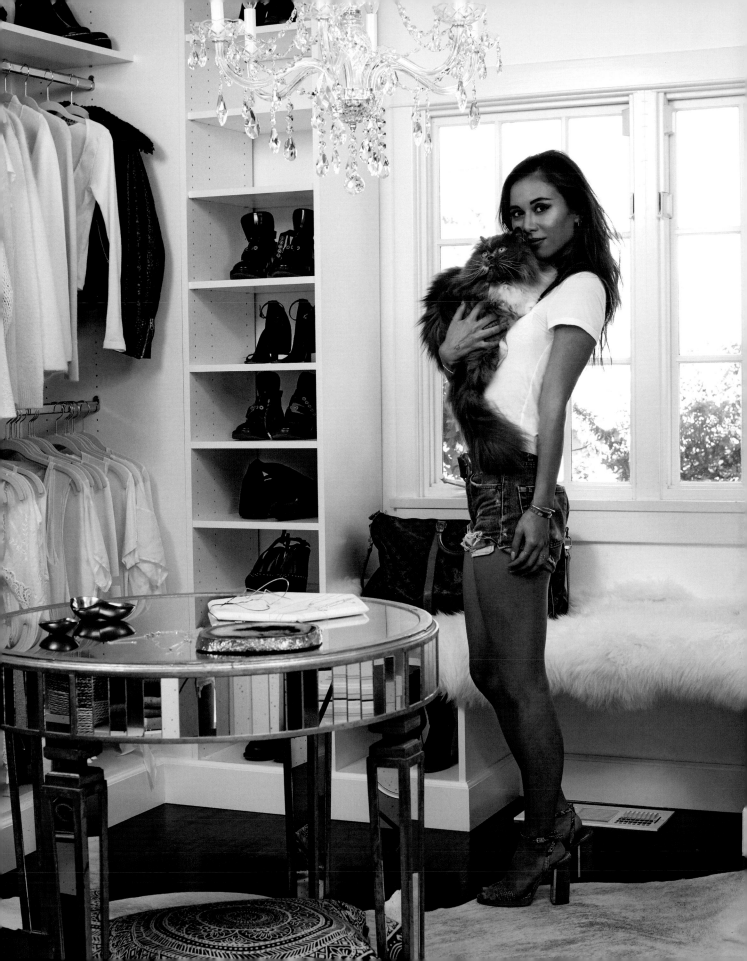

"You are my role model tbh @rumineely."
—@thepeachyneko

"For Rumi Neely, what looks to be a bright future in fashion will owe much to Fashion Toast's success."

—CNNMONEY.COM

At home,
Hollywood Hills,
August 2015

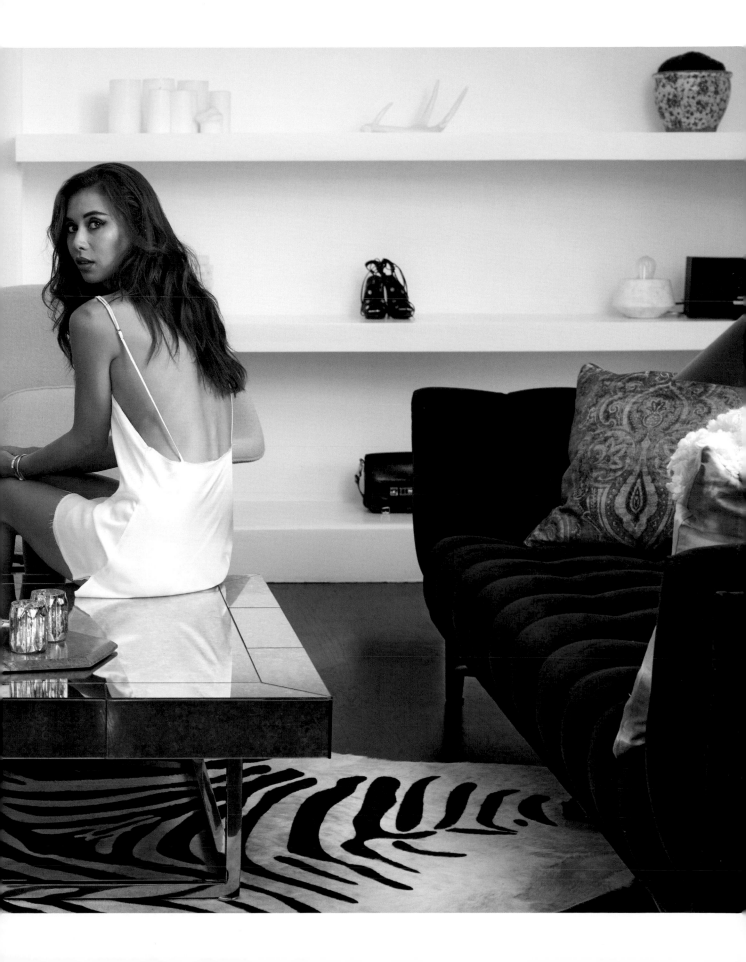

FashionToast.com

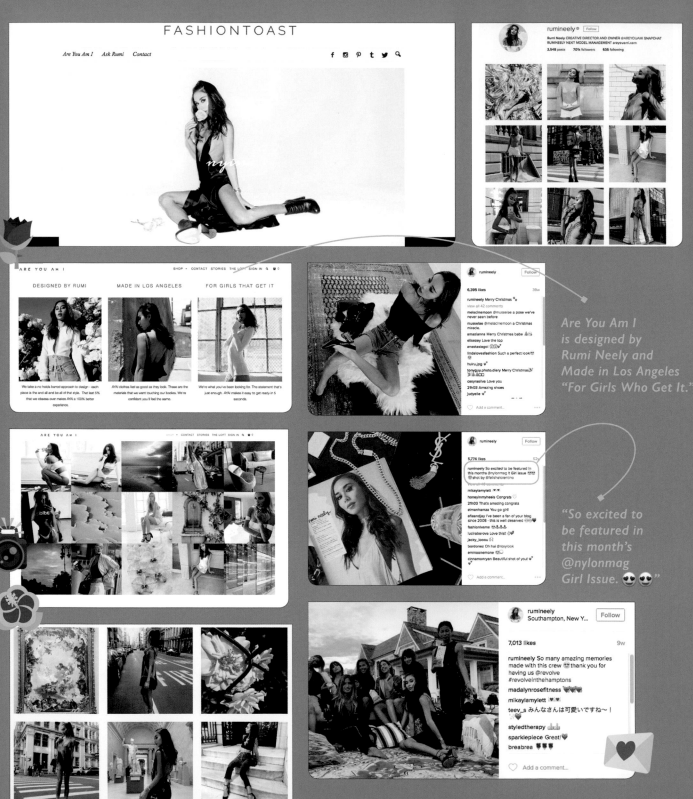

Are You Am I is designed by Rumi Neely and Made in Los Angeles "For Girls Who Get It."

"So excited to be featured in this month's @nylonmag Girl Issue. 😍😍"

rumineely Follow

8,331 likes — 3w

rumineely Us 🐱@knighttcat 🐱🐱
view all 44 comments
sparklepiece 🤍🤍🤍
wwwowwwme WWW🖤WWW
zoviahanna love it 🖤
aziya_aldridge_moore 🤍🤍
il.leonor 😍
fashionbyagatha 🖤🖤🖤🖤🖤🖤🖤
thefleurstyle 🖤🖤
yllarimar Una foti ashi contigi en tu espeju @mayumeeeee
perriee Favs
nina.brielle A selfie like this @caragh_cooper
caragh_cooper yaassss @nina.brielle
pacoruiz.life Yes!!
mariageronico Wonderful make up 🖤🖤

Add a comment...

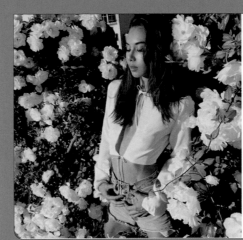

rumineely Follow

3,706 likes — 22w

rumineely Bed of roses 🌹 the Alessia blouse #ayal
florkasado Egomaniac
baileycaitlynn love love love 🔲🔲🔲🔲
babyblue_kid loovee
emmahoareau Yes 👌
space46boutique Yes babe 🙌
monicaflatland 🙌🙌
louboutinsandlove Gorgeous
silverado_one Nothing better than a beautiful woman buy beautiful flowers
tjswim_ 🙌
deise_nicolau @anndrrelima se vira ...
edenpret
_alyssamay So effortless
chill_chiliiii I don't think you only have white top, black or denim short

Add a comment...

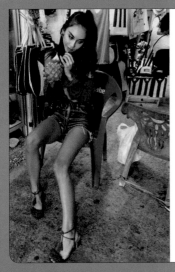

rumineely Follow
Havana, Cuba

7,646 likes — 8w

rumineely At the Havana flea market like 📸 @revolve #revolvearoundtheworld
gypsynouchka 🖤💯🖤
jessie_khoo Loves it
thegrisgirl 🖤🖤🖤🖤🖤
mommy_nannan 🖤🖤🖤
fmbyjelena ✔️🖤🖤
cristinamonti In love with the red
nick.vrs Work it
stylebygina_ Love this 🖤🖤🖤
stellchi Cool shot
kunihosaka Lovin' it 🐈🐈🐈
mimisfancylife So beautiful!!! 😍😍😍
kateemao LOVE
anjaschuschu Beautiful shirt and shoes 🖤🖤🖤
barez111 :-*

Add a comment...

FASHIONTOAST

Are You Am I Ask Rumi Contact

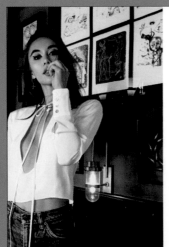

rumineely Follow
La dama

5,823 likes — 21w

rumineely 🐱
chrisellelim @rumineely love 😎
the_fashion_advocate 🖤🖤🖤🖤🖤🖤🖤
mery_caa So fantastic!
isasierra Shirt brand? @rumineely
imdreamingthehardest 🖤🖤🖤
mariapolansky Beautiful
_tiffanyluu This top is everything
cocobaby_coco love this 🖤🖤
fbyelin So gorgeous dear
style.rarebit Love 🖤🖤🖤
21h03 Love that shirt
carcupri 😍
navrockaya 😍
kekekahlo 🙌🙌

rumineely Follow

5,738 likes — 48w

rumineely Prim 🐱
view all 47 comments
cookieyammi @ayufaye
may_lin1219 好喜歡這衣服哦
kingalann @butterlovinmarie @04flowergirl04
romainbets Woaw babe @au_r0re jolili
isabellafera omg
rianne.bongers so pretty @benna.c xx
krystalfrenche Super beautiful 😍X
belinda_bdc Muy bonito!
mariapolansky Beautiful top
au_r0re @romainbets nappe ?
shopfoxsie Makeup is on point
style2beatz You're gorgeous doll!! Cute top 🖤
andeavee @dannahmikhaela super 😍

Add a comment...

"In many ways, Neely was the original model for the hundreds of personal style bloggers that came after her." —FASHIONISTA.COM

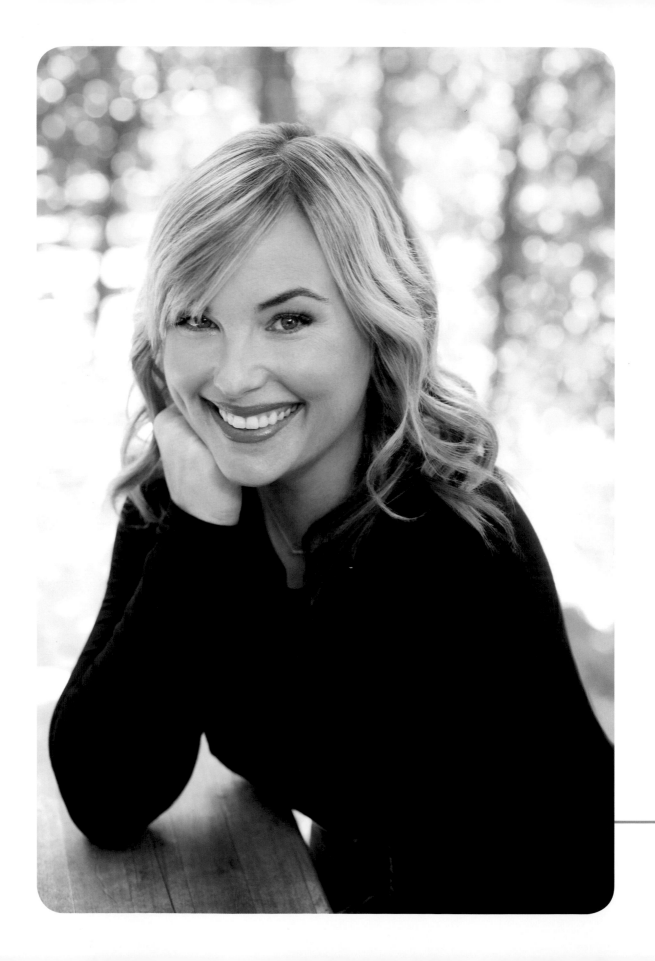

Hillary Kerr

WhoWhatWear.com
@hillarykerr

"Cofounder: @whowhatwear, @mydomaine, and @byrdiebeauty. Also: lover of puns, Pomeranians, and panache."

■

BEAMS OF SUN WAFT THROUGH THE WINDOWS OF HILLARY Kerr's West Hollywood bungalow, tossing light onto dozens—okay, hundreds—of coffee table books scattered around the room. "Doesn't New York feel a million miles away?" she asks.

Before moving back to Los Angeles in 2005 and founding Clique Media, home of Who What Wear, Byrdie, and My Domaine, the Cali native had been a young editor in New York City.

"My first job was in the features department at *ELLE*," Kerr says. "But what I remember about that time isn't the work. It's the five girls who started out with me: Eva Chen, Jane Herman, Susan Cernek, Leigh Belz, and Danielle Nussbaum, who now hold jobs at Instagram, Vogue.com, *InStyle,* and *Entertainment Weekly.* "It must have been kismet. What are the chances that the five women you meet on your first job all end up doing such killer things?"

At home,
West Hollywood,
April 2016

The women remain close friends to this day. From fashion week to baby showers—theirs is a bond that transcends age and distance.

“ Have I told you lately that I think you are amazing???? 😘 . ”
—@rachnasays

At home,
West Hollywood,
April 2016

"It was, and continues to be, the most amazing group of women," Kerr says. "We still get dinner—pizza and wine at Rubirosa—the first Friday of every New York Fashion Week. More than ten years have gone by, and we're closer than ever."

Even though Kerr looks back on New York fondly, she doesn't regret the decision to move west.

"I loved living in New York," she explains. "And I loved working in print, but I found myself frustrated. The higher you're promoted at a magazine, the less writing you do. It's all editing. My career in New York began to feel very constricting, and Los Angeles felt like this undefined opportunity."

Kerr left *ELLE* in 2005, moving back to Los Angeles in pursuit of a free-lance career. As luck would have it, Kerr met her business partner, Clique Media cofounder, Katherine Power, that very first day.

"We met on the set of *Project Runway*," Kerr says. "Season two…Which is kind of an amazing 'meet cute.' She was the West Coast editor of *ELLE* and *ELLE Girl*, and I was on set freelancing for *ELLE*. We clicked instantly."

The new friends watched as magazines began to fold, noticing that celebrity gossip sites—think USWeekly.com and Perez Hilton—seemed to be escaping the massacre. Sensing an opportunity, they dreamed up a celebrity site that talked about the *clothes*. Not the drama.

"We started our first site, Who What Wear, in 2006," Kerr explains. "And you would be shocked to hear how little we knew about digital media at the time. We knew nothing of code, user experience, or Web design. Katherine designed the first version of the site on PowerPoint, for goodness sake."

To turn Power's PowerPoint into a functioning website, the pair enlisted the help of a family friend—someone learning to code as a hobby. Their only ask? To build a content platform that mirrored MySpace.

"I'm not sure if anyone even remembers MySpace," Kerr says. "But it was a very rudimentary site. It had one button to upload images, and one open area where you could cut and paste text. We needed our site to be a non-social media version of that, to be able to upload without having anyone there."

★ **HIT LIST** ★

- Got her start working at *ELLE*.
- Founded Who What Wear with Katherine Power in 2006.
- Calls New York her favorite city, even though she lives in Los Angeles.
- Studied at USC and got a master's degree at NYU.
- Is a Virgo.
- Loves listening to Motown music.

At home,
West Hollywood,
August 2015

And by "there," Kerr means the Beverly Hills apartment where Clique Media saw its earliest beginnings. From day one, Power and Kerr used their print publishing roots to differentiate the site. They applied print sensibilities, like fact-checking, and traditional reporting, to the Wild West that was online.

"There has always been—and continues to be, in certain circles—the idea that the Internet is 'less than' print," she explains. "But we weren't going to succumb to that. Everything we put on our sites could easily run in a print publication."

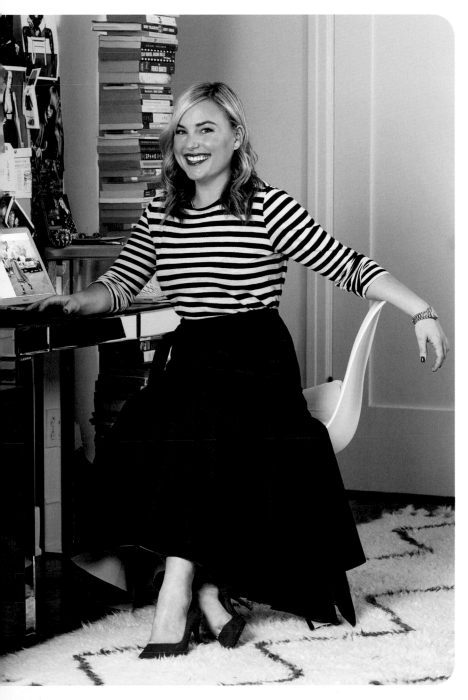

Who What Wear's MySpace-inspired beginnings are now a thing of the past. The last decade has seen Clique Media grow into a comprehensive digital media and commerce company with over on hundred employees and three distinct properties. In 2015 they launched in both the U.K. and Australia. Kerr attributes their success to good old-fashioned experience—something she says every young Digital Girl must gain.

"The best thing I ever did was intern," Kerr exclaims. "I loved getting my master's [at New York University], but work experience is the best experience. It gives a sense of various company cultures, and enables you to find the best fit for you. Whenever I look to hire people, the number-one thing I look for is work experience."

WhoWhatWear.com

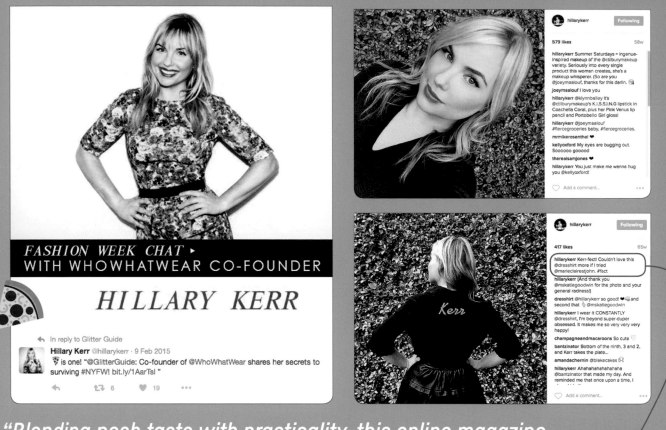

FASHION WEEK CHAT ▶
WITH WHOWHATWEAR CO-FOUNDER

HILLARY KERR

In reply to Glitter Guide

Hillary Kerr @hillarykerr · 9 Feb 2015
✌ is one! "@GlitterGuide: Co-founder of @WhoWhatWear shares her secrets to surviving #NYFW! bit.ly/1AarTsl "

🔁 6 ♥ 19 •••

579 likes 58w

hillarykerr Summer Saturdays = ingenue-inspired makeup of the @ctilburymakeup variety. Seriously into every single product this woman creates, she's a makeup whisperer. (So are you @joeymaalouf, thanks for this darlin. 😘

joeymaalouf I love you
hillarykerr @klynnbailey It's @ctilburymakeup's K.I.S.S.I.N.G lipstick in Coachella Coral, plus her Pink Venus lip pencil and Portobello Girl gloss!
hillarykerr @joeymaalouf #fiercegroceries baby, #fiercegroceries
mrmikerosenthal ♥
kellyoxford My eyes are bugging out. Sooooo gooood
therealsamjones ♥
hillarykerr You just make me wanna hug you @kellyoxford!

Add a comment...

417 likes 65w

hillarykerr Kerr-fect! Couldn't love this @dresshirt more if I tried @marieclairestjohn. #fact

hillarykerr (And thank you @mskatiegoodwin for the photo and your general radness!)
dresshirt @hillarykerr so good! ♥👌 and second that 👆 @mskatiegoodwin
hillarykerr I wear it CONSTANTLY @dresshirt, I'm beyond super-duper obsessed. It makes me so very very very happy!
champagneandmacaroons So cute 🤍
bantzinator Bottom of the ninth, 3 and 2, and Kerr takes the plate...
amandachemin @blakecakes 👊
hillarykerr Ahahahahahahahaha @bantzinator that made my day. And reminded me that once upon a time, I

Add a comment...

"Kerr-fect!..."

"Blending posh taste with practicality, this online magazine and daily e-mail newsletter aims at high-end buyers and also appeals to the classic girl next door." —VANITY FAIR

WHO WHAT WEAR SHOP CELEBRITIES STREET STYLE FASHION TRENDS WHOWHATWEAR COLLECTION ✉ Subscribe

Today / STYLE TIPS

9 Fall Outfit Ideas You'll Wear on Repeat

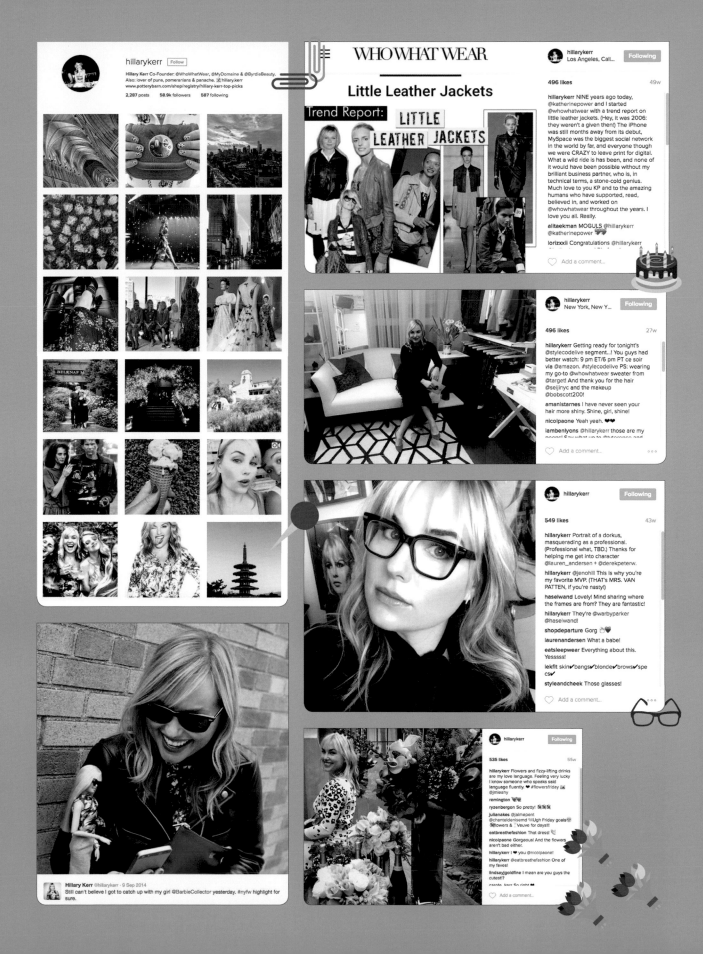

hillarykerr Follow

Hillary Kerr Co-Founder: @WhoWhatWear, @MyDomaine & @ByrdieBeauty.
Also: lover of puns, pomeranians & panache. ⚡ hillary.kerr
www.potterybarn.com/shop/registry/hillary-kerr-top-picks

2,287 posts 58.9k followers 587 following

WHO WHAT WEAR

Little Leather Jackets

Trend Report: **LITTLE LEATHER JACKETS**

hillarykerr
Los Angeles, Cali... *Following*

496 likes 49w

hillarykerr NINE years ago today, @katherinepower and I started @whowhatwear with a trend report on little leather jackets. (Hey, it was 2006: they weren't a given then!) The iPhone was still months away from its debut, MySpace was the biggest social network in the world by far, and everyone though we were CRAZY to leave print for digital. What a wild ride is has been, and none of it would have been possible without my brilliant business partner, who is, in technical terms, a stone-cold genius. Much love to you KP and to the amazing humans who have supported, read, believed in, and worked on @whowhatwear throughout the years. I love you all. Really.

alitaekman MOGULS @hillarykerr @katherinepower

lorizxxii Congratulations @hillarykerr

Add a comment...

hillarykerr
New York, New Y... *Following*

496 likes 27w

hillarykerr Getting ready for tonight's @stylecodelive segment...! You guys had better watch: 9 pm ET/6 pm PT ce soir via @amazon. #stylecodelive PS: wearing my go-to @whowhatwear sweater from @target! And thank you for the hair @seijinyc and the makeup @bobscott200!

amanistarnes I have never seen your hair more shiny. Shine, girl, shine!

nicolpaone Yeah yeah. 🖤🖤

iambenlyons @hillarykerr those are my people! Say what up to @tutorence and

Add a comment...

hillarykerr *Following*

549 likes 43w

hillarykerr Portrait of a dorkus, masquerading as a professional. (Professional what, TBD.) Thanks for helping me get into character @lauren_andersen + @derekpeterw.

hillarykerr @jenohill This is why you're my favorite MVP. (THAT'S MRS. VAN PATTEN, if you're nasty!)

haselwand Lovely! Mind sharing where the frames are from? They are fantastic!

hillarykerr They're @warbyparker @haselwand!

shopdeparture Gorg 💚💚

laurenandersen What a babe!

eatsleepwear Everything about this. Yesssss!

lekfit skin✔bangs✔blonde✔brows✔spe cs✔

styleandcheek Those glasses!

Add a comment...

hillarykerr *Following*

535 likes 55w

hillarykerr Flowers and fizzy-lifting drinks are my love language. Feeling very lucky I know someone who speaks said language fluently. ❤ #flowersfriday 📷 @jmleahy

remington 🌷🌷

ryzenbergon So pretty! 💐💐💐

julianakes @jaimepent @chanteldenisemd 😵Ugh Friday goals😩 🌸flowers & 🍾Veuve for days!!!

eatbreathefashion That dress! 😍

nicolpaone Gorgeous! And the flowers aren't bad either.

hillarykerr I ❤ you @nicolpaone!

hillarykerr @eatbreathefashion One of my faves!

lindsayjgoldfine I mean are you guys the cutest!?

carole_kerr So right

Add a comment...

Hillary Kerr @hillarykerr · 9 Sep 2014
Still can't believe I got to catch up with my girl @BarbieCollector yesterday. #nyfw highlight for sure.

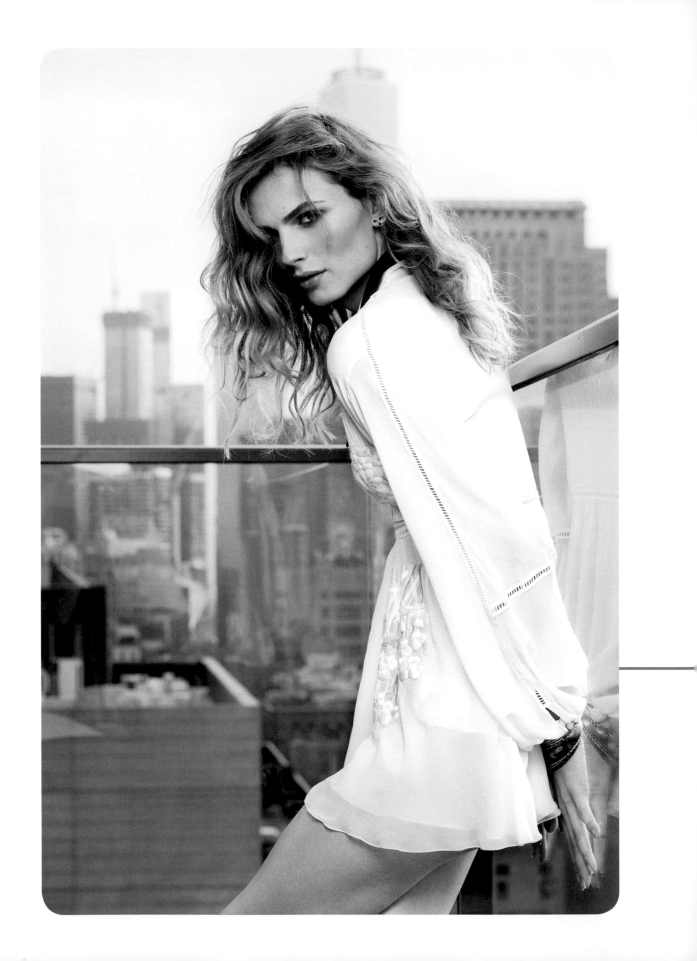

Andreja Pejic
@andrejapejic

"Free your mind and the rest will follow."

THERE PROBABLY ISN'T A PERSON ALIVE WHO WOULDN'T FLIP
their lid to have cheekbones like Andreja Pejic's. While the twenty-five-year old
Serbian-Australian model has good looks to spare, she is much more than just
a pretty face. In 2014, Pejic underwent gender confirmation surgery to become
a trans female, a lifelong goal that allowed the model to finally live
the life she wanted. By 2015, she was the first openly trans model to
ever be featured in *Vogue*, shortly thereafter becoming the first trans
model to ever sign a contract with a top beauty company. As a face of Make Up
Forever, her likeness appears in stores around the world, but you don't need to
travel to your local shopping center to catch a glimpse of Pejic in her element.
The Digital Girl documents her journey on an Instagram account that boasts
over 225,000 followers.

Hotel Hugo, SoHo,
New York, March 2016

"I try to be as real as possible and not filter too much of myself or change
myself too much," Pejic says of her social media style, warning of the dangers

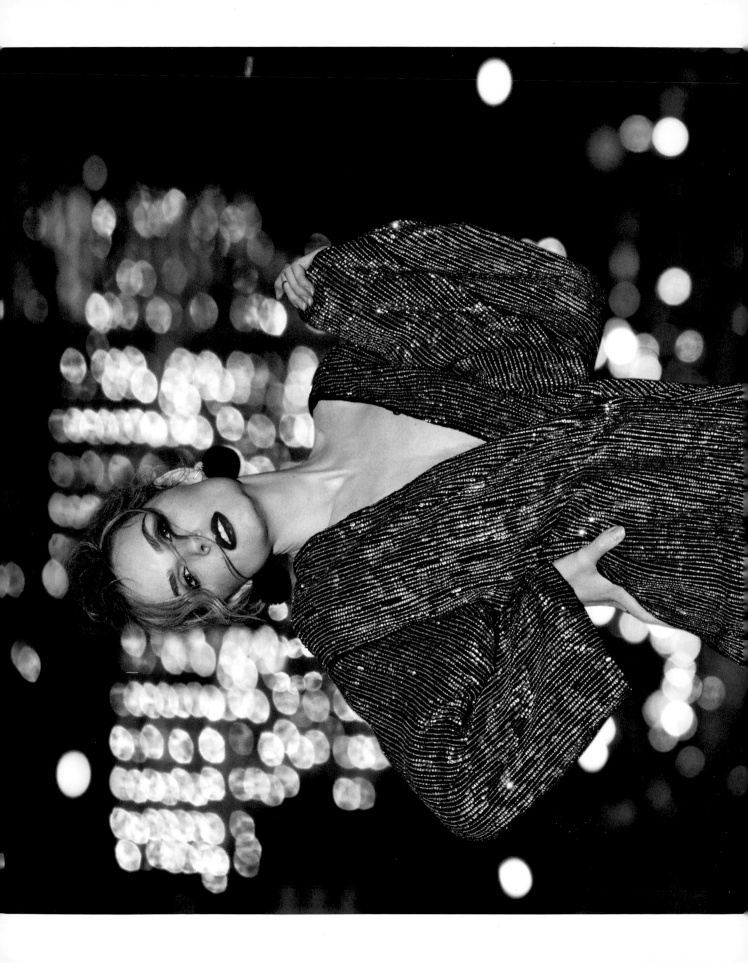

"I'm so proud to be a longtime fan. Thanks for your words and your dedications to the souls lost out here. My heart goes out to those around the world facing hardship because of the way they look and the way they are. :[" —@ageoflife

SoHo,
New York,
March 2016

104·105

of over-editing one's presence. "People almost become bland, they're like corporations. I think it's better to show a little more honesty." For the international model, her honest life includes everything from appearing onstage with Taylor Swift at the pop sensation's *1989* world tour, to taking backstage selfies with Marc Jacobs at his Resort 2017 show. Glamorous? You bet, but Pejic also shares plenty of down-to-earth snaps from photo sets and early morning gym workouts.

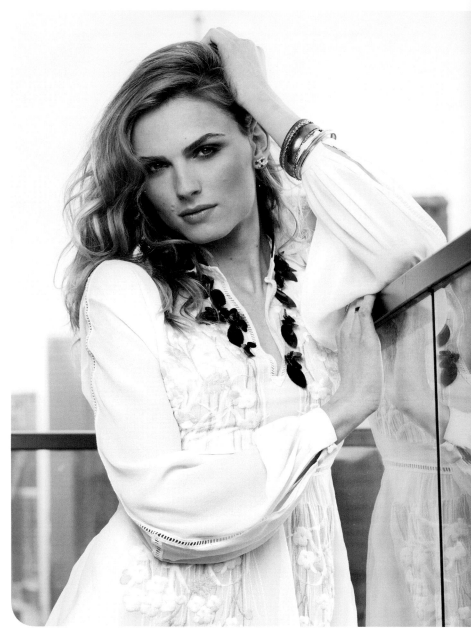

She even took to Instagram to share a picture from her first-ever modeling job. "Yesterday I posted a #TBT picture from my first-ever paid job—because god knows that all jobs in modeling are paid!" she laughs. "It takes some time to receive a paid job and you have to do the promotional work first. It was for a hair color company called Fudge. At the time I was working in a deli in Melbourne, and getting the hair color ad inspired me to quit my deli job. I said, 'Bye Felicia!' to that. That was the beginning of my career. Once I graduated school I went overseas to start modeling."

Pejic achieved success as an androgynous male model, challenging conventional gender norms with her every appearance. She lists her highs from that period as a Marc by Marc Jacobs campaign shot in Morocco and her appearance as the bride in Jean Paul Gaultier's Spring 2011 haute couture show.

When she finally transitioned in 2014, Pejic chose to share her story on her social media channels. "Coming out to the world and having people accept my story and find inspiration in it—not just in the industry, but outside of it, too—definitely felt amazing," she says. "It's nice to connect with people who've gone on a journey with you."

Still, the model worried at first that she might not be accepted post-transition. "I finished my transition and to be honest, I didn't really know that I would have a career afterwards. There was a point where I thought it might not happen in this industry and I should think about doing something else," she admits. "There was definitely a period of refashioning of my career. It took a bit of time to get back on the horse and work as a woman rather than this androgynous creature in between. I also changed agencies to The Society after my transition, and they've done a really great job. Obviously the cultural shift, I have to admit, has helped my career a lot. If I had done this in any other time, in any other decade, I don't think that I would have had the same response or the same opportunities, so I'm pretty grateful for that."

Shortly after Pejic came out as a woman, the photo shoot with *Vogue* and her Make Up Forever contract followed. "I was kind of like, 'Wow, this is big.' It gave me hope. It just shows that diversity is a beautiful thing and there's no reason why a trans model can't be a viable model, like any other model and do the same things and sell products to everyone that a model needs to sell products to. It just gave me a bigger platform to tell my story and keep doing what I love."

Though she might not be a blogger or influencer in the traditional sense, the Internet has been a large part of Pejic's life. "I discovered that I was transgender at the age of thirteen by basically Googling 'transition.' In that way, the Internet definitely saved my life. I discovered I wasn't crazy, that this is a real thing, and that there are people all around the world like me. The trans movement was very much and still is now a very online community." Today, trans teens have Pejic as a source of inspiration—and she's never more than a click away.

★ HIT LIST ★

- Danced on stage with Taylor Swift at her *1989* world tour.

- Is the first openly trans model featured in *Vogue*.

- Has modeled for Marc Jacobs and Jean Paul Gaultier.

- Starred in David Bowie's "The Stars (Are Out Tonight)" music video.

Hotel Hugo, SoHo,
New York, March 2016

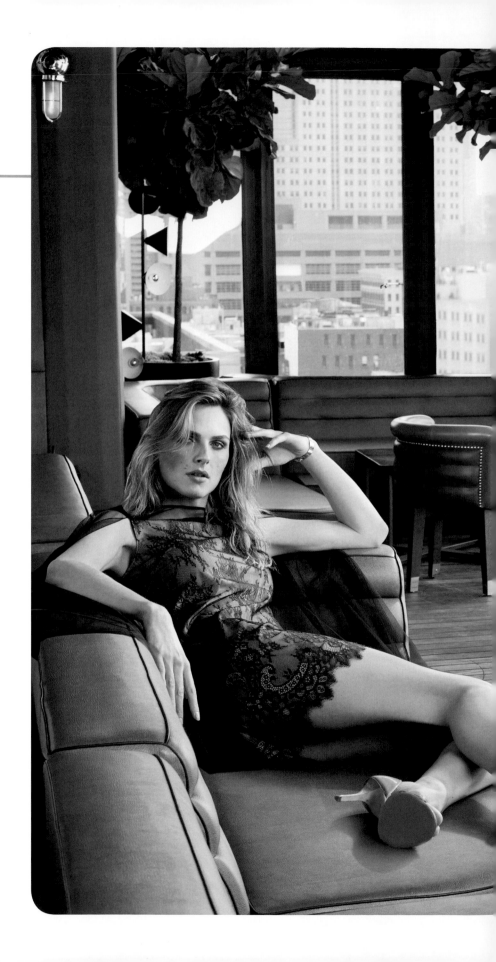

@andrejapejic

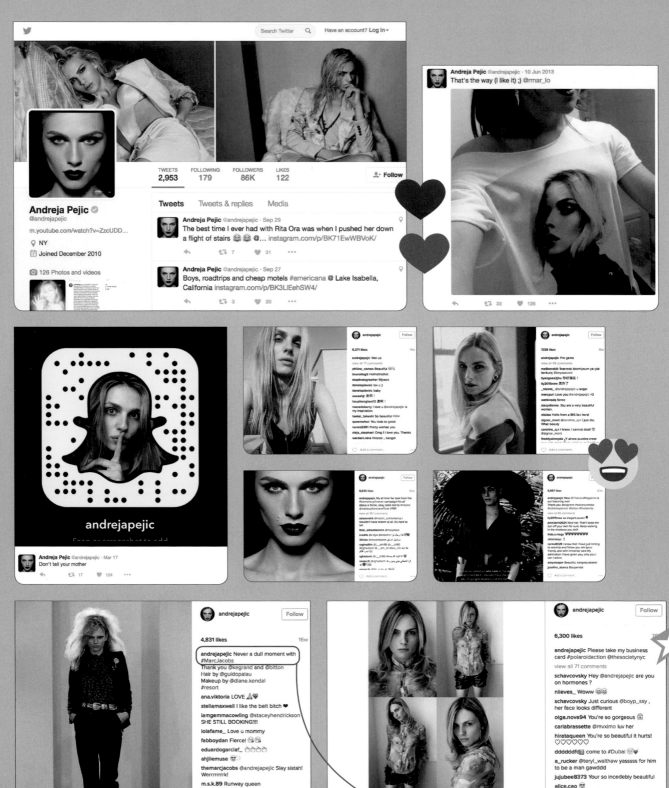

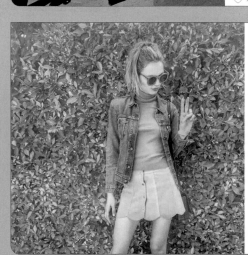

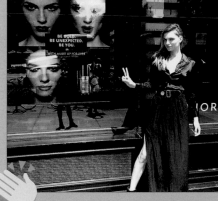

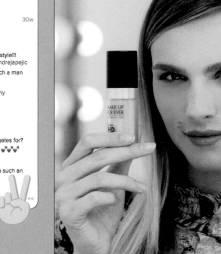

"She engages—and dismantles— all one's visceral perceptions of gender." —VOGUE

"Never a dull moment with #MarcJacobs."

"Wow so this just hit the front windows of every @sephora in the U.S. & Canada!"

Caxmee
MamaCax.com
@caxmee

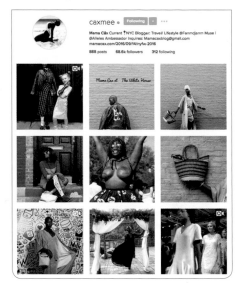

"Blogger: travel/lifestyle @fanmdjanm muse | @alleles ambassador."

MAMA CAX IS IN NEW YORK'S JOHN F. KENNEDY AIRPORT, nestled in a quiet area near her gate, minutes away from boarding a plane to Reykjavík, Iceland. She's conducting this interview having just passed through security, where she was recognized by a TSA agent. It's multitasking at its best—and this is what she specializes in. The model-activist-blogger balances a day job in the office of the Mayor of New York City with modeling gigs and her own ever-growing social media accounts and blog. To say she is probably New York's most popular city employee, with fifty-seven thousand Instagram followers, is something of a given.

Vinegar Hill, Brooklyn, May 2016

This blogger uses a handle like her Digital Girls predecessors. "My name is Caxmee and my alter ego is Mama Cax," she explains. The difference is subtle. "The way that I describe Mama Cax is that she's this much older version of

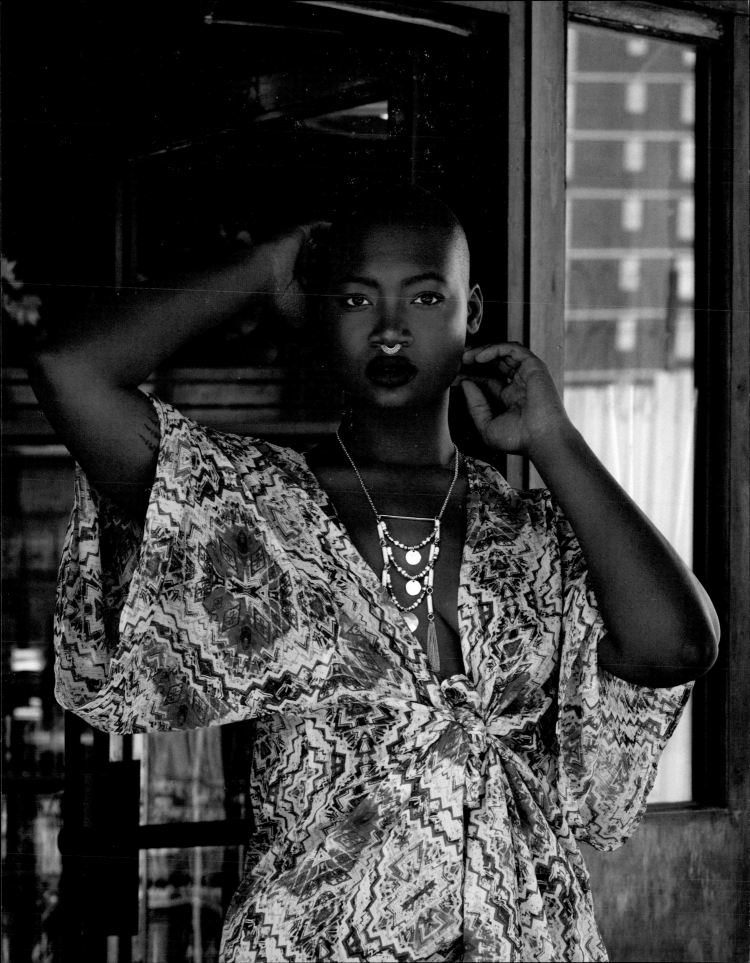

" Best of luck, girl! Can't wait to watch your star shine brighter and brighter x."

—@maymmalik

Vinegar Hill, Brooklyn,
May 2016

me. She's wise beyond her years—or she thinks she's wise—and she is so mature that any negative comment cannot get to her and she's very much confident, secure, and knows exactly who she is."

Mama Cax launched her website and social media accounts several years ago. Her blog and Instagram were initially used as platforms on which to share her travel tales with close friends; blame her effervescent personality on the fact that both channels became sensations. "It quickly grew into what it is now, with people all over the world reading the blog and following me on Instagram," she says. "It was definitely surprising to see people from all walks of life relating to things that I was posting about."

In addition to her travel diaries—she rattles off a list of twenty-odd countries she's visited like she's reading a map— Cax's blog serves as a document of her vibrant personal style and a place to share her experience of living with a prosthetic leg, the result of overcoming cancer in her late teens. "When I first started sharing posts about having a prosthetic leg and how I hope to walk without crutches through therapy, people started commenting, saying things like they have a daughter

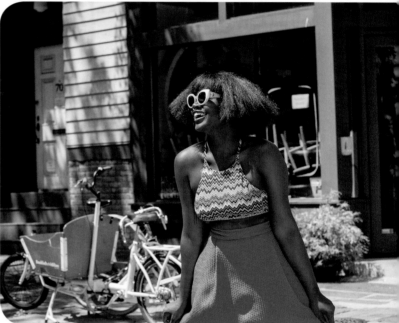

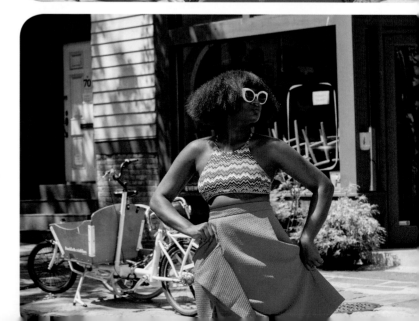

with a prosthetic and she started ballet, or that they have a friend who saw my metal prosthetic and they want to be just like me. That's when it became important to me to share more of that story," she says.

"We know that most people filter their pictures, and I was fine with filtering my pictures, but I didn't want to filter out my emotion, so whatever I was feeling—whether it was negative or positive—I wanted to show it so people see the true me," says Cax. "Sure, I talk a lot about body acceptance, about loving who you are, and growing into the person that you one day will be proud of, but at the same time I do struggle with body insecurities, and I talk about how I fight those every day."

Vinegar Hill,
Brooklyn,
May 2016

Though her prosthetic certainly doesn't define her, she's become an advocate for others living with disabilities. Today, she's an ambassador for Alleles, a prosthetic design studio based in Canada. "About three years ago, when I was in Southeast Asia, I was going crazy just looking for things to read and information about the area. A lot of sites were addressing women's issues abroad, but what I wanted to know was are those places going to be accessible if I have an emergency with my crutches? If I need to get a tune-up for my prosthetic, is there some place where I can get that done? I don't think any of those blogs were offering that information, which is something I hope to bring to my blog at some point," she says.

Also on the horizon for the Brooklyn-born, and Haiti- and Montreal-raised Mama Cax: merging her blog with her day job, something we'd venture we'll see happening sooner rather than later. "I studied international relations and what I really want to get into is working in international development with a focus on disability rights," she says. "In the meantime I will keep on blogging and modeling—those things have a different purpose and they share my story with a different crowd."

★ HIT LIST ★

■ Works in the office of the Mayor of New York City.

■ Is an ambassador for Alleles, a Canadian prosthetic design studio.

■ Is a model as well as a blogger.

@caxmee

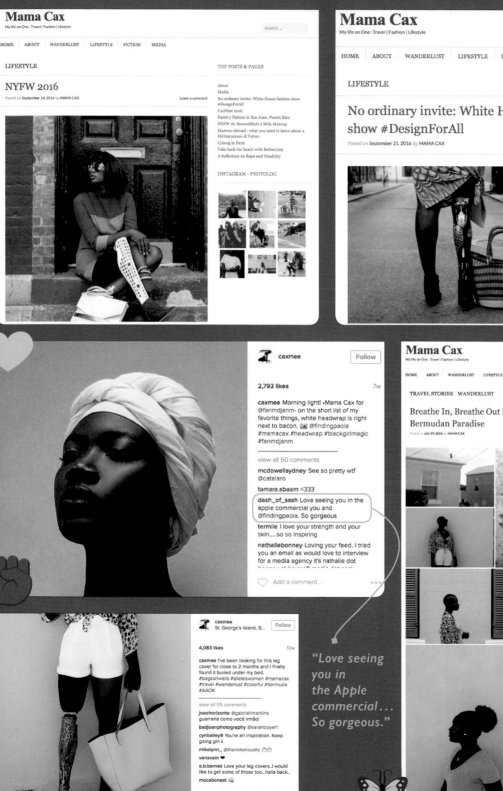

"Love seeing you in the Apple commercial... So gorgeous."

caxmee Follow

2,824 likes 9w

caxmee The Color Full Lives is a podcast sponsored by @Statefarm. It's a podcast series for African American women on personal and professional empowerment. As a black woman, I'm proud to mentor young girls with disabilities. Youth in marginalized communities often get paired with mentors with great careers but who look nothing like their mentees. My relationship with my mentees allow me to have open dialogues about disability and gender and how that affects different aspects of their lives. For me, every day is an opportunity to make a difference and live a life with a purpose.- Check out the podcast on iTunes #ad #livecolorfull #mamacax #alleleswomen #_blackstage

blackstage 😍😍😍

Add a comment...

"My relationships with my mentees allow me to have open dialogues about disability and gender and how that affects different aspects of their lives."

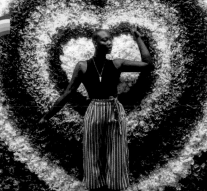

caxmee
Instagram New York

2,391 likes 5w

caxmee Spread love...Always! • Today was my last day at my job - and another amazing visit at @instagram. Check my IG story to see Everyone who decorated my @alleles chalkboard leg cover 😊 #alleleswomen #mamacax

yafan__ Too much sauce 🔥😍 @caxmee
farah_zera213 A real life beauty
allthtndabagof_chips Beautiful
caxmee @larri03 thanks
caxmee @alaynacasey OMG the girl with the elephant tattoo😍 thanks snapping a pic of me and @wardrobebreakdown that day.
caxmee @a_girl_named_aubri @maymmalik I'll see you all before i leve 😭😭
caxmee @alleles thankssss😊😊😊

Add a comment...

caxmee Follow

3,019 likes 23w

caxmee Free the nipples • #mamacax 🙈 @l3iila

b.svn @lxurx._
natbzlv @damnitsmadi this pillow tho
ashlyndyne @soultry_urth creative!
piecesof_ree @rodney_b87
5a3eth 😂😂
diamondalexandria @beoutspoken Happy Birthday!
thebasicbee @mollycanela

caxmee Follow
SoHo, Manhattan

2,284 likes 1w

caxmee Excited to partner with @KennethCole in defying beauty standards. #MyStepsWill empower other young women. Who's joining me?! #MamaCax #KennethColeCollaboration #AllelesWomen

alleles 👏🏾👏🏾👏🏾👏🏾👏🏾
mapaige I was wondering where is the bag from? Is it also @kennethcole?
caxmee @mapaige yes it is :)
ermikah Those shoes😍 😍😍😍
get.familiar 🔥for the future, tag us in your captions for repost👏
wayfaring_blissfully Wow so cool
findingpaola Yasssss!

caxmee
Milk Studio's

6,296 views 2w

caxmee 🙌🏾👏🏾💫RewardStyle NYFW event with @liketoknow.it & @milkmakeup #LTKxNYFW #NYFW #mamacax
Kimono + necklace: @marcheruedix
Bangles : @fanmdjanm

gurlrizzo So dope
bedebabi @graubeauty @elidaquino inspiração
naylalana QUE LACRE!!!
jiightsky Looking fierce!
jetset56 Slayyyyy
larri03 Lovely
oma_be Me encanta tu estilo, demasiado perfect y con pura actitud de Queen@caxmee
ryeichsanj @naminus ni orang badass

Add a comment...

caxmee ✓ Follow ▾ •••

898 posts 71.4k followers 242 following

Mama Cäx Current 🎈NYC Blogger: Travel/ Lifestyle @Fanmdjanm Muse I @Alleles Ambassador Inquires: Mamacaxblog@gmail.com Mamacax.com

"The twenty-five-year-old Brooklynite, who prefers to be called Mama Cax, is disarmingly beautiful with her covetable wardrobe, flawless skin, stunning smile, and one phenomenal leg."

—THE HUFFINGTON POST

Danielle Snyder & Jodie Snyder Morel

Dannijo.com
@danielleasnyder
@jodiesnydermorel

"Luxury jewelry handmade in NY with 🖤."

■

SISTERS JODIE SNYDER MOREL AND DANIELLE SNYDER SHARE many things: a genetic code, flowing brown locks, an apartment building. They also share the jewelry company Dannijo, which they founded in 2008. Their designs can be found at Neiman Marcus and Liberty London and online at Net-a-Porter.

"We grew up in Jacksonville, Florida," Danielle says. "And because Jodie was three years older, I thought she was the *coolest*—which, of course, she is. I always wanted to hang out with her and her friends.... Typical 'little sister' stuff. And then one day—I can't remember why—we decided to make jewelry together. It kind of became our thing."

Jodie and Danielle at Jodie's home, Downtown New York, August 2013

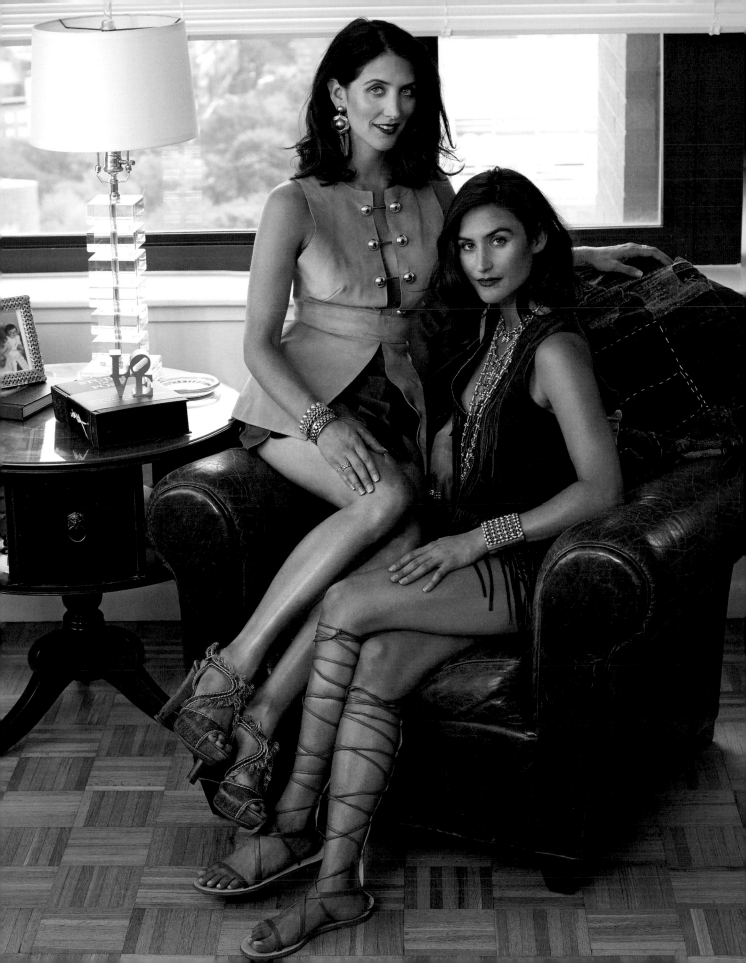

" Beautiful. It's nice to see people out there that are passionate and love what they do. "
—@best_dressed_secret

Jodie with Margaux
at home, Downtown New York,
August 2015

"Your creativity is mind-blowing!"
—@z.dardania

Danielle at home, Downtown New York, August 2015

Their father, Gary Snyder, is a cardiologist—which made it easy for the girls to find handy tools for creative projects. "We made—and even sold—this really intricate beaded jewelry that used our dad's surgical wire as string," Jodie recounts. "We carried that on for years until I left for college."

Jodie and Danielle went separate ways after high school, attending the University of Florida and Vanderbilt, respectively. The pair reunited in New York City after graduation—just in time for the economic crisis.

"We were both living in New York when the recession hit," Danielle recounts. "I lost my job working for a diamond jewelry designer. It was a risky time to launch a luxury brand, but in reality, it ended up being the best decision we ever made."

Around the same time, Jodie was fired from her job as head of private label sales at a fashion shoe label. The sisters decided they would launch a luxury accessories label. They toiled over their first line for several months until they felt the collection was ready. Their first order of business? Cold call every department store until someone agreed to meet with them.

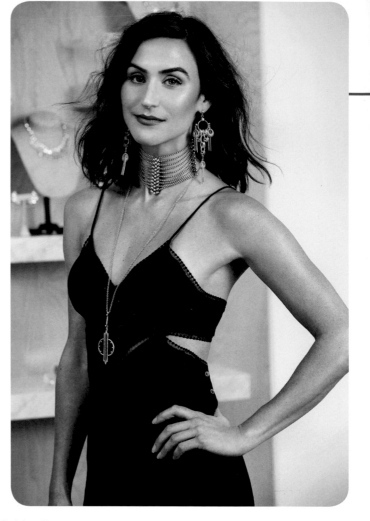

"Somehow, we were able to get through to an assistant buyer at Bergdorf Goodman," Danielle remembers. "And we convinced her to take our pieces on consignment, meaning we wouldn't get paid unless they were sold. It just so happened that Beyoncé went into the store and bought one of our pieces that week. It was exactly the break we needed."

To add fuel to the fire of their instant success, the Snyder sisters launched a comprehensive e-commerce site on Dannijo.com—one that served to complement, not compete with, in-store sales.

"We always believed Dannijo should have a strong Web presence," Jodie says. "And so we had e-commerce from day one. It was 2008, and designers were afraid of putting their work

★ **HIT LIST** ★

- Founded Dannijo in 2008.

- Beyoncé was one of their first customers.

- No, they're not twins— Jodie is three years older than Danielle.

- Their first collection was inspired by *Star Wars*.

Danielle, Dannijo showroom,
Meatpacking District,
New York, April 2016

Jodie, Dannijo showroom,
Meatpacking District,
New York, April 2016

online for fear that it would compete with their retailers. But for us, it felt so natural to have a place where we could interact directly with our customers. When you're a big, global brand, you don't always have control over how your products are presented and sold. The only place you do have full control is on your own site."

Dannijo.com has grown consistently over the past eight years, with direct Web sales now representing approximately 30 percent of the business. And as the brand has grown, so, too, has the team. Dannijo now has twelve full-time employees, a far cry from the days when the sisters were threading beads on surgical wire.

"Sure, we butt heads sometimes," Danielle says. "We're sisters....But it works, because Jodie and I are really different. We have different strengths, and different skill sets. I'm creative, and Jodie has this amazing, business-oriented mind. We've found a way to operate that works for us; it's like a marriage."

Jodie agrees. "I actually think it's easier to work together because we're sisters. Normally, when you work with partners, you need to treat them with kid gloves. But because Danielle and I are siblings—because there's no escaping that bond—we can say anything. We simply let ourselves have the disagreement, say our peace, and move on."

There's much to be learned from the Dannijo story—even for those of us who don't have a jewelry designing sister by our side.

"Danielle and I were very fortunate to have one another," Jodie continues. "Because the most important thing you can do is to find the right partner—someone who shares your overall goals, and will push you forward no matter what. Find someone who is good at the things you aren't [good at]. I've always relished having Danielle as a support system."

Oh, and you should always have thick skin. "You're going to hear 'no' more often than you hear 'yes,'" Jodie laughs. "Whatever you do, don't be afraid."

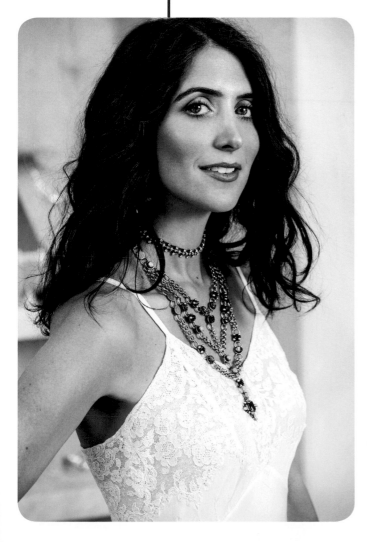

Dannijo.com

DANNIJO

ABOUT

NEW
FALL 16
PRE-FALL 16
#CHILLCHELLA
#DANNIJOCUBANO
JEWELRY +
COLLECTIONS +
BRIDAL +
CASES +
GIFT CARDS
SALE +

ADVOCACY
BLOG
VIDEO
LOOKBOOK
CONVERSATION
PIECES

JODIE + DANIELLE

The Snyder sisters grew up in Jacksonville, Florida, where they used their cardiologist father's medical tools to teach themselves how to make jewelry while in middle school. Once the two reunited in New York after their college years, they went back to their childhood hobby and created a capsule jewelry collection for Danielle's non-profit L.W.A.L.A. (Live With A Lifelong Ambition), which fundraised for grass-roots initiatives in Africa. Seemingly overnight, the two built their jewelry passion into a mega-successful brand. Since its inception in 2008, DANNIJO has advocated creating sustainable economic opportunity for women in underdeveloped areas of the world. All DANNIJO.com packaging is handmade in Rwanda as part of their women's empowerment initiative in partnership with Indego Africa.

DANNIJO jewelry is handmade in New York and sold at select, high-end stores worldwide including Net-A-Porter, Bergdorf Goodman, Neiman Marcus, Shopbop, Holt Renfrew, Lane Crawford and Liberty.

Danielle and Jodie were featured on Inc Magazine's 30 Under 30: America's Coolest Entrepreneurs List, are members of the CFDA and were recently profiled by The New York Times and WSJ. They've been featured on the TODAY Show as well as Fox Business. Danielle was named Forbes 30 under 30 in Art and Style as well as honored at Glamour Women of the Year Awards. Additionally, Danielle produced and hosted an interview series for Harper's BAZAAR entitled Conversation Pieces wherein she interviewed fascinating women across industries including prima ballerina and icon Misty Copeland.

Dannijo jewelry is handmade in New York and sold at high-end stores worldwide including Net-a-Porter, Bergdorf Goodman, Neiman Marcus... and Liberty.

inara

belinda

kimberly necklace

DANNIJO @DANNIJO · Jul 28
Wild thing, you make my heart sing 💕 bit.ly/2aqcc95 #naturalmedalist #calypsoearrings #vikandernecklace

"The Snyders are jewelry designers by trade, but it is largely through social media that Dannijo went from a few homemade necklaces, strung together in an East Village apartment, to a top seller at Bergdorf Goodman and Shopbop.com." —THE NEW YORK TIMES

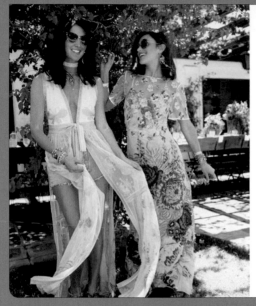

dannijo — Palm Springs, Califor...

1,314 likes — 22w

dannijo One good thing about music, when it hits you, you feel no pain - Bob Marley #chillchella

nikkim928 @youcancallheral both 😎

afirm3 @kateecooper already liking weekend 2 outfits better

olio_goods The dress on the right 😍

puhchangah @daniella__marie

shelliefrai @mayafrai us

jennavina One of the best dressed at @coachella

closet_therapy_now That dress 😍😍😍

annakula Looks like u r chillin @sparrowlodge

kateecooper @afirm3 you were so right about creativity and vibes being way higher weekend two!!! Down for weekend 2 next year

Add a comment...

dannijo — Follow

698 likes — 37w

dannijo "Style perpetuates itself through a recognizable personality of its own" #andrecourreges #bertstern #dannijocubano

ashleychurch111 Must have every color

ashleychurch111 Run it!

modellieber 👏

shesheshow Love it!! 🖤

carriec Oh love that necklace!

indiamackenzie 🖤🖤🖤

danielleasnyder 👏🖤👏

pomegraddict Absolutely stunning!!!! 👏👏👏

jodiesnydermorel 🖤

dannynlemar Haha nice name @dannijo ☺

Add a comment...

dannijo — Follow

624 likes — 7w

dannijo Splash into summer with up to 70% off at DANNIJO.com (all spring summer styles now 50% off) 👙🏄‍♀️☀ #amistacuffs #desinecklace

antique_gypsy_tribal_jewelry Nice

ekammeyer Great texture!!

smother58 Love the bag to the left where is it

sahranouhi ☆⋆✩⋆☆⋆✩⋆☆

leahornyak @liza.bean

Add a comment...

dannijo — Aspen, Colorado — Follow

1,161 likes — 31w

dannijo In other news, #dannijotravels pit stop in Aspen for Danielle's bday ☺ to loads of sunshine, snow and adventure for the year ahead @danielleasnyder #jordieearrings

bijoubliss Earring love 😍

janelmmoore @kdubbs4344

meglavs25 @ajslport GOD DAMNIT!

laramnay Happy birthday @danielleasnyder

carlystjean We need to go to Colorado

Add a comment...

dannijo — Follow

638 likes — 35w

dannijo It's blizzarding on Dannijo.com! Up to 70% off some of our favorite snowflakes. Limited quantities so take off your ski gear and hit the slopes online 🎿❄

huckandleni So great 🙌❄

childbridekelly Where are the Wren and Vix chokers?

danielleasnyder @childbridekelly They're on site under jewelry>chokers. They're not on sale xx

Add a comment...

dannijo — Follow

645 likes — 37w

dannijo Morning reflection ☀ #farrynnecklace #eldridgenecklace

jetsetfarryn @dannijo the FARRYN necklace!??? 🙌

carollynespindler @leticiadsantos 😍😍😍

leticiadsantos Uauuuuu 😍 @carollynespindler

leticiadsantos Uauuuuu 😍 @carollynespindler

danielleasnyder @jetsetfarryn 👏

triciacollie @sarahdorio

sarahdorio @triciacollie incredible!

Add a comment...

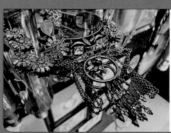

"Style perpetuates itself through a recognizable personality of its own #AndreCourreges #BertStern #DannijoCubano."

DANNIJO @DANNIJO · May 11
We had a blast talking all things vintage jewelry with @onekingslane bit.ly/1OnZ8fA #MyOKLStyle

↩ ⇄ 1 ♥ 5 •••

Aimee Song
SongOfStyle.com
@songofstyle

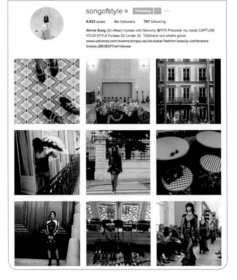

"[Ah-Mee] rhymes with Mommy 송아미
👇 *check out what's good."*

THE YEAR WAS 2008 AND AIMEE SONG—PRONOUNCED *AH-MEE*— was studying interior design and dreaming of building her own design business one day. In her downtime, she posted images and snaps of her daily life on a blog. It was just a fun, after-class hobby until she posted a shot of one of her outfits—that's when things really changed. Nine years later, Song is one of fashion's most influential bloggers, with over three million followers on Instagram.

At her office, West
Hollywood, May 2016

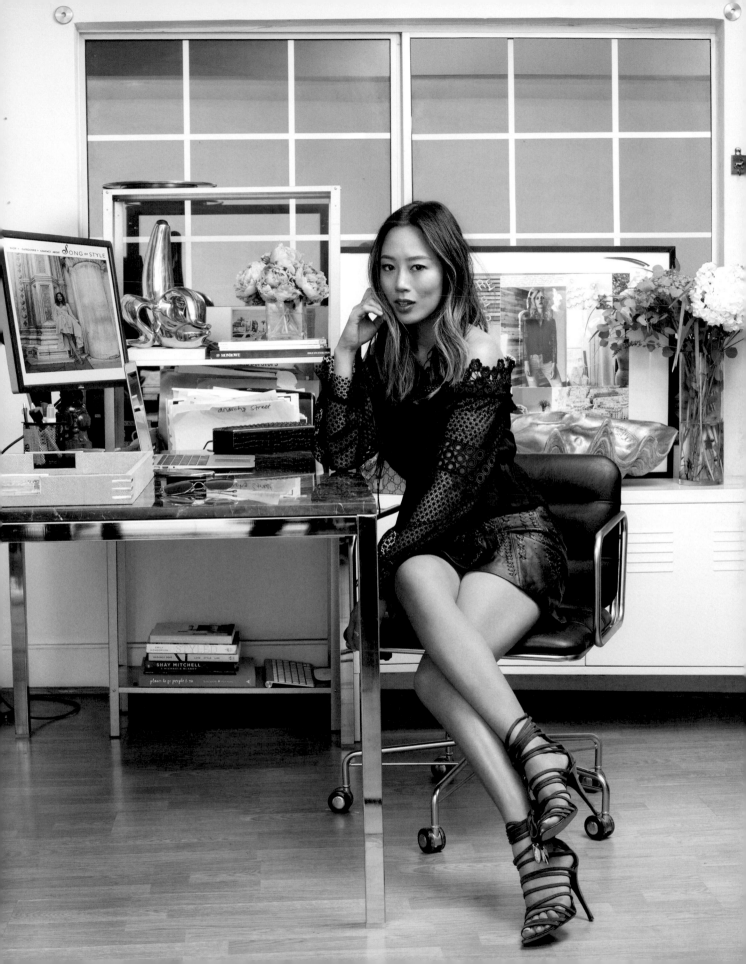

"I was always interested in fashion. I felt like you didn't have to be in fashion to like fashion, you could be a doctor, lawyer, or teacher and still be interested in clothes," Song said. Growing up, she always had a keen sense of style and she and her sister would customize their outfits. "We did a lot of DIY; we used to rip our own jeans and make them into shorts or distress them. We always liked that. Also, having a budget made us try harder."

After graduating from the Academy of Art University in San Francisco, Song landed a design job at an architecture firm, but slowly the world of interiors started to lose some of its luster for the native Californian. That's when she decided to dedicate herself more to fashion. "It's all about prioritizing what you like the best," the blogger says.

She relaunched Song of Style as a personal style blog, documenting her easy Californian style on a more regular basis. To say it was a hit is putting it mildly. With other Digital Girls like Michelle Phan and Leandra Medine, Song came to define the first wave of digital trendsetters with unique styles and relatable personalities that they documented on blogs, YouTube, and social media.

If it sounds like a lot of work to manage such a massive following, well, it is, but Song does it in stride. "I think I'm always sort of working, but it doesn't feel like work because I really like it," she says with a laugh. "I feel like I don't really turn the work brain off, because I really, truly enjoy it."

In the years since the digital boom of the late aughts, Song has found ways to turn her onetime hobby into a business. She's partnered with 7 For All Mankind, was named an ambassador for Laura Mercier, and released a book of blogging and style tips in 2016, *Capture Your Style*, but she admits she turns down

★ HIT LIST ★

- Started Song of Style as an interior design blog.
- Her sister Dani is also a blogger.
- Wrote a fashion guide, *Capture Your Style*, in 2016.
- Was cocaptain of her high school cheerleading squad.
- Got Lasik eye surgery.

West Hollywood,
May 2016

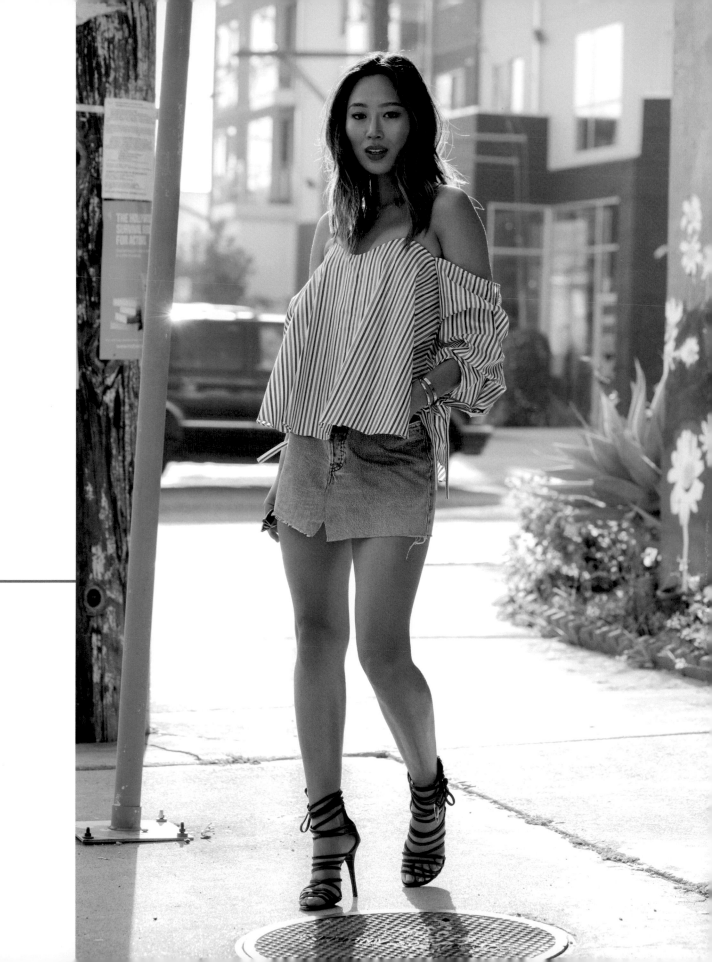

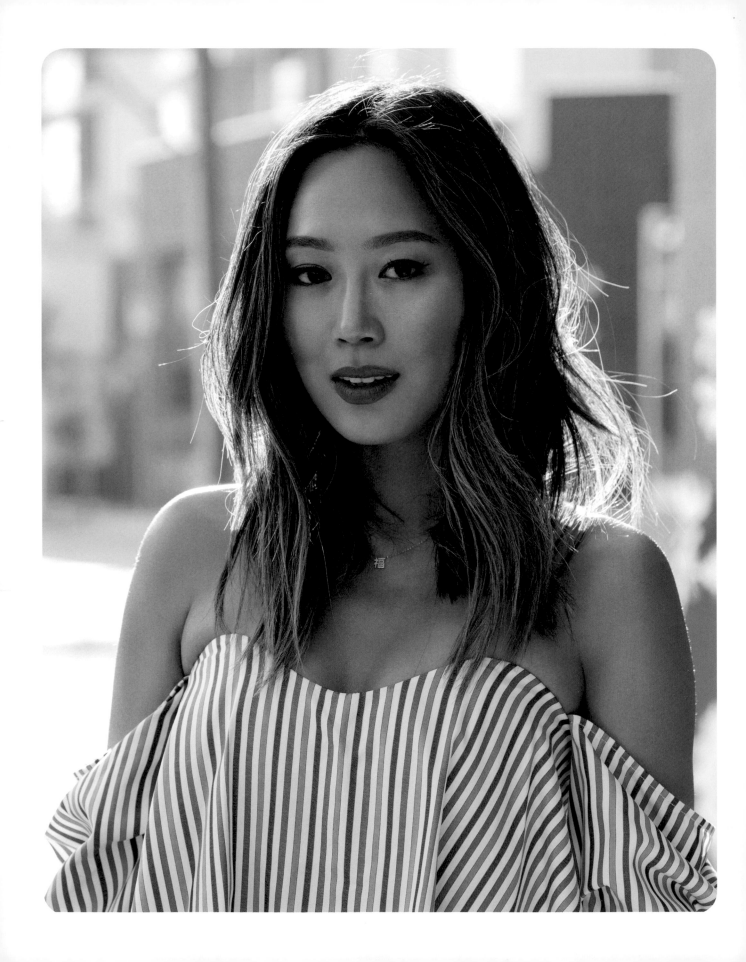

"What makes Song stand out from the pack of preening, self-consciously hip trendsetters is her accessible but aspirational sense of style." –BILLIONAIRE.COM

more partnership deals than she accepts. "If I do say 'yes' to a partnership, it's because I'm generally interested and the partnership excites me," she explains. "That way, I think the end result comes off as genuine instead of forced."

It's Song's strong self-confidence that's kept her grounded throughout all her successes, which have included being named to *Forbes*'s 30 Under 30 list and *Business of Fashion*'s 500 list of relevant figures in fashion. "I think if I were to worry about every single person out there, then I wouldn't be me and I wouldn't be happy. It's been a while since I thought, 'What will people think?'" she says.

"Right now, everything that I've produced is something that I would produce regardless of whether I had one follower or 3.7 million followers. The content couldn't change. Rather than be everybody's everything, I'd rather just be one person's everything—and mainly, the most important person is myself. I want to be happy, I don't want to please everybody out there."

In a digital world of artifice, Song has captured that elusive trait: realness. "Even though I get to go to these amazing couture shows, I have the same everyday girl problems. Sometimes I get pimples on my face. Sometimes my eyebrows are not perfect. Sometimes my mom drives me crazy!" she laughs. "I think I'm just a normal girl who gets to travel to really cool places. I think the people who follow me, because I'm so real, they also see my life as aspirational, too. If I get to do all these things, then it kind of gives them hope that if I can do it, they can do it, too."

136·137

"You are literally my inspiration, my goals in life. I wish one day I can achieve what you have achieved. I'm obsessed with your work and Instagram 🖤🖤. " –@evberz

At home, Little Ethiopia,
Los Angeles, May 2016

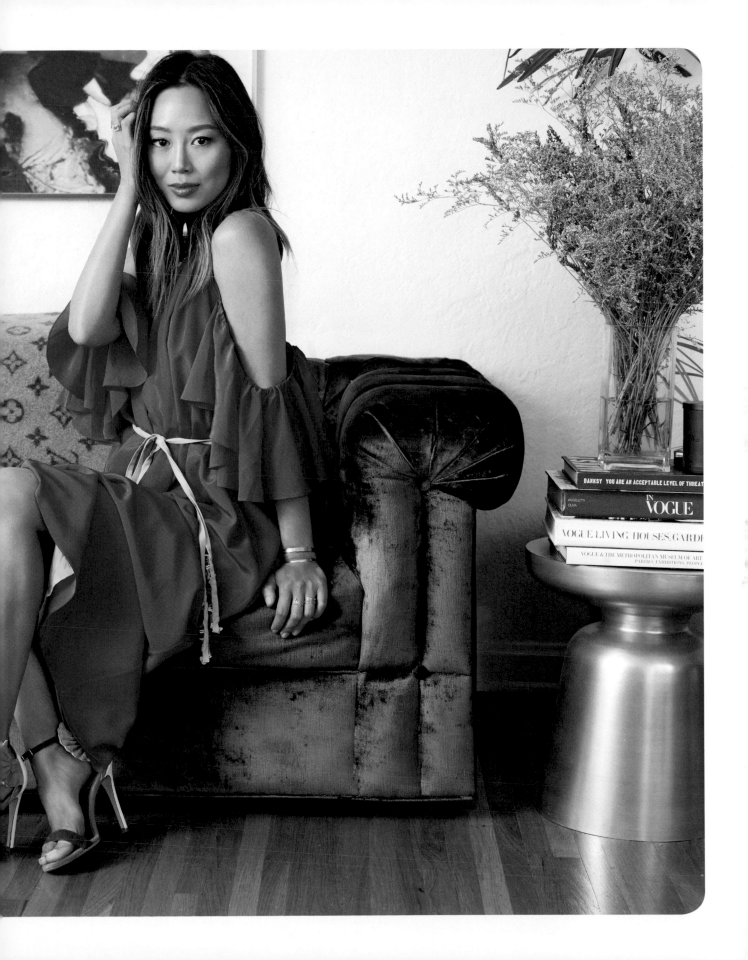

@songofstyle

songofstyle
Bloomingdales 59th ...

25.5k likes 2w

songofstyle Ready to head into Bloomingdales now! Thank you Jerry from the @lauramercier team for my makeup! Today we used my favorite candle glow foundation in macadamia, creme blush in sunrise, velour lovers in foreplay!

view all 230 comments

stylist_insight 😍😍😍
ribeirotardoqui Mais q gata
lmlifestylist So effing gorgeous @songofstyle
versepasi Absolutely love how down to earth you are. Watching your snaps/IG stories make me so hungry all the time 😋

daniella.ma @schangeitup darker hair color for me soon? 🙄
schangeitup @daniella.ma ooh I like it.

♡ Add a comment...

Aimee [Ah-Mee] Song @AIMEESONG · May 25
In the bright alleyways wearing the perfect stripe dress from my current fav brand rstyle.me/cz-n/bqnusmbtd

Aimee [Ah-Mee] Song @AIMEESONG · Aug 29
My closet circa 2013. Giving @whowhatwear a tour on their Facebook live at 1:30 PST today!

songofstyle

29.5k likes 1w

songofstyle Came home to my 6 page spread in the September issue of @voguechina! Thank you @yuhang_yao @harrietquick @paolozerbini for the opportunity. ❤ #voguechina

view all 299 comments

wxy123321123 💕💕
chen.cohen._ Pretty 🌷
cloudylimits Cool
behindthebo1t New blog!! Come follow us!
teeprinzessin_3738 Super 👍
makenabeachcafe Gorgeous! You deserve this girl 😍
nikayakay You go Aimee!!!!
sparklepiece Congrats Aime! Such en excellent article 🙌🖤
fashionbyally 😍😍🖤

♡ Add a comment...

songofstyle
Los Angeles Internati...

46.1k likes 1w

songofstyle Time to pack my bags and head to my next destination. Watch from @nicolevienna

#jetsetaimee

view all 262 comments

wscommunity 🖤
thestylesociety_ 💛💛💛
imacacali somebody pls tell me if that's gold? or rose gold??
lifeandotherthingsme 😍😍😍😍😍
gadamhamed Wow like it
farahchsneros Bello!
woshimaibaode8 工厂直销，最低价最高品质包包＃原单正品支持验货 买全行最实品质您找我不吃亏 ➡请加微信：bfm789
thebigsdeal @songofstyle I need your closet now 😂😂😂

♡ Add a comment...

songofstyle
Paris, France

34.8k likes 12w

songofstyle Sorta 4th of July vibes in @Kenzo #KenzoWorld #Kenzofw16 ❤💙
view all 234 comments

mariapolansky Cool sweater
samonimciara Slay!
fabrikkuk Love the Jumper!
darylcheng ❤ V E !
omphile_senne i love your page
joelmalmeidam @camila_gaio
garmentgoddess in love with that sweater!
523oo523 I
523oo523 I love it!
zinsstagram @snoonieb I see you rocking this outfit 😂
2wnstyle 👏 great outfit!

♡ Add a comment...

songofstyle
Singapore

84.8k likes 10w

songofstyle Just incase I forget my name...

view all 712 comments

catepbeauty I love it 💙💙💙
woshimaibaode8 💕💕💕💕💕💕点我 👜 更多潮牌新款包包，加微信：bfm789 # 全球邮寄
aimee1505 I want it too!
xiannv_6 💕💕都说自己顶级 图片每家都一样 💕💕来看我实拍视频 💕💕真正境外代购都来拿 💕💕支持退换货 💕💕永久售后💕💕 支持Paypal💕💕每天发海外➤➤➤➤微信：xiannv_6
cflow509 @mrs509jones
aymaelee My name too! It's a good name, isn't it? Where did you get it @songofstyle?
_aimlesss I need this! Mine is spelt the same way. 😆

♡ Add a comment...

AIMEE SONG

songofstyle
SM City Makati

43.8k likes 12w

songofstyle Still can't believe this happened. I'll never get used to this and I'll never take this moment for granted. Salamat ❤ http://liketk.it/2oHS4 @liketoknow.it #liketkit

view all 296 comments

rapxzl Selamat
rocio_reboiledo GOALS.
iamkleranc So proud of u!!
duoduojiabag 又买到垃圾了吗？ @白花那么多钱不敢寄出去吗？别担心，在我这里不会遇到最好的都在这里，认准多多客➡➡微信私聊
nymms_ @sophiaasong if I were your sister
cristinamonti I'm so happy for you @songofstyle I seriously almost started crying when I saw your banner on your snap!! Congrats X 1M babe 🙌🙌🙌

♡ Add a comment...

> *"Came home to my 6-page spread in the September issue of @voguechina!"*

A

*"Her laid back, girlie-grunge style has made her blog,
Song of Style, a daily visit for thousands of people envious
of her effortless take on personal dressing."* —TEEN VOGUE

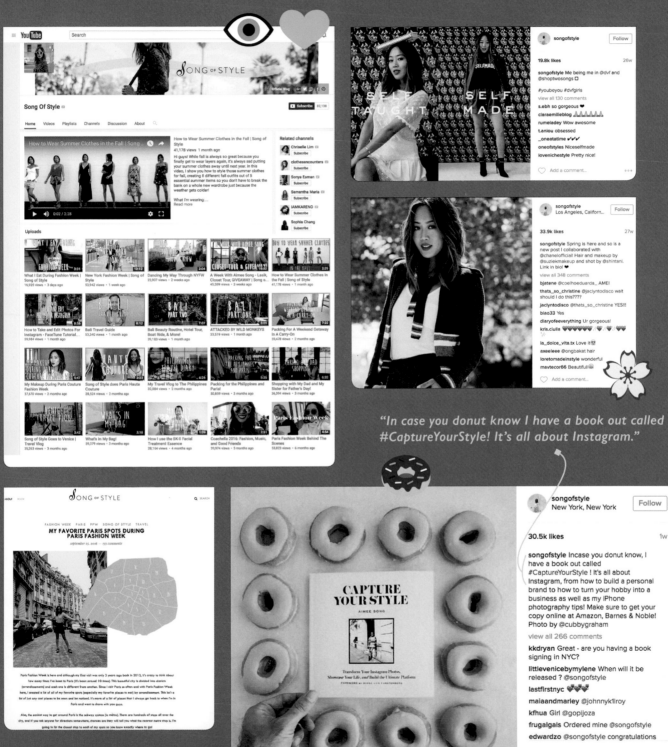

*"In case you donut know I have a book out called
#CaptureYourStyle! It's all about Instagram."*

Jillian Mercado

Manufactured1987.com
@jilly_peppa

"Model, creative, activist, Latina, and loving life."

■

"I NEVER PLAN THINGS, AND I'M PRETTY MUCH GAME FOR
anything and everything," says model Jillian Mercado. "Why not go on adventures and do crazy stuff that I never thought I would do?"

Well, it's safe to say Mercado's open-mindedness has really paid off. After being diagnosed with spastic muscular dystrophy when she was a child, Mercado attended the Fashion Institute of Technology in New York City. "Going to FIT, I felt like I belonged there and was so excited to go to school every day," she says. She then took internships with various publications and photographers, but decided that she wasn't going to settle for any old desk job. "I told my parents I didn't want to take a job that I'm miserable in," she begins. "So I just made that into a reality."

SoHo, New York,
March 2016 ■

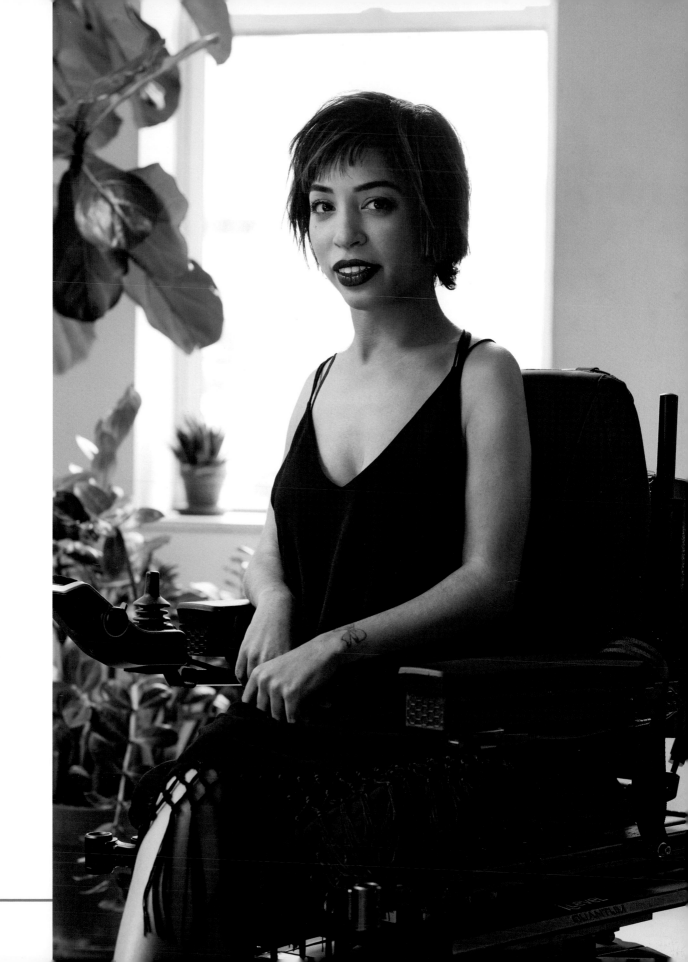

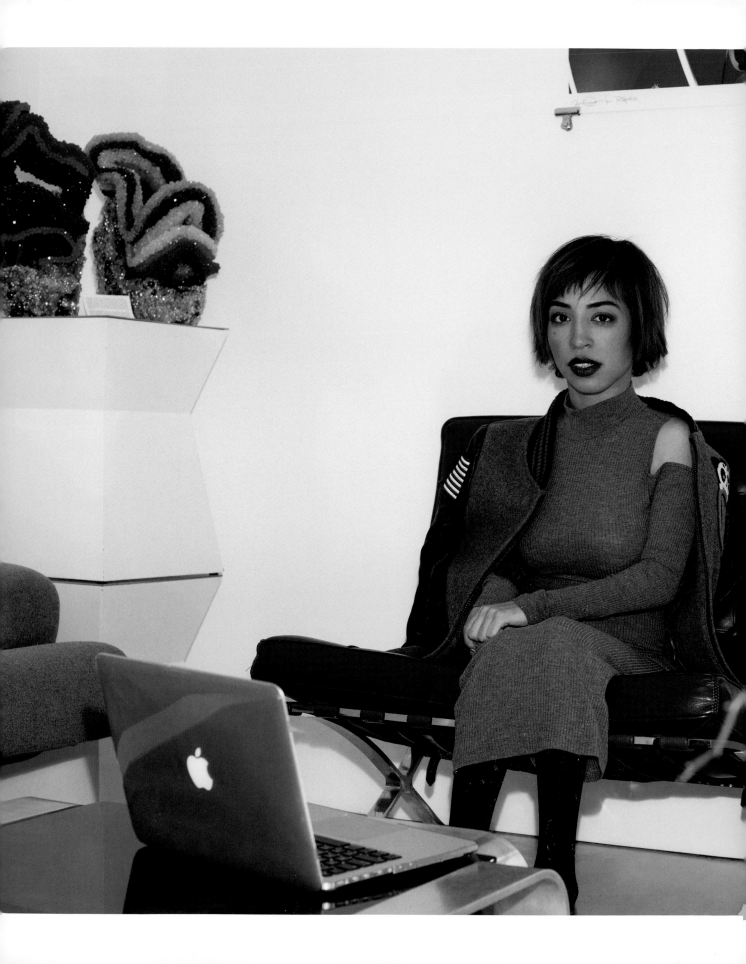

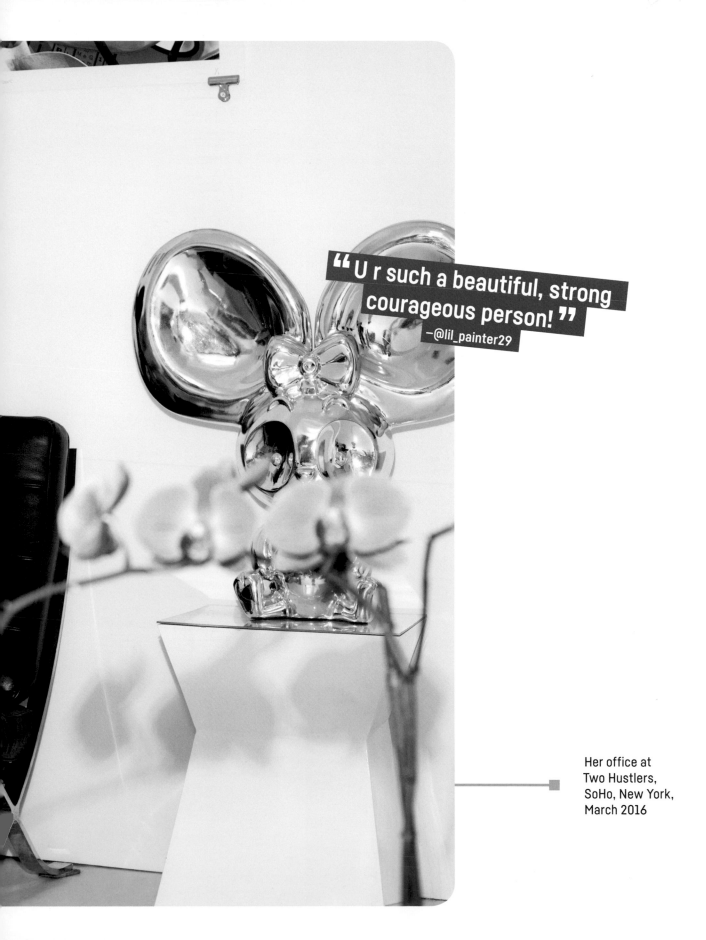

"U r such a beautiful, strong courageous person!"
—@lil_painter29

Her office at
Two Hustlers,
SoHo, New York,
March 2016

Today, the New York native is signed with leading talent agency WME|IMG and has modeled for a full host of brands, from Diesel to Nordstrom. She has over twenty-six thousand Instagram follows and several thousands on Twitter. Oh, and she's a model for Beyoncé's tour merchandise, sold on the singer's e-commerce site. That's right, Mercado's got the Queen B. stamp of approval. "It all really sunk in when I went to Beyoncé.com and I saw my face," she says. "I was like, 'Oh my god!'"

So how did she go from student to Beyoncé-adjacent? It all began with an open call for Diesel and a little social media savvy.

Back in 2014, Mercado responded to a casting notice posted online for Diesel jeans. She was selected for the Inez and Vinoodh–lensed advertisements and posed alongside artist James Astronaut. The pictures garnered widespread international press and turned Mercado into something of an overnight sensation.

"I'm so blessed to have my life the way it is and to have something like social media where I can connect to the world," she says. "People can write good things and bad things, but thankfully I've gotten a lot of positive messages from people."

Still, in the early days of her social accounts, the model was a bit hesitant to reveal she was differently abled. Reminiscing about her LiveJournal and MySpace days, Mercado remembers, "I used to take selfies of myself—not full body, just neck-up selfies because I was a little bit ashamed about who I was and the fact that I had a disability back when I was younger. I didn't want anyone to know, not because I thought that I would get bullied, but because I was not

★ HIT LIST ★

- Graduated from the Fashion Institute of Technology in New York.
- Her first modeling job was for Diesel jeans.
- Modeled for Beyoncé's e-commerce site.
- Visited the White House in 2016.
- Signed to the same modeling agency as Gisele.

"Queen Bey has proved yet again why the whole world loves her, by casting Jillian Mercado in her latest campaign." –I-D

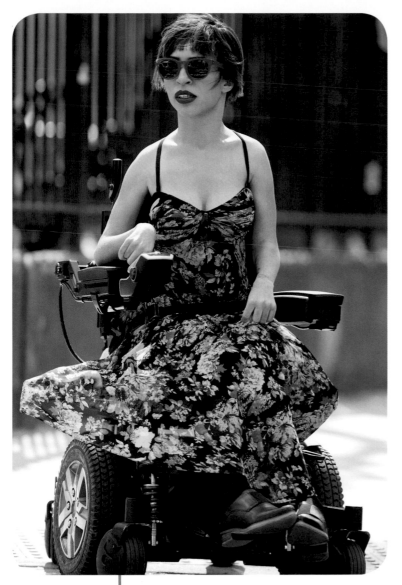

comfortable in my own skin back then. I [worried] about what everyone would say about me." That fear was unfounded. "As soon as I did post a full-body shot I got so much positive feedback from people. It really, really helped my self-esteem and it really helped me as a person to love myself."

Now she's something of a role model herself, serving to inspire people all around the globe. "At first I think I was a little taken aback about being a role model to kids," she admits. "Then I realized that when I was growing up I didn't really have anyone to look up to that felt the way I felt, looked the way I did, and had the same dreams or aspirations that I had as a child— which kind of sucked! I had to find my own way in the darkness, so to speak. Today, it's an amazing feeling to know that I'm a role model to some people."

This isn't to say Mercado's accounts are preachy. Actually, they're quite the opposite, a peppy mix of selfies, travel snaps, and tweets about binge-watching *Orange Is the New Black*. "Knowing that I am a role model to some people, I don't want that to change who I am on social media," she says. "My message is just to be you and not to try to be anyone else. Everyone in this world has such an interesting story, no matter how boring they think their life is. Be you!"

SoHo, New York, March 2016

"You are a gorgeous woman and an inspiration to all those, like myself, who are disabled!! You show that we can do anything if we work hard!!"
—@diddydaveuk

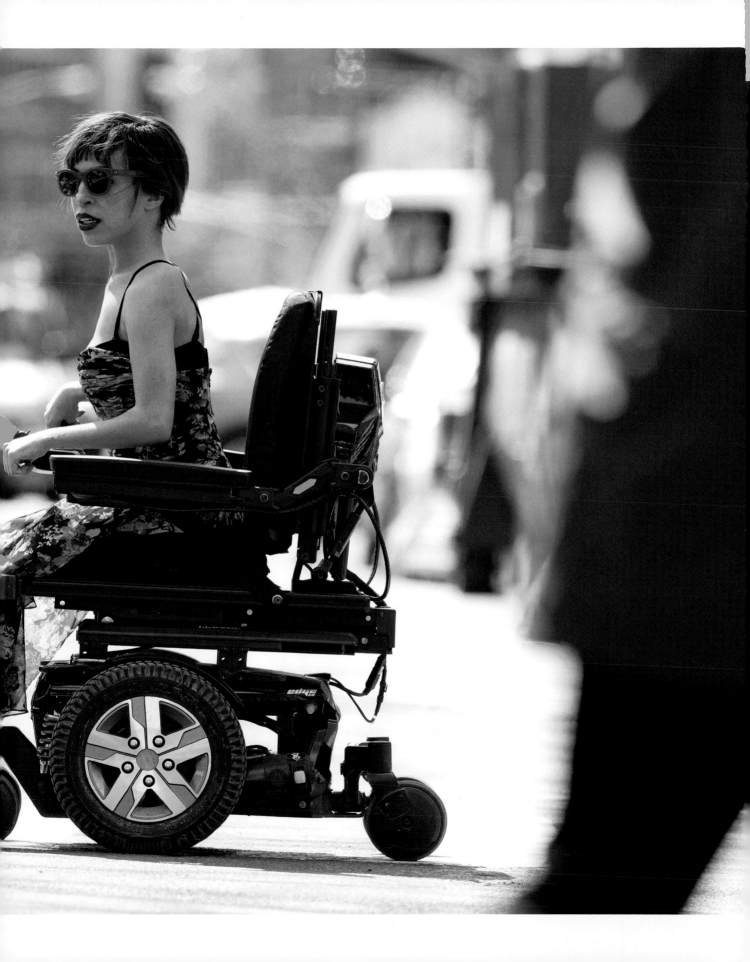

@jilly_peppa

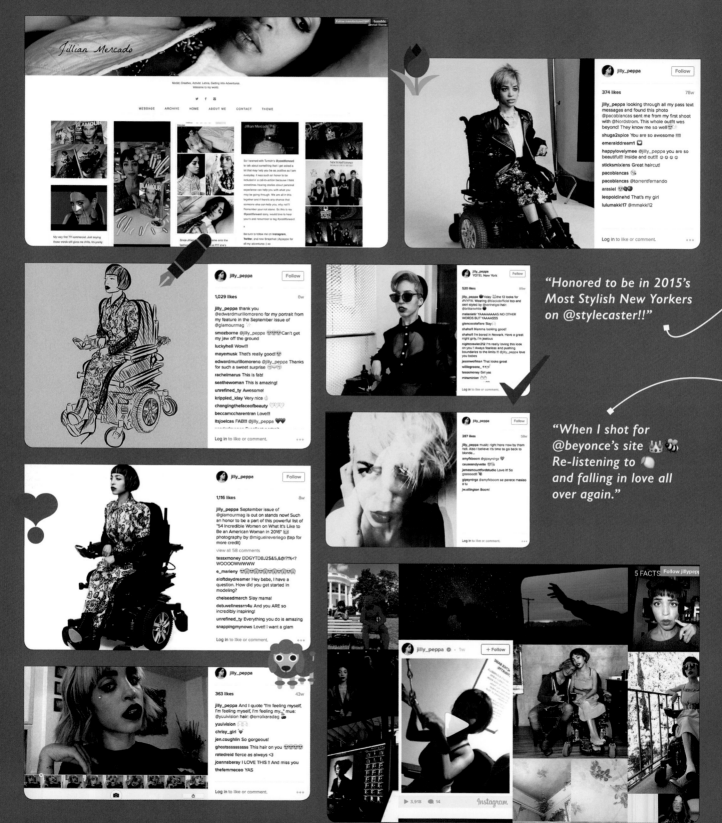

"Honored to be in 2015's Most Stylish New Yorkers on @stylecaster!!"

"When I shot for @beyonce's site 👑🐝 Re-listening to 🍋 and falling in love all over again."

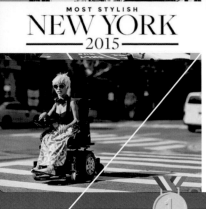

"When the next generation of disabled models searches the Web for inspiration, they'll find her." —THE WASHINGTON POST

Chriselle Lim

TheChriselleFactor.com
@chrisellelim

"Chriselle's goal is to encourage, educate, and inspire all women across the globe through her personal style, runway trends, beauty secrets, and fashion tips and tricks."

■

"BEAUTIFUL SHOT OF @CHRISELLELIM IN A #FALLWINTER1617 pastel pink look enriched with black diamond Swarovski after the #HauteCoutureFW1617 show." So reads an Instagram caption by Valentino's account that was blasted out to its seven million followers with a picture of Chriselle Lim in a blush-colored dress. So how did Lim, who boasts over 690,000 Instagram followers of her own, go from working at California's *Genlux* magazine to being one of the world's most sought-after Digital Girls? One word, two syllables: YouTube.

It was back in 2010 when she launched a channel posting videos of her outfits and shopping habits after some advice from a fellow DG. "Michelle Phan introduced me to the world of YouTube. I met her through mutual friends, and I was just so fascinated by what she did and what was happening there. I saw that there was no one really doing fashion—there were a handful of girls covering beauty, but no one was really doing fashion—and I saw an opportunity for me to get started," says

With Chloe, Downtown
Los Angeles, May 2016

"Imagine a fashion blogstar Hall of Fame. Without a doubt, petite powerhouse Chriselle Lim would be inducted immediately." —RACKED.COM

Downtown Los Angeles, May 2016

Lim. "I uploaded my first video on YouTube and I saw immediate results. I just knew there was something there, so I started building the channel, creating interesting, editorialized—but still very relatable to the audience—type of video content focusing on fashion." Today, she counts over 620,000 subscribers on the video platform.

At first, Lim's video operation was a one-woman show, with the vlogger shooting and editing each video herself. "Video takes a lot more work on the post-production side, so I was only able to get up one video a week, max," she explains. That kind of release schedule just wasn't going to cut it for the driven Californian, so she decided to launch a blog that could be updated more easily. "That's when I started The Chriselle Factor, and the blog and video channel grew together."

Since then, Lim's online presence has developed further; she now publishes photos, fashion tips, and peeks inside her personal life on a variety of platforms from Twitter to Snapchat. "It's not just a blog anymore, it's not just a YouTube channel. There are so many different platforms to manage," says Lim. "The Internet is so different from where it was five years ago, and it's still going to continue to change. It scares me sometimes, because it's like how many more things can we keep up with? But that's just the reality. It keeps me evolving."

As someone leading the pack, Lim lists Snapchat as her current favorite app. "It's the most organic and easy content to build, to push out, and to digest. It's a platform where people can really see beyond the filter, see beyond the fancy editing, and see who you really are," she says. "I use Snapchat specifically to introduce my followers to my personal life. I really focus on honing in and allowing them into my personal life so they're in my house with me, with my baby."

It was becoming a mom to the now two-year-old Chloe that changed Lim's perspective on blogging and vlogging on the whole. "After having a baby, I was really so nervous that things would slow down for me because people would view me differently or my followers wouldn't be interested in my life anymore," she says. In truth, the exact opposite proved true. "Becoming a mom completely changed my business in a way I could never think of," she continues. Sharing her struggles as a working mother who runs her own business and still gets home by bath time opened Lim up to the idea of including more lifestyle content on her channels. Since Chloe was born, she's produced minute-by-minute tutorials of her nighttime routine with the baby and made videos with Rachel Zoe where they talk about being working moms. "Now my accounts are more about my personal lifestyle—that all started with me becoming a mom."

Her office, Downtown
Los Angeles May 2016 ◀—

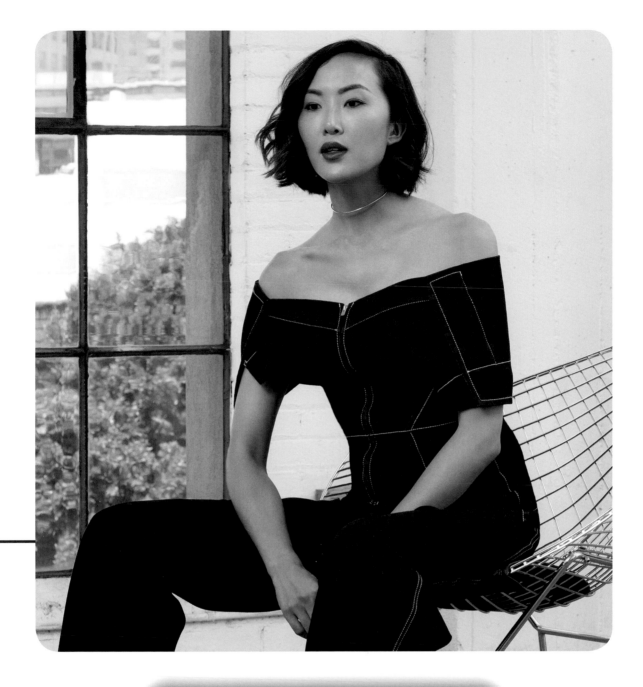

★ HIT LIST ★

- Started her fashion career as an editor at *Genlux* magazine.

- Was introduced to vlogging by Michelle Phan.

- Her first job was in retail at Express.

- Is an Aries.

- Was an accounting major in college.

"Your positivity is the dream
you go girl xxx."
—@lauraegabriele

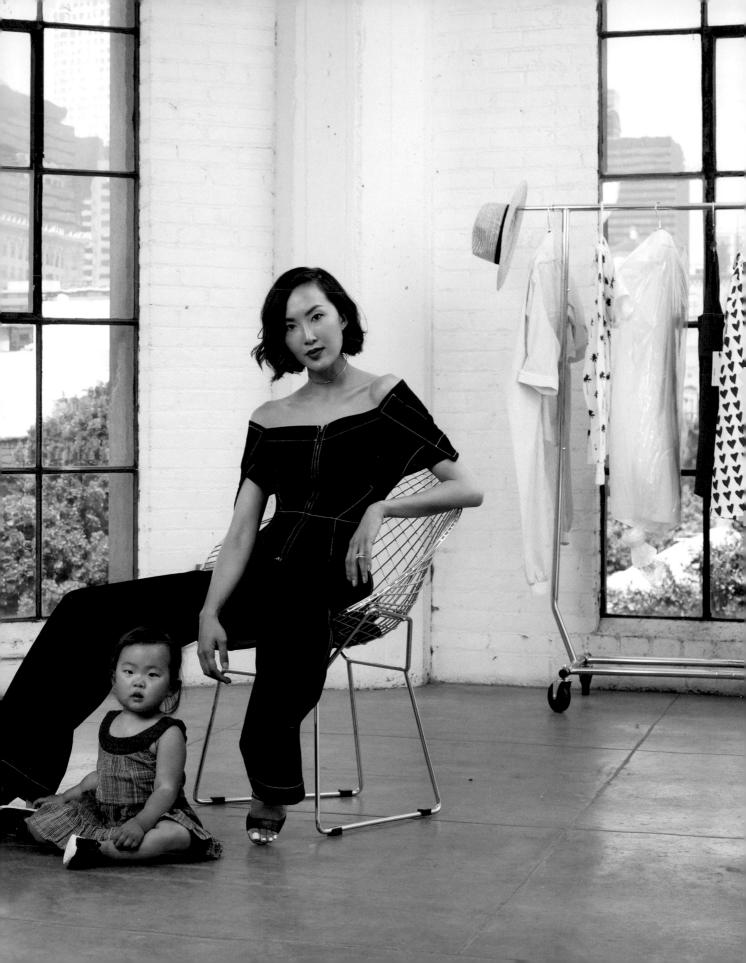

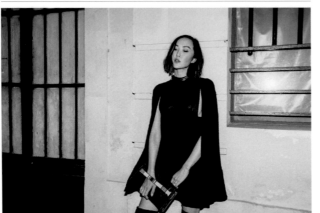

"Most memorable NYFW moment: walking my first (for @voguemagazine & @hillaryclinton) and second runway show (@rebeccaminkoff)."

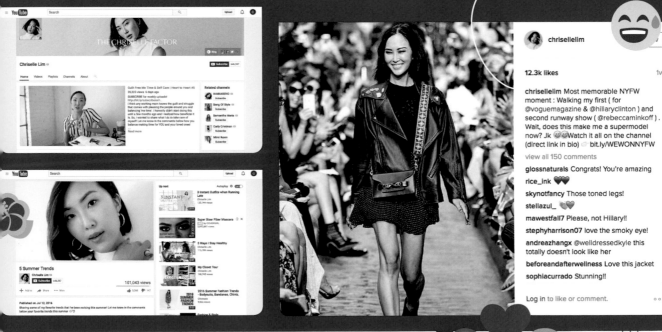

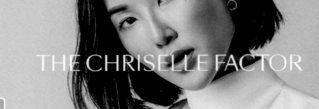

THE CHRISELLE FACTOR

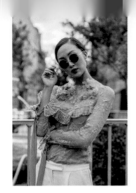

TWEETS	FOLLOWING	FOLLOWERS	LIKES	LISTS	
32.1K	591	47.8K	1,885	1	Follow

CHRISELLE LIM
@CHRISELLEtweets

★ 임소정 ★ @chriselllim ★
TheChriselleFactor.com ★ ✕
YouTube.com/ChriselleLim ✕ //
@TheSocietyNYC // @TheRealDBA
📍 Los Angeles
🔗 TheChriselleFactor.com
🗓 Joined April 2009
8,117 Photos and videos

Tweets Tweets & replies Media

CHRISELLE LIM @CHRISELLEtweets · 29m
PFW Diary Day 5 now live on
#thechrisellefactor 👉 ift.tt/2dnNbOv 📷
:@janawilliamsphotos_

New to Twitter?
Sign up now to get your own
personalized timeline

Sign up

You may also like · Refresh

M I C H E L L E ✓
@MichellePhan

Aimee [Ah-Mee] Song ✓
@AIMEESONG

Wendy Nguyen
@wendynguyen

Shea Marie ✓
@peaceloveSHEA

Bubbi ✓
@bubzbeauty

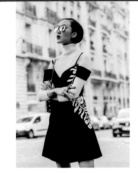

chrisellelim Follow

5,240 likes 26w

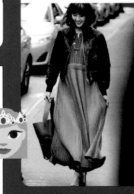 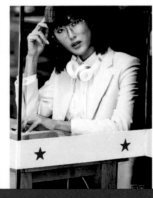

chrisellelim Thank you SELF China for
having me be a part of this issue and for
the 10 page spread! If you follow me on
snapchat you know we shot this editorial in
1 degree weather in NY during fashion
week, but thanks to the awesome team for
making it the best day ever. Wearing Celine
& @dior
Shot by @kennethwillardt
Styled by @anyaziourova
Hair by @frankiefoye
Makeup by @christopherardoff
Nails by @julieknailsnyc
@thesocietynyc #societysquad

leenmai_84 You look amazing with bangs!!!

thechrissycollective This looks amazing!

juliekabulo Congratulations!

*"Chriselle Lim's Instagram feed reads
like a dream vacation: breakfast bowls,
gilded interiors, and filtered beach shots,
sprinkled to her 641K followers."* –W

chrisellelim
New York, New York Follow

9,813 likes 31w

chrisellelim Can't get enough of the
images on today's post on
#thechrisellefactor . Direct link in bio ☞
http://thechriselle.factor.com/2016/02/3-1-
philip-lim-fall-2016/
view all 71 comments
yolpalice So pretty ! :)
t_____blog Beautiful❤
sensibestylelala You are a goddess!
tsilyurre I love this photo so so so much!!!
You look beautiful 😍😍
draenmeehr Amazing photo
mibsweet Stunner
kidddobbsen Beautiful
amandahejmstad Beautiful picture !
rachelchraime @salmanhendaye

Log in to like or comment.

chrisellelim
DTLA Follow

71.8k likes 7w

chrisellelim Fall mood today 🍂❤
view all 117 comments
carmllive such a pretty combo 😍
eerimkere 💛💛💛
thasmalinoble Love ♡
backineque Nails on fleek :)
dev_ried Stunning this is! Everything about
this is awesome 💛
abergarcia29 Love! What is this lip color?
stylesfmina_ Love 💜 where is your
choker from please 😊 @thekikellellin
hennelepia_ So pretty!
memeeli What lipstick is this? I've been
looking for the perfect rust for an eternity
hiba
chennellycamille Obsessed with this look!
Cannot wait for fall!

Rachelle Hruska

GuestOfAGuest.com
@rachellehruska

*"Founder of Lingua Franca @linguafrancanyc; and
@guestofaguest. Wife of Sean, Mama to Maxwell and Dash."*

HERE'S WHAT WE KNOW ABOUT RACHELLE HRUSKA: SHE'S THE
founder of the Internet's favorite party place, Guest of a Guest. The web-
site has become a standby for the fashion industry, because, really, if a party
isn't chronicled on GoaG, did it even really happen?

Now here's what you might not know about the tech
impresario: she has two sons under the age of six,
and her West Village brownstone is decorated with
antique leather goods—a nod to her husband, hotelier Sean MacPherson's, leg-
acy in the business.

At home, West Village,
New York, May 2015

"I cofounded GoaG with Cameron Winklevoss in 2008 to serve as a dig-
ital diary of all things cool," Hruska says. "It didn't matter if it was a party, a

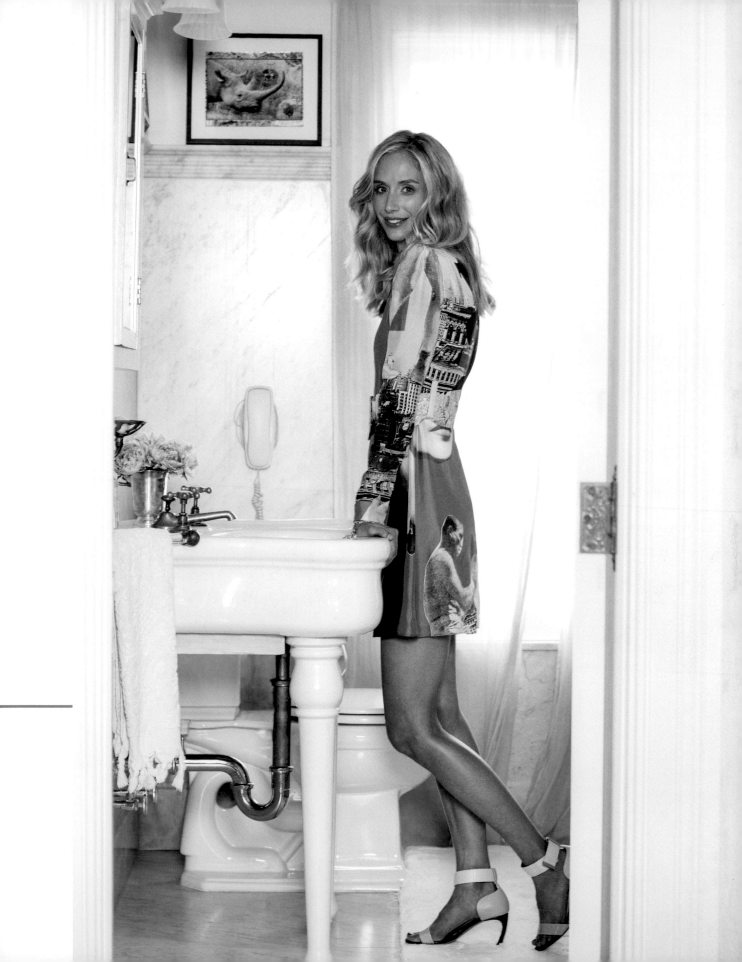

" Beauty & brains!
Love you @rachellehruska. "
—@sydneyreising

Veronica Beard
Fall/Winter 2016–17
NYFW, February 2016

"[Guest of a Guest] has become a must-read publication in almost no time, the new Page Six." —BUSINESS INSIDER

Hruska (center),
Veronica Beard
Fall/Winter
2016–17 NYFW,
February 2016

restaurant, or an opening; we were going to be there, and we were going to photograph it. It just so happened that we were often in the right place at the right time."

"I suppose it's not surprising that I ended up in tech," she adds. "Because growing up in Nebraska, I was completely obsessed with the Internet. I definitely stole an AOL disk or two from the local library so I could get online."

Hruska remembers those AOL disks as a means of logging on to ICQ chat—something that connected her young, Nebraskan self with foreign cultures around the world. "All I wanted was to talk with people in other countries," Hruska says. "To connect with anyone, anywhere who was different from me."

As a teenager, Hruska left home to matriculate at Omaha's Creighton University. Her goal? To study medicine—something a 2001 car crash would force her to reconsider.

"After my accident, I rethought things," she remembers. "I acknowledged I wasn't passionate about medicine. What I *was* passionate about was my blog—something I'd started to keep in touch with friends and family back home. I remember asking myself, 'Why couldn't this be my career?'"

It was several years later that Hruska got her answer when she and Winklevoss hit the town one night in Southampton. "It all started at Pink

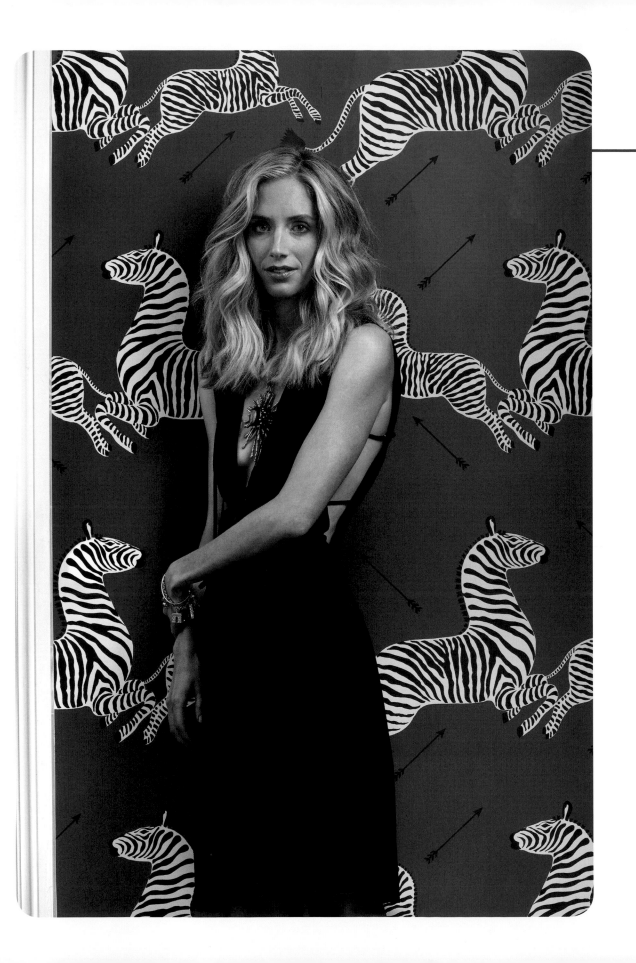

Elephant, this long gone club in the Hamptons," she remembers. "Cameron and I were there with our friends, and we started photographing everything around us on our PalmPilot Treos—yes, *PalmPilots*. The next day, we posted the photos online."

The site's traffic was so big that it crashed. Instantly. Recognizing an obvious demand for a voyeuristic style of photos, the duo expanded to include nearby New York City. Soon, even the *New York Times* was republishing their photos.

By 2009, Hruska had a flourishing digital business, and counted Nick Denton (former CEO of Gawker), Jack Dorsey (Twitter), and Lockhart Steele (Curbed, now part of Vox Media) among her friends.

"It's funny, because I was such a baby at the time," she says. "I was only twenty-four, and was watching Twitter debut at South by Southwest. I'm thirty-four now, and I already feel old for this business, which just goes to show how fast things are changing."

Hruska's business acumen is also changing. In 2016 she launched Lingua Franca, a small clothing collection that features hand-embroidered rap lyrics. "I learned how to sew and embroider from my Grandma when I was in sixth grade and started picking up the hobby again this winter on my own sweaters. I posted a few to Instagram and I had dozens of friends start asking for them," Hruska says. "I loved the juxtaposition between hip-hop phrases and fine cashmere. I also love the fact that each one is done by hand and is the opposite of mass produced."

"We're still in the beginning of a massive technology shift," Hruska says. "We don't know how it will play out. The best thing any of us can do is to keep things in perspective. Adapt quickly, but stay true to yourself. Sure, it's 'cool' to be an entrepreneur—but if you can't be *yourself*, it won't work."

★ HIT LIST ★

- Cofounded Guest of a Guest in 2008.

- Has covered over 50,000 events on the site.

- Learned how to embroider in the sixth grade.

- Lives in the West Village of Manhattan.

- Her first Lingua Franca sweater read "Booyah!"

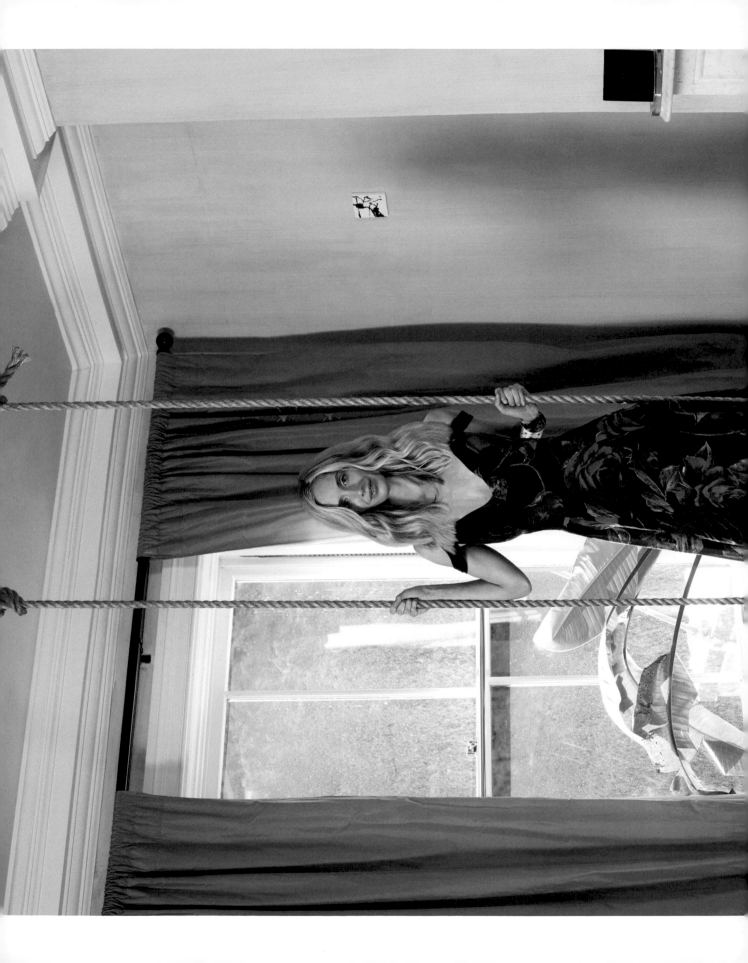

"@rachellehruska is a creative genius."
—@euanreilly

At home, West Village, New York, May 2015

GuestOfAGuest.com

rachellehruska
Cafe Gitane

Follow

261 likes 24w

rachellehruska A perfect NYC postcard moment in my favorite café. 🕶️🔍📷 #springuniform #VBwishyouwerehere @veronicabeard

liseannefrankfurt Beauty! ✨✨✨
sogladimhere Lovely! That blouse!
natalie So pretty!
jina_huh Beautiful, Rachelle 👸
jonnysurfer 😍😍😍
veronicabeard Love! 😊
jacqueanne1213 Love those jeans!!
modaobsession Very chic!
theshackyoga Beauty
liz.a.kopiasz Beautiful! 😍
kenfulk 🤍🤍🤍
fiercegrandma Miss you beauty!
cafegitanejanehotel So gorgeous!

Log in to like or comment.

guestofaguest
Trevi Fountain Rome

Follow

431 likes 12w

guestofaguest Karl did it again! #fendicouture @fendi
erriettelenas Great shot!
ashleyy117 @raquelpressberg
prattkm4 Woah! @robbinwatson
robbinwatson @prattkm4 that is cray
karamia3uh @deirdreluz so cool
martiniillustration Yay 👏✨

Add a comment...

guestofaguest
Samsung NYC

Foll

176 likes 17w

guestofaguest Current scene at @samsungmobile's block party with @diplo ✖️ @837nyc #837nyc #diplo
khusbupatel820 @mill_lion
annierooneyy @j_liningt
evesthatgural @rmulveny
notyourbasicbeach @patten221 this is what's going on!
sweetnlow_ny @danielsan_nyc you should go!
katherineahn @dechung is that you?!

Add a comment...

Guest of a Guest @guestofaguest · Sep 19
I went out every single night of #NYFW, here's what I learned...bit.ly/2cD2Vip

Guest of a Guest @guestofaguest · Sep 15
The 6 #NYFW shows all the cool kids are talking about: bit.ly/2cJcWZu cc: @VFILES @LyzOlko @ECKHAUS_LATTA

G∫G PARIS CALENDAR PHOTOS NEWSLETTER GUIDES YSK

PARIS | EVENTS
Did Aquazzura Throw The Craziest Party Of Paris Fashion Week?

Like | Share | Tweet VIEW ALL ⊞ VIEW SLIDESHOW ▶

by Stephanie Maida · October 3, 2016

"Rachelle is as much a savvy New York entrepreneur as a down-to-earth Nebraska native who studied psychology and pre-med." —LEVO

Guest of a Guest @guestofaguest · Sep 7
Grecian chic @miamoretti #aboutlastnight @RosettaGetty #nyfw

rachellehruska [Follow]

Rachelle Hruska MacPherson Founder of Lingua Franca @linguafrancanyc;
and @guestofaguest. Wife of Sean, Mama to Maxwell and Dash.
bit.ly/2b69ztJ

1,726 posts 10.2k followers 810 following

"A chic lesson
in throwing the
ultimate bridal
shower."

Guest of a Guest @guestofaguest · Jun 21
A Chic Lesson In Throwing The Ultimate Bridal Shower
bit.ly/28KW7bN

guestofaguest [Follow]
Montauk End Of The...

327 likes

guestofaguest Summer officially starts now.
Check out our founder @rachellehruska
and her husband, Sean MacPherson, in
their vintage dune "thing" in Montauk in this
summer's @dominomag - on stands now.

"Summer officially
starts now...in
Montauk in
this summer's
@dominomag."

rachellehruska [Follow]

130 likes

guestofaguest [Follow]

152 likes

guestofaguest [Follow]

152 likes 25w

guestofaguest Hats off to the ladies who
#hatluncheon @centralparknyc
#centralparkconservancy 📷:
@flyonthewallproductions

yesyams @guestlistblog did you go?

angelicactorres @samsung
@SamsungMobileUS @SamsungUSA

alextoccin @suzybuckleywoodward 🖤🖤

automatikfresh @emilythomas2

kposocco @ashley_acosta

guestlistblog @yesyams sadly no fabulous
hat in my possession

Log in to like or comment.

Danielle Bernstein

WeWoreWhat.com
@weworewhat

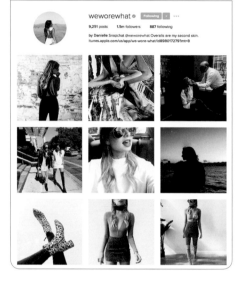

"Overalls are my second skin."

THE WORLD KNOWS TWENTY-FOUR-YEAR-OLD DANIELLE
Bernstein as a chameleon, shifting seamlessly from fashion (she founded the prominent fashion blog We Wore What), to nightlife (she's the creative director of an invitation-only Manhattan nightclub). Bernstein, however, categorizes herself differently—as a lover of plants.

 "I've become infatuated with plants," she says, gesturing to the many cacti scattered around her loft apartment in New York's West Village. "I photograph plants all the time. I'm pretty sure I even coined the hashtag #PlantSlut. Do you think I should trademark that? I should probably trademark that. Hold on, let me send an e-mail…."

At home, Greenwich Village,
New York, October 2015

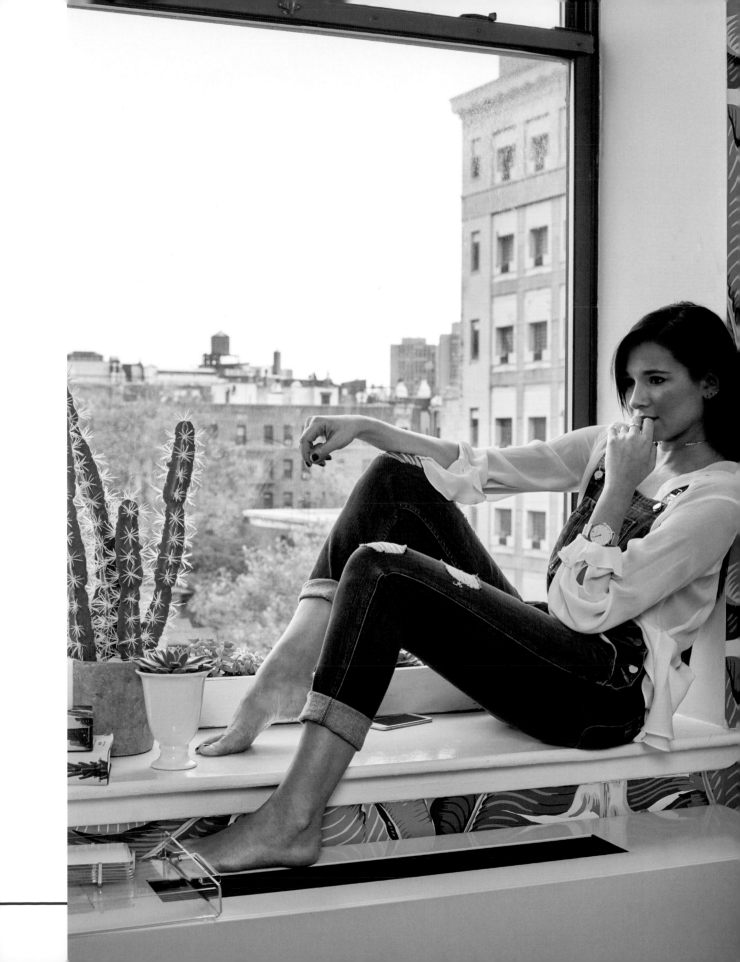

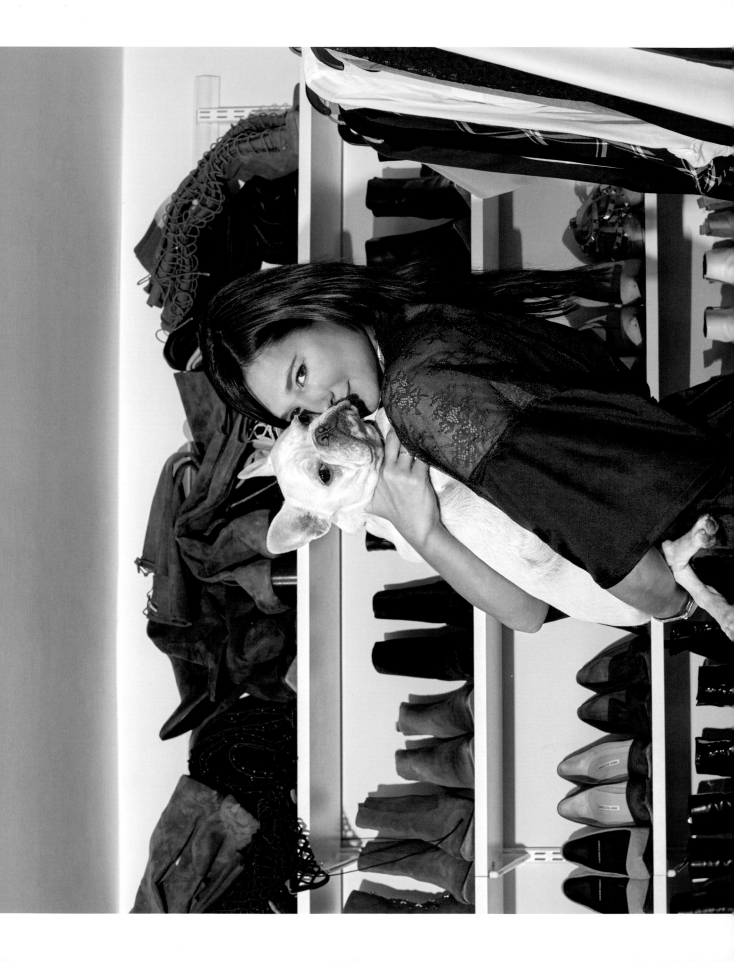

"She's starting her own line of overalls I can't wait!!!!"
—@deandradenapoli

At home with Bleecker,
Greenwich Village,
New York, October 2015

174-175

This is but one indication of the speed at which Bernstein's brain operates. In the hours we're together, she pauses several times to note ideas and breakthroughs. Bernstein is among the youngest of our Digital Girls. She grew up with the technology so many struggle to learn; Instagram is as easy to her as, say, styling outfits. Or watering a cactus.

"I never questioned my desire to work in fashion," Bernstein says. "When I studied at the University of Wisconsin, blogging was the only way I could connect with the industry. Because other than Vogue.com and various street style sites, there wasn't that much out there. I saw a gap in the space, and knew I could fill it."

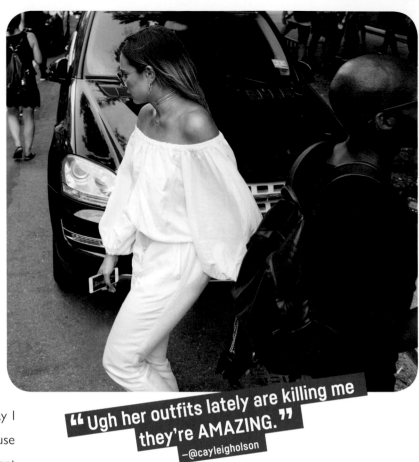

" Ugh her outfits lately are killing me they're AMAZING. "
—@cayleigholson

Bernstein started We Wore What as a personal style blog in 2011, in order to reach the industry she was determined to join. Her success was near immediate, prompting the nineteen-year-old student to transfer from Wisconsin to the Fashion Institute of Technology in New York City. "This," she thought, "felt right."

"For the first year or so, my blog was little more than a hobby," she remembers. "A way of parlaying my personal style into a dose of outfit inspiration for women around the country. I didn't intend for it to become a business. But when I realized how much my personal style resonated with readers, I knew We Wore What needed to expand."

Bernstein's turning point came in 2012, when she signed with Next Management. (Fellow Digital Girl Rumi Neely is also a client.) "Next helped take my business to the next level," she says. "Monetizing existing relationships with brands,

and helping to create new ones. I've now worked with just about every brand you can imagine—you can see my collaborations on my Instagram—but I'm very careful about the brands I promote. I won't work with anyone I don't like."

Even though she's collaborated with everyone from Chanel to Estée Lauder, Bernstein's self-described "holy shit" moment had nothing to do with brands. It was more personal.

"Three days before my twenty-third birthday, my Instagram account hit one million followers," she recalls, excitement pinging from her body. "My friends threw a surprise party at Jack's Wife Freda in SoHo with little '1 Million' balloons everywhere, and all I could think was, 'I did it.'"

Her success secured, Bernstein has found herself taking a more relaxed approach to We Wore What. Which isn't to say she's less thoughtful about her brand—or that she's generating less content.

"When I started out, I would post upwards of nine times per day on my Instagram," she recalls. "Now that I have a million followers, I can tone that down a little. Less is more. I'll interact with my readers if something is controversial, or if a follower tags me in a photo, but I feel like I can finally breathe."

Bernstein's version of relaxation may be different than yours, though. She recently launched Second Skin Overalls, a collection of flattering overalls, and The Archive, a range of shoes in styles she loves. She's also preparing to expand into menswear, music, and food. Her end goal? To become a comprehensive lifestyle brand that frequently collaborates with leading designers across all verticals.

"The blogosphere has become so saturated that it's tough to stand out," Bernstein says. "And it's still such an undefined industry. We make the rules up as we go. The best advice I can offer is to network without fear. Don't be afraid to ask questions, or to speak to anyone—no matter how high up or powerful they are. My boldness is the single reason for my success."

★ HIT LIST ★

- Coined the term "plant slut."
- Has her own line of overalls, Second Skin Overalls.
- Collects vintage Chanel bags.
- Has a French Bulldog named Bleecker.

WeWoreWhat.com

"I ordered this bathing suit because of you hope it looks just as good on me."

weworewhat ✓ Follow
by Danielle Snapchat @weworewhat Overalls are my second skin.
www.weworewhat.com
9,192 posts 1.5m followers 874 following

"*Mixing high-fashion brands like Chanel and Chloé with affordable classics like Zara, Bernstein has found the perfect styling sweet spot between affordable and aspirational.*" —AOL

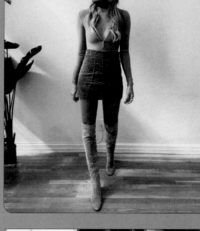

weworewhat Follow

21.9k likes 1d

simplytandya Obsessed with this outfit 😎
slang629 @jamiepaige92 I want these boots
aliiideee 😍 @clarsmode
staceface8788 @weworewhat Danielle, please stop by our Guess Event this Thursday 6p-9p at the Soho location for our new His and Hers Collection
shoesandshibas Yes Danielle 🖤 love the colour
pop.fizz.clink 🥂
hmmcintoshh @paigehayduk
rosefl0 @taylangg_ obsessed
blacksaintclothing 😍
sssshanel 😍😍
flexigen 👌

♡ Add a comment...

weworewhat Follow

10k likes 6d

iremsayim_ ✓✓✓✓
pllerlin_leet Princess vibes 😍 New fashion blogger
synellagonzales @karinafarruya why this look like she took it w a selfie stick
sehrishraza ✓✓✓
cmariethelabel GOALSSSS
cmariethelabel 😍😍😍😍
merynly 😍😍😍😍
cortescristii love the fucking top!!!!
tatmaranhao Love this ⚡

♡ Add a comment...

weworewhat Follow

13.3k likes 1w

xo.brooketaylor Just wanted to say your post the other day was really inspiring. I've looked up to you and your blogging for almost a year now and I'm so happy to follow you on your career path! You have one of the best styles and I look forward to seeing your posts daily! Keep doing you girl, it's pretty damn amazing!
lajamie I just 🖤 you

♡ Add a comment...

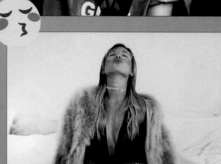

weworewhat Follow

17.3k likes 7w

weworewhat Home is where the heart shoes are.
load more comments
paolamorera bitchhhhh @nelaseguranela
impolishgirl This is what heaven looks like 💕
whiskeybones 💀💀💀
steph.iexx 💀💀
aviv1399 @oliyahu_buzaglo עכשיו אתה אחרי הצבא? שווי לי גם!?
laurahammainen @katakek mun mielest

♡ Add a comment...

weworewhat Follow

15.4k likes 22

weworewhat Doing a closet tour on my app soon - any other requests for tutorials or things you guys want to see on my app?! 😜
view all 251 comments
jesunilo @weworewhat best vintage stores in nyc!!! Please
camelog @guilloootine same
funjoyride @sethlinus @trachellechye

weworewhat Follow

16.4k likes 1w

your supportive words, and I will always support you 🖤
waketowear I'm OBSESSED with this outfit. You are the most inspiring blogger to me. The fashion industry THRIVES because of bloggers. Keep being amazing Danielle!
jana.cecilia Love 💯🖤
stylists.to.a.t Love that velvet cardigan! Perfect way to add a bit of texture ❤
almatjar_al3alamie حياكم الله في متجري العالمي
rosecrest_events Perfect fall uniform - your feed is always entertaining, but I seriously think you nailed a fall fashion statement here - thanks!
rapunzilie Loved your insta story babe 🖤 blogging is a new form of advertising, and many people don't quiet understand the power of it yet! ❤❤😍😍 @weworewhat

♡ Add a comment...

Hanneli Mustaparta
Hanneli.com
@hannelim

"In 2009, Hanneli decided to set up her own blog, Hanneli.com, where she continues to post a mix of street-style photographs and self-portrait shoots. Hanneli has art directed and shot for various publications."

HANNELI MUSTAPARTA IS A FASHION WORLD DO-IT-ALL. THE Norwegian beauty started out as a style-obsessed tween, became a model, picked up a camera, and turned into a photographer, only to find her calling as a blogger. Today she's an influencer and social media star who consults for brands like Dior, Chanel, Net-a-Porter, and Prada and is a brand ambassador for Calvin Klein. Busy? You bet. But Mustaparta handles her whirlwind schedule with ease.

Her love of fashion started early—very early. "I was six or seven years old at the time, and I remember looking around Norway wondering, 'Why isn't anyone wearing fabulous red shoes?'" she recalls. "Fashion could make life more exciting."

Mustaparta nourished her then-fledgling obsession with frequent visits to an older sister's closet—a ritual so inspiring, she says it defined her childhood. "My sister Silja is four years older than me,

Outside Michael Kors
Fall/Winter 2016–17 NYFW,
February 2016

The Jane Hotel,
New York,
November 2015

"Hanneli Mustaparta is an example of refinement and fashion expressed in all their nuances." —VOGUE ITALIA

and she would go on school trips to London, where she went bananas at Top-shop. When she got back, I would wait for the minute she left to school before sprinting into her room, and then the raid was on."

At seventeen, Mustaparta was scouted as a model. The year was 1999, and she followed her new career across Europe: Paris, London, Milan. Her end goal, however, was always New York.

"At five feet eight-and-a-half inches, I'm a pretty short model," Mustaparta laughs. "And so to have someone in New York who believed in me enough to fly me over and to sign for my visa, well, that was the best feeling in the world."

For a decade, Mustaparta modeled, picking up an SLR camera along the way. One day, she was asked to accompany a friend, model Sunniva Stordahl, to New York Fashion Week. She agreed, bringing her new camera along for the ride.

"This was still Bryant Park, and it was the first time I'd ever been to New York Fashion Week. I was waiting for my friend, taking pictures of people, and people were also taking pictures of me. Those were the first images I ever put on my blog."

The rest, shall we say, is fashion history. Mustaparta fell in love with photography, relishing the chance to capture her subjects as their most beautiful selves.

"That's why I started my blog," she remembers. "Not because I wanted to become a blogger—or an editor, for that matter—but because I wanted a gallery to display the pictures I loved so much, and it eventually became a place where I could show what inspired me.

In 2009, when she started Hanneli.com, other bloggers like Tommy Ton and Scott Schuman were becoming more influential in fashion—and not everyone was happy about it. "Blogging wasn't very popular because it was a new force to be reckoned with and a lot of people didn't want us to be there," Mustaparta remembers. "It's interesting to see how that has evolved, today we work together with magazines and brands."

In 2017, Mustaparta serves as a consultant, art director, and photographer for the labels that once wanted to

★ HIT LIST ★

▪ Started her career as a model.

▪ Loves riding her bicycle.

▪ Had her likeness printed on T-shirts sold at Zara in 2011.

▪ Contributed to Vogue.com.

▪ Was one of Bill Cunningham's favorite subjects.

collaborate with her on her blog. "Being in front of the camera, behind the camera, consulting, art directing for brands—that's what I wanted to do anyway, so I was happy to see that what I did on my blog was able to help get me those jobs," she says. As a result, she's put her blog on hold, though she continues to update her Instagram and Snapchat accounts.

"It's nice to have my contact with people and my fans," Mustaparta says. "It's sad in some ways that I stopped blogging, but I'm happy that I've moved on because all the things that I did on my blog are what I am being asked to do from all the big brands that I work with. Now, I have an Instagram for work things, while I can be a bit more silly on Snapchat."

As for where Mustaparta might end up next, time will tell. "I try not to plan out the future," she says. "Looking back, I didn't know that I was going to be able to start blogging or contributing to *Vogue* or shooting campaigns for Diesel and Rag & Bone—that's something that didn't even exist when I went to school! I think the most important thing is to work hard wherever you're at and always appreciate the moment you're in, and then anything can happen."

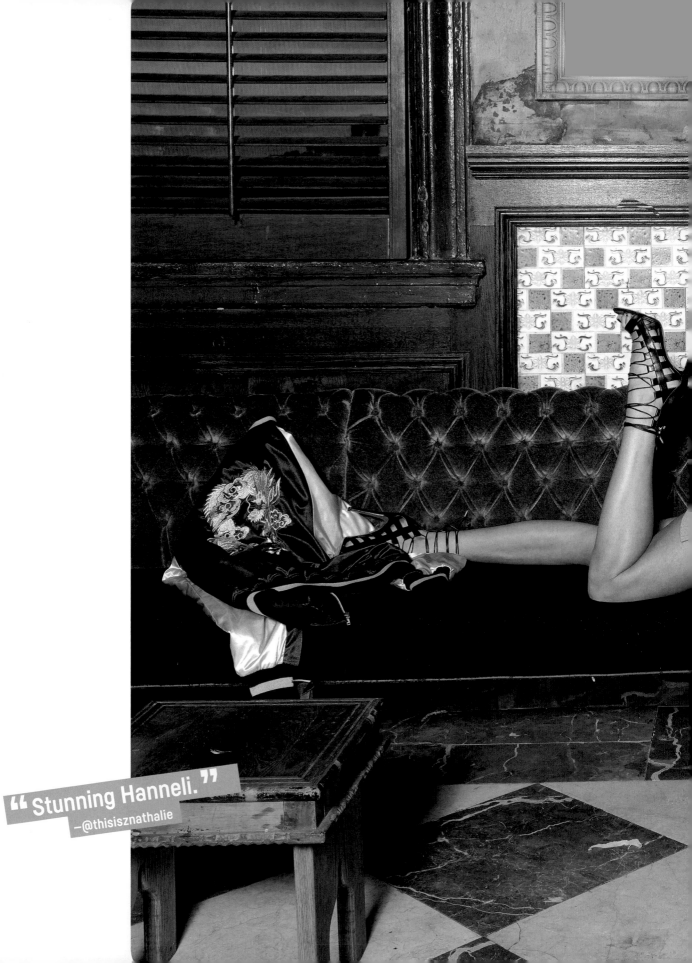

" Stunning Hanneli. "
—@thisisznathalie

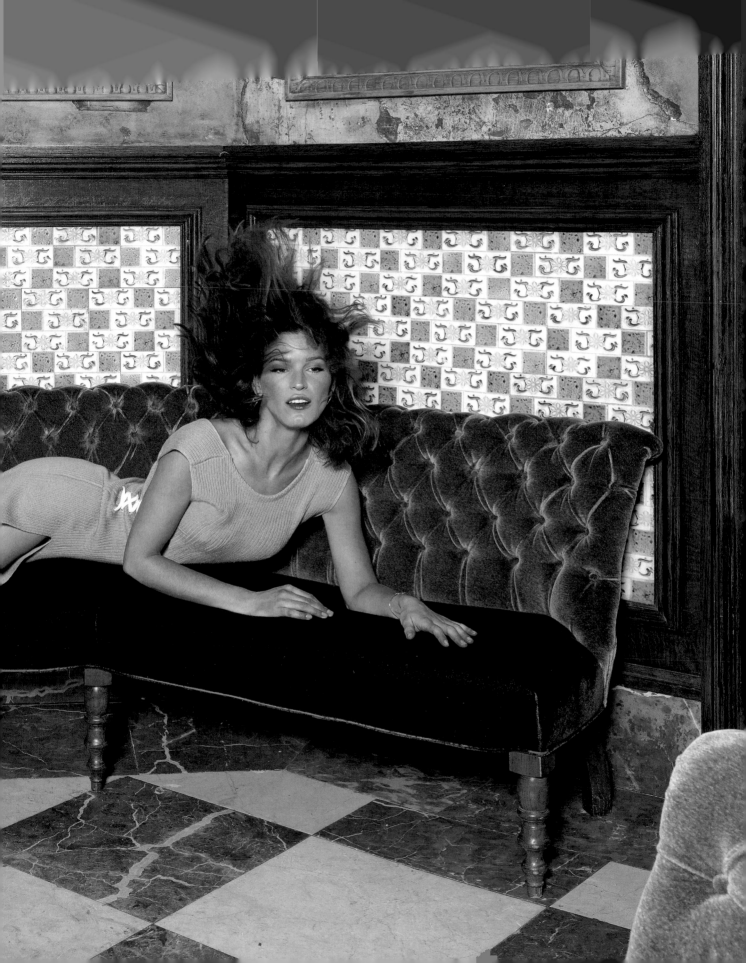

@hannelim

HANNELI

Torn from the pages of Vogue Paris.

> "Hanneli is one of the most gorgeous women I know, living the life of a successful model/photographer, and still managing to stay down to earth." —GUEST OF A GUEST

HANNELI

IN PARIS

THE WINTER COAT!

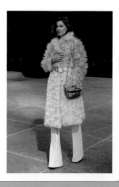

hannelim
5,101 likes 74w
hannelim in shoe heaven @levelshoedistrict in Dubai ♥ Only the largest shoe shopping area in the world. Can you guess what pair I ended up with?
view all 94 comments
camila_b_u @alejandrabf
alejandrabf @camila_b_u me encanta!
danellaericson @thomasericson_ this place will be our first to do list
oscar.artcat @christ.inlove
huphotels ♥
malpharma Perfect
elisetorz
Add a comment...

hannelim
Ninja Training Corp. Follow
2,980 likes 77w
hannelim These are the real deal! Sandals by @hannegabysees for @mattbernson
mattbernson
maxiliemi
hannegabysees
dom.2000
carmenberdonces Muy cool
thedutchcountryside Theyre stunning!
aliceandwil Love the bag
camillachristensen__ stunning!!
simonepjardim Perfect
milanofashionguide Love your style
Add a comment...

hannelim
Hotel Atlantic Kempi... Follow
2,560 likes 57w
hannelim Sick day at 5 star hotels makes it all a little better #fever
view all 53 comments
fabiolafigueroa @rominasacre
marinatinita God bedring
kaynakci_mustafa15 Merhaba
rominasacre @fabiolafigueroa Jajaja mi mega piraña !
lamjillroberts @ladyc913 thought this was you!
annettewalther0710 God bedring, søte♥
slinossier I Wish I was half as beautiful as you
michellekornbluth Thanks @stephaniemwong, but she's much prettier than me! Miss you xo
ladyc913 @iamjillroberts wow! Thank you! I'll take it!!!
Add a comment...

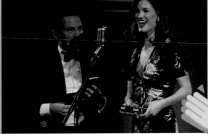

Hanneli Mustaparta @HanneliM · 27 Jan 2014
Yay! Thank you @CostumeNorge for the awards and for a hell of a party! #bestdressed #bestblog
13

Hanneli Mustaparta @hannelim 16 Apr 2013
Honey and I am having a day #withoutshoes for @TOMS I'm wearing leather overalls by @louisvuitton bag by @TheRow

hannelim
Stella McCartney Sho... Follow
4,556 likes 86w
hannelim Ready for #nyfw with my brand new @stellamccartney bag!
view all 263 comments
ddrumondperfil Kkk...
lailadrumond Só pode ser @ddrumondperfil
_christine @riskabel
marihektoen
s.lale @e.s.sarg
e.s.sarg @s.lale
momo225588
thouraya_g
Add a comment...

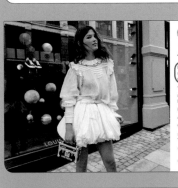

hannelim
Oslo, Norway Follow
4,696 likes 17w
hannelim Wearing my dream dress by @louisvuitton for their store opening in Oslo
view all 62 comments
raimonda_dauti @hannelim so beautifull! Follow for follow
hannelim Miss you too ♥ @bambilegit
celinecarneiro
turquoiselove9
mariannehaugli Helt nydelig @hannelim Veldig koselig å se deg igår xxx
migerm Amazing outfit!!
Add a comment...

"Wearing my dream dress by @louisvuitton for their store opening in Oslo."

hannelim Follow
Hanneli Mustaparta @HanneliSnap hanneli.com
811 posts 244k followers 756 following

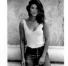

hannelim
4,545 likes 111w
hannelim S nday! My outfits in a month for @glamourmag by @lesliekirch #septemberissue
view all 50 comments
norazehetner
vacation_nyc
marttchelton
sylwia_maria
kupi_remont_05 все самое вкусное только у нас , заходите к нам !!!
itms_node Beautiful
quelc_nyc Amazing, both ladies xx
levanillamilla Very cool shot from the clothes to the ice cream :) yummy
Add a comment...

Alexandra Macon

Vogue.com & OverTheMoonBlog.com
@otmblog
@alexandramacon

"Vogue.com's Contributing Living Editor loves a chic wedding and is always on the lookout for couples to feature in the site's weddings section (and on her blog, Over the Moon). She is also a horse enthusiast, an avid follower of the royal family, and a Southerner through and through."

THE DAY STARTS AT 6:30 A.M. FOR ALEXANDRA MACON. "THE first thing I do in the morning when I wake up is do the daily rounds: read theSkimm, check Instagram, check Snapchat, check Facebook, check Twitter, check my e-mail," she says from her office at One World Trade Center, where she's a contributing editor and former managing editor of Vogue.com. (Fun fact: her office is

With Eleanor, The Battery Carriage House Inn, Charleston, South Carolina, July 2013

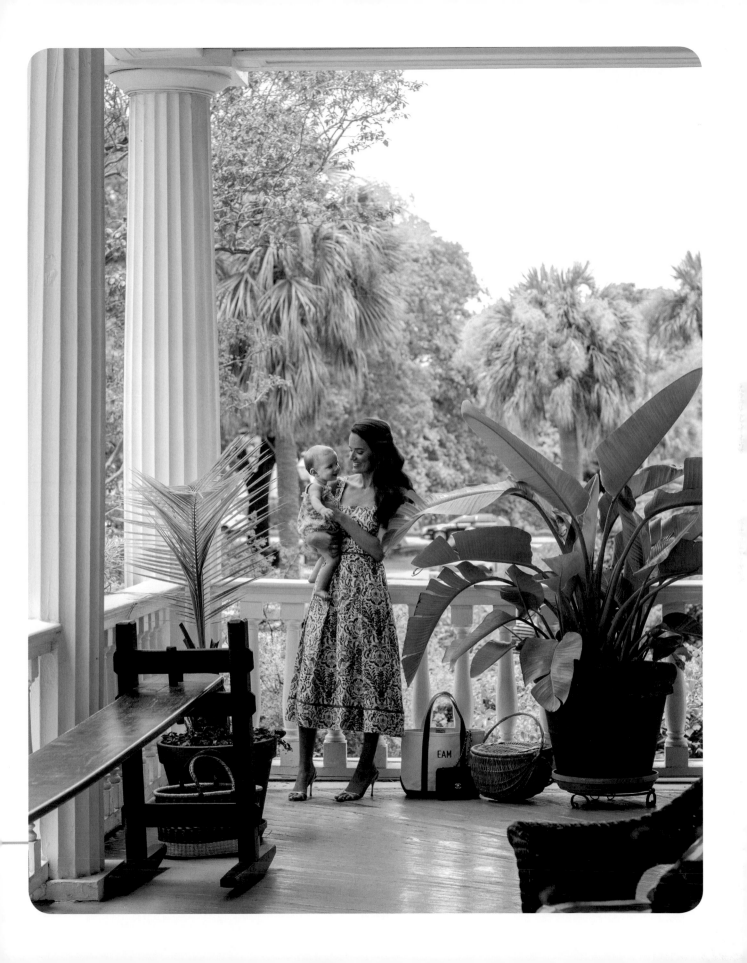

lined with Tim Walker photographs of Kate Moss and has wallpaper in lieu of corkboards—very chic.)

"It was pretty nonstop," she admits of her managing editor role. "Throughout the day I met with section editors and I looked at the homepage, saw how things were performing, and thought about what message we were trying to say on Vogue.com that day—then I tried to make sure there was a mix and all the sections were well represented on the site." It's no small feat, considering Vogue.com's staff tends to publish upwards of fifty articles a day.

Macon held the role of managing editor of Vogue.com for seven years— an accomplishment in and of itself in the high-turnover media industry. She started her career on the print side of *Vogue*, as an assistant to the managing editor, becoming the assistant managing editor at *Domino*, and then the managing editor at *Interview* before returning to *Vogue* as part of its new digital team that brought the magazine online in 2010.

"I think I was the third person to be hired for Vogue.com, which is crazy because I think we have about fifty-five full-timers and seventy-five people total here now!" Macon says.

Needless to say things have changed a bit during her tenure. "I feel like we've migrated content so many times!" she laughs. "It goes to show you can never sit still when you work for the Web because there's always the next thing, whether it's moving from Instagram to Snapchat, one CMS to another CMS, or launching a new vertical. There has never been a quiet summer at Vogue.com."

Leading what's arguably the world's top fashion magazine into the digital frontier means Macon has had a front-row seat for what it means to be not just a Digital Girl, but a Digital Warrior. In addition to managing Vogue.com's staff, she is also on the hunt for the Next Big Thing. When Snapchat became the social platform of choice, the editor helped Vogue.com put together a team

At her office at *Vogue*, 1 World Trade Center, New York, March 2016

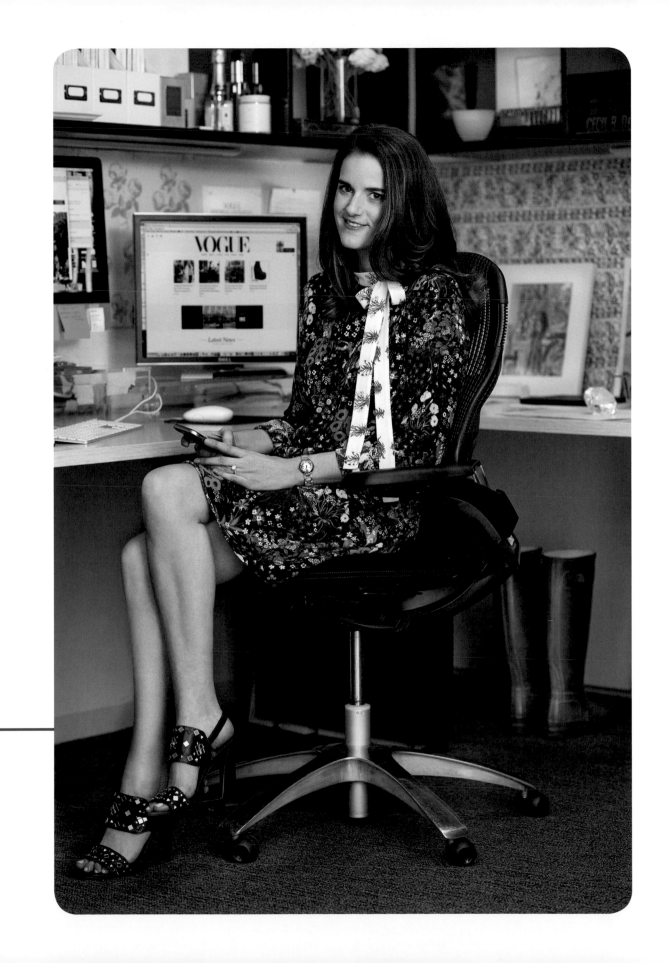

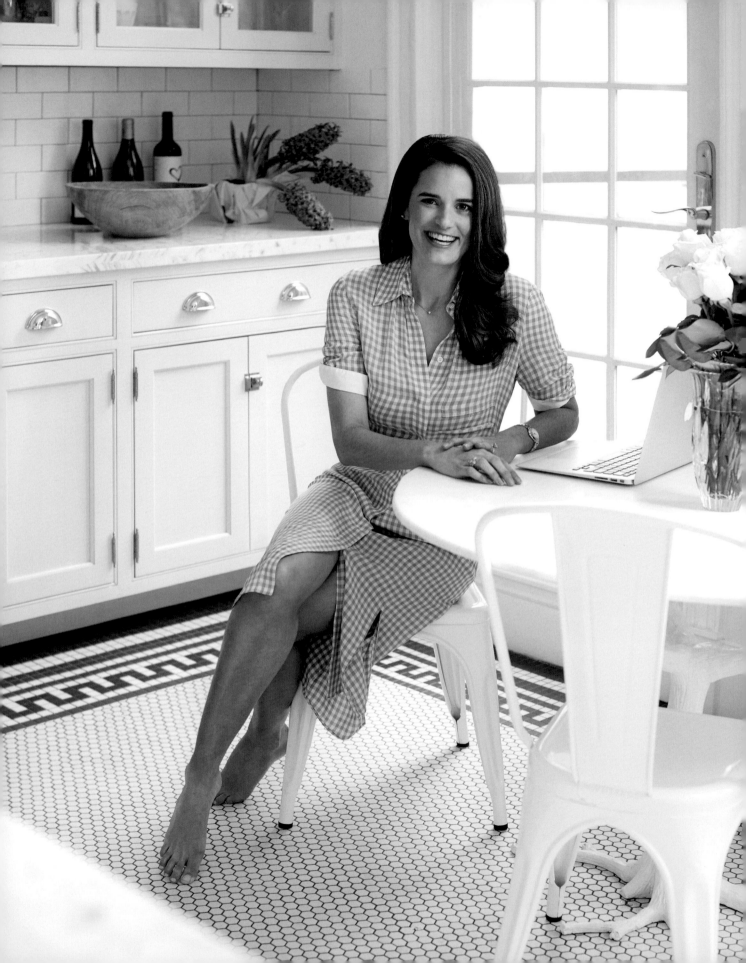

to create engaging Snapchat Discover stories, and has been instrumental in launching *Vogue* Living's Facebook and Instagram pages.

Daunting? Not to Macon. "The nature of working online makes every day really interesting and keeps you on your toes. It's been really amazing to see the magazine transform online. Vogue.com really started more as a magazine posted online, and now it's more of *Vogue*'s presence on multiple platforms. It's becoming all different content depending on the platform, but it all connects into this larger thing that is the brand."

As if all that isn't enough work, Macon also contributes to Vogue.com's wedding section and runs her own wedding-centric blog, Over the Moon, with The Coveteur's site director Andee Olson. "I just love looking at the pictures, hearing the stories of the couples, and getting to tell those stories on Vogue.com or Over the Moon," she says.

"Doing it for both Vogue.com and Over the Moon is exciting because I get to find the stories that are just right for each outlet. Vogue.com weddings are incredibly glamorous—and most seem to take place in the South of France! Over the Moon is a little bit more about the girl next door. We wanted to create a site that pulled together those images and told those stories in one place where you're not wading through the sea of images on Pinterest."

As for her life offline, the editor is a mother of two daughters, ages two and four. "My eldest daughter loves to take pictures with my iPhone," she says. "She's obsessed." Sounds like she's a second generation Digital Girl in the making.

★ HIT LIST ★

- Her favorite *Vogue* covers include those of Kirsten Dunst as Marie Antoinette, Penelope Cruz, and Michelle Obama.
- Hails from North Carolina.
- Her favorite shoes are a pair of pink metallic Gucci heeled sandals.

" I love this blog 🎀🎀." —@reneebrockinton

At home, West Village,
New York, March 2016

Middleton Place,
Charleston, South
Carolina, July 2013

@alexandramacon

otmblog Follow

75 likes 23w

otmblog Enjoying @thesouthernc's #tcsummit, but also missing these two babies big time today. Cannot wait to see them soon! 🙌 #TBT #squad 📷 @cyorsz

reneebfarmer 🖤🖤🖤

lindsaytimlin Gorgeous!

leanrice Such s sweet picture! 💕

acburris75 Make sure to go to Fritz Porter. SHH is my niece!!

lolaandlocke I love this!! Next time they're coming with you!! 😍

carriejeancrozer Gorgeous gals 🤍🤍🤍

lyndsayerickson So cute!!! 🖤

the_sift 🖤🖤🖤

Add a comment...

THE BEAUTY ROUTINE THAT WILL GET YOU GLOWING FOR THE BIG DAY

FEATURED PRODUCTS

MOST POPULAR

"Enjoying @thesouthernc's #TCSummit, but also missing these two babies big time today."

WEDDINGS
A CELEBRATION OF LOVE IN THE MOUNTAINS OF COLORADO

"Kate arrived at the agreed Brooklyn restaurant [for our first date] in a Ford pick up truck, with a can of Budweiser in the cup holder, playing Bruce Springsteen," says Benjamin Towill. "For a boy from England, that was it."

READ MORE

WEDDINGS PLANNING SHOPPING

otmblog Follow

28 likes 38w

otmblog Wedding party selfie! 📷 Bride: @laschwab Dress: @inbaldrorofficial Photo: John Dolan @easthampton #laurenbobby @voguemagazine

luxury_square_feet 🖤🖤🖤

Add a comment...

FASHION
SHOP THE LOOK OF GIOVANNA BATTAGLIA'S WEDDING IN CAPRI

It's been declared the wedding of the decade. When street style supernova Giovanna Battaglia married Swedish realtor Oscar Engelbert on the Italian island of Capri in June, we couldn't stop refreshing the #giovandoscar feed—now you can dress the part.

READ MORE

FEATURED PRODUCTS

MOST POPULAR

otmblog Follow

44 likes 46w

otmblog "Brad and I recessed down the aisle to 'She's A Rainbow' by the Rolling Stones while our guests showered us with rainbow-colored confetti," remembers @dectraces's @ellewalish of her wedding in #Tuscany. 📷 Photo: Lelia Scarfiotti @voguemagazine

rharary5 @marilyngesch

jabeljewelry What a wonderful moment!

Add a comment...

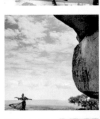
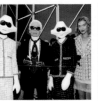

voguemagazine ✓ Following ⌄ •••

2,780 posts 12.6m followers 409 following

Vogue Snapchat and Snapchat Discover: @voguemagazine vogue.cm/ZqSI50T

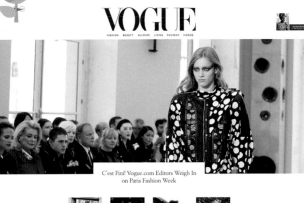

VOGUE
FASHION BEAUTY CULTURE LIVING RUNWAY VIDEOS

C'est Fini! Vogue.com Editors Weigh In on Paris Fashion Week

Fall Oh's Best Street Style From Paris Fashion Week
FASHION

It's Kendall vs. Kaelse in Paris's Model Wallet Off
FASHION

Spring 2017's Best Street Style: Beauty Shots From New York to Paris
BEAUTY

The Most Major Front Row Moments From the Spring 2017 Collections
FASHION

VOGUE FASHION BEAUTY CULTURE LIVING RUNWAY VIDEOS SUBSCRIBE 6 issues for $6

MOST WATCHED VIDEOS SEE ALL VIDEOS →

Louis Vuitton | Spring 2017 Ready-to-Wear

Chanel | Spring 2017 Ready-to-Wear

Stella McCartney | Spring 2017 Ready-to-Wear

SAINT LAURENT
PARIS

14 Famous Exes You Forgot Were on *Sex and the City*
by CHELSEA HAEBLER

SAINT LAURENT
SUNSET

otmblog

54 likes 47w

otmblog The custom job @numberfoureleven did for my sister. Check out their Modern Rules for Monogramming on the blog.

ludoswell So good!!

ohheycvmk @maggiewehmer relevant for the new initials!

jenalclem Thanks @otmblog for making Christmas shopping much easier this year!

sashanicholas 🖤 @numberfoureleven

♡ Add a comment... •••

"Alexandra Macon is the perfect combo of Southern Belle and City Chic." —SHOP BURU

VOGUE FASHION BEAUTY CULTURE LIVING RUNWAY VIDEOS

Alexandra Macon

Vogue.com's Managing Editor loves a chic wedding and is always on the lookout for couples to feature in the site's weddings section (and on her blog, Over the Moon). She is also a horse enthusiast, an avid follower of the royal family, and a Southerner through and through.
follow 🐦 💬 📷

3 days ago
WEDDINGS
Valerie Boster and Michael Macaulay's Whimsical Wedding in the Woods of New Hampshire
by ALEXANDRA MACON

3 days ago
WEDDINGS
Valerie Boster and Michael Macaulay's New Hampshire Wedding
by ALEXANDRA MACON

Sep. 28, 2016
LIVING
Kate Middleton Visits the Yukon's Capital During Day 5 of the Royal Tour
by ALEXANDRA MACON

LOUIS VUITTON
Beyond Perfume

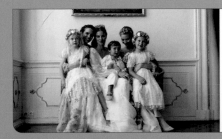

otmblog Follow
Oettingen in Bayern

97 likes 9w

otmblog Actress, model, and (we saved the best for last) Baroness @cleovonadelsheim married Hereditary Prince Franz Albrecht zu Oettingen-Spielberg at a beautiful #summerwedding in #Bavaria. 🖤 #triplethreat #vonshavemorefun #cleofa #royalwedding #princessbride 🖤 Karl Anton Koenigs @voguemagazine

sashanicholas Gorgeous

♡ Add a comment... •••

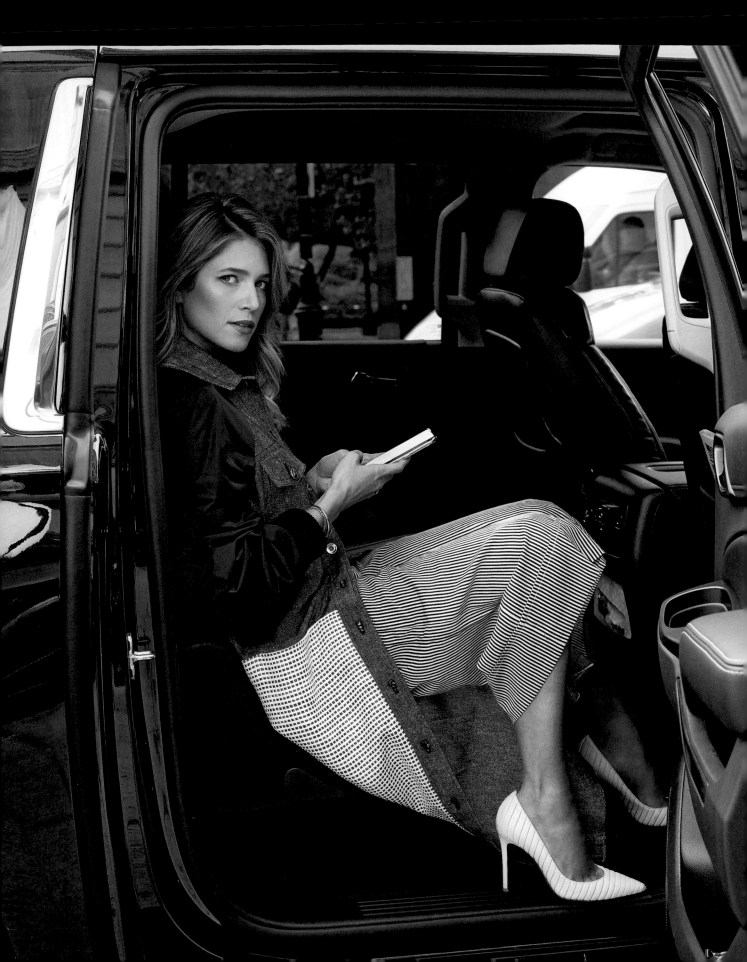

Helena Bordon

HelenaBordon.com
@helenabordon

"Brazilian digital influencer."

HELENA BORDON IS FASHION ROYALTY. AS THE DAUGHTER OF
Vogue Brazil's current style director and the former international director of famed boutique Daslu, Donata Meirelles, Bordon spent her childhood in the showrooms of Paris and Milan.

"I've always loved fashion," Bordon remembers. "I have this vivid memory of the Dolce & Gabbana showroom when I was ten, running around and pretending it was my own little store, and I was the shopkeeper. It's hilarious to imagine what those designers must have thought at the time."

Around seventeen, Bordon's passion began to dwindle. She still loved clothes, of course, but she began to feel uninspired by the business she'd always loved. In hopes of getting "as far away from fashion as possible," Bordon moved to London and enrolled at the American InterContinental University's business school.

New York City,
September 2015

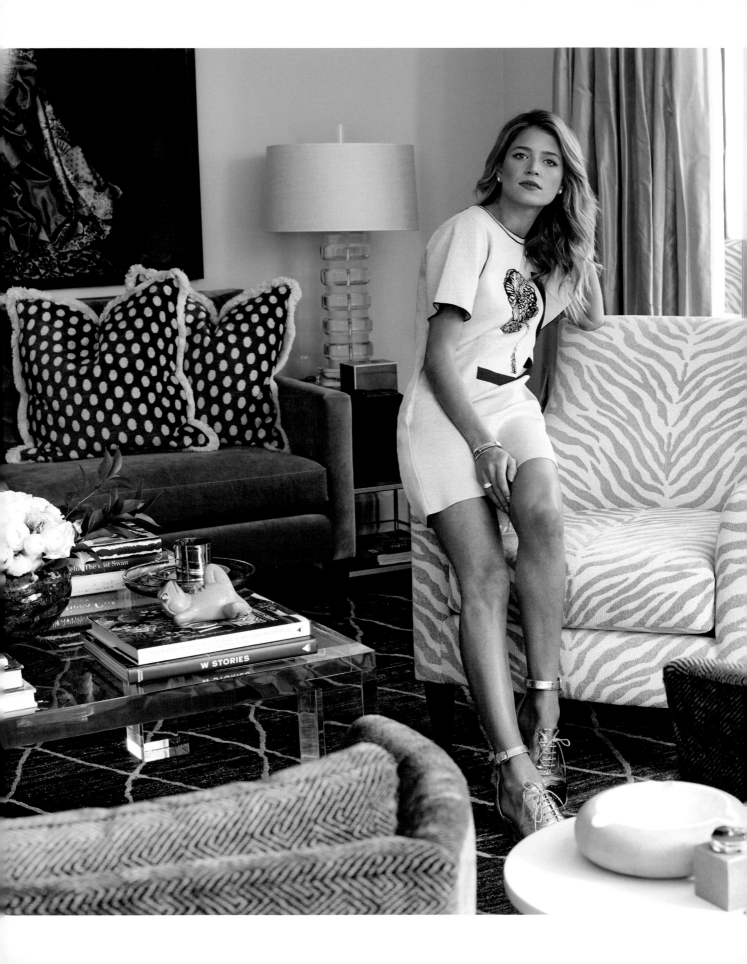

" My muse. "
—@lousaibel

At home,
Central Park South,
New York,
September 2015

"I wanted something different," Bordon remembers. "While I'm glad I got a break from the fashion industry, it appears I couldn't stay away. When I graduated, I practically sprinted back."

Back in São Paulo, business degree in hand, Bordon teamed up with friends Luciana and Marcella Tranchesi to open a boutique: 284. Bordon helped run the store from 2009 to 2014, founding HelenaBordon.com in her free time. She sold her shares in 284 in 2014, but she credits the store as a defining moment in her career.

"At 284, I was really involved with social media and with the website," she says. "I was simultaneously learning things that could be applied at both the store and at HelenaBordon.com. Eventually, though, it became too difficult to manage both. I had to choose."

Like many Digital Girls, Bordon found it impossible to balance a "normal" job with her own site. Her reason? Competition over brands. Bordon remembers that the same brands carried at 284 would approach her to be featured on the blog, rendering it impossible to stay neutral.

"Collaborating with brands is my *favorite* thing," Bordon explains. "At a certain point, I began to feel like my site was competing with the store—it wasn't good."

Bordon has designed everything from lingerie, to ready-to-wear, to shoes. And when she's not designing, she's traveling the world shooting campaigns for brands like L'Oréal and Cîroc vodka.

"One of my best 'career' moments happened last year," she remembers. "Mario Testino had just shot me for this Cîroc campaign, and a friend called me yelling, 'Helena! I'm in Kyoto, and you're on a giant billboard!' It was an amazing feeling."

It's an undeniably glamorous life—one Bordon maintains she could not have achieved on her own.

"You need a team of people you trust," she says. "I started HelenaBordon.com with the same two partners I have today—Marcelo Figueiredo and Fábio Kestenbaum. We've been friends since childhood. It was actually *their* idea to start HelenaBordon.com, which is the other thing: when you have a great team, it doesn't matter who comes up with an idea. It only matters what you do with it."

★ HIT LIST ★

- *Vogue* Brazil's style director, Donata Mierelles, is her mom.
- Owns 284 Boutique in São Paulo.
- Was an intern at Valentino.
- Has several small tattoos, including a butterfly and a heart.

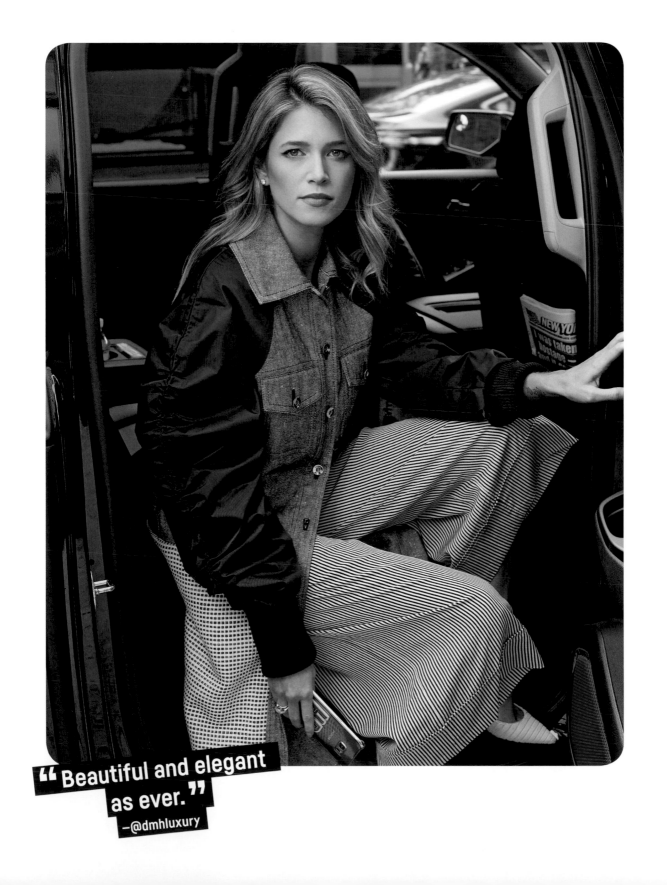

"Beautiful and elegant as ever."
—@dmhluxury

HelenaBordon.com

Buscar

FASHION - LIFESTYLE - BEAUTY - TRAVEL - SHOP - PRESS - BACKSTAGE

FASHION – 17/09/2016

LFW SS17 – DAY 1 – LOOK 2

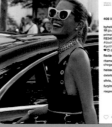

HELENA BORDON

QUEM USA

"As her personal brand continues to grow, other opportunities aren't far behind— to wit, she recently designed a capsule jewelry collection for Brazilian company LOOL." –VOGUE

byhelenabordon
New York, New York — Follow

182 likes — 8w

byhelenabordon 👈 #tb @helenabordon em NYC do DOSHOW preto lente preta total 💰 R$349 #getthelook www.byhelenabordon.com/doshow #byhelenabordon #helenabordon #nyc

ismeniawalmeida Esse eh lindo... E olha o valor... 😊 @nathrinaldi

filmwithlight Very nice

carosalonski Como compra esse óculos? @byhelenabordon

byhelenabordon @carosalonski Olá! Direto no nosso site www.byhelenabordon.com ! Modelo DOSHOW 😘😘

andreiadksteim Muito toppppppp uma arraso

pimentalu @ietpimenta olha que lindo.

Add a comment...

byhelenabordon — Follow

169 likes — 13w

byhelenabordon #voguecover feelings 💜 @helenabordon e DIDI roxo --> R$359 #shopnow www.byhelenabordon.com #didi #vogue #vogueportugal #helenabordon #getthelook

lenasritchie Olá ! Sou do Rio e gostaria de adquirir um didi ! Caso eu não vista bem no meu rosto , tem reembolso? @byhelenabordon

byhelenabordon @lenasritchie Olá! Claro! Fazemos o estorno sem problemas! 😘😘

vivianefranzin Este vestido!!!! simplesmente, MARAVILHOSO!!!!

lenasritchie Ok

Add a comment...

Helena Bordon

helenabordon
Dean Street Townho... — Follow

7,473 likes — 8w

helenabordon Night night London 😴 amazing day with @gucci #guiltynotguilty

view all 68 comments

talitamansurmonteiro Sempre linda😍😍

uhhmaneee My Gucci sweater !!!! 😻😻😻 😻😻 @_aaatiyeh_

esthererreza Bellisima 🙌

alealtara 😍

zilmagalmeida Linda ! Sua blusa e da onde ? 😊

kaelecollection Linda!

suzaneleticia Queria esse rosto, essa pele e essa roupa! @lucasnovakowski

organicskibunny OMG that kitty sweater is EVERYTHING!!!!!

dresswithyas 🖤🖤🖤🖤

champsdapraia Linda 😻

Add a comment...

byhelenabordon — F...

171 likes — 12w

byhelenabordon #silvermood com o nosso novo ZERA transparente lente PRATA 💰 R$339 --> #shopnow www.byhelenabordon.com #zera #shopnow #byhelenabordon #helenabordon

giguimaraes98 @brunocardoso02 esse é mara, eu quero

jtourinho Qual a previsão de chegada, no site, do DOSHOW caramelo? @byhelenabordon

byhelenabordon @jtourinho oi!! Início do mês que vem!! 😘😘

brunocardoso02 @giguimaraes98 💙💙💙 amei

adrianasterse É espelhado?

byhelenabordon @adrianasterse sim!! É

Add a comment...

helenabordon
Hotel Principe di Sav... — Follow

9,678 likes — 1w

helenabordon 👋 out Milan! Thanks for an amazing stay @principedisavoia #principedisavoia e muito obrigada por organizar toda viagem @onmywaytravel vcs arrasaram!! @onmywayexperience #onmywaytravel | partiu Paris 🙌🙌

view all 45 comments

mafemarconi @andrezacoury eu so queria essa bolsa/mala

cidapacheco Olha essa bolsa @barbaranahara

souzabs @manueladomingues

alldreamspa Maquiagem profissional a domicílio. Agende já!

caaroicostaa @vasconcelosesther tb n curto n

southerncrossapparelgirls Love it!!

vipturismoparis Bienvenue

giberdin @juliamaculan

Add a comment...

byhelenabordon — Follow

492 likes — 16w

byhelenabordon DOSHOW CARAMELO! Última chance de comprar um dos nossos óculos com 10% off! Cod. Promocional: diadosnamorados 🖤 #shopnow #shoponline #byhelenabordon #helenabordon

mood_store = @flaviaslima

rosproesser E onde encontro???

byhelenabordon @rosproesser no nosso ecommerce www.byhelenabordon.com

lvlovemakeup Whats up friend! Check GetInstaFollowers.org ⬅⬅⬅ to get 400 friends on your IG every single day! It's freakin sweet!

rosproesser Obgda pela atenção...

xpattymedeiros Amanhã à promoção está valendo?

suvaalbuquerque 😂😂😂

Add a comment...

Milan Fashion Week essentials:
Gucci Ghost bag and Louis Vuitton wheelie bag.

GLAMOUR

#DIETA DO MOMENTO

Fama Fortuna Followers

#TOPMODA

·REDES SOCIAIS

helenabordon — Fo...

4,726 likes — 5w

helenabordon E a capa para assinantes 😍😍 @glamourbrasil | @gil_inoue , editora de moda @kvilasboas , beleza @maxwebertotalbeauty e um obrigada especial para @monicagsalgado @adribechara @danielafalcao1 | espero o tag de vcs 💕 #HBnaGlamour #glamourdesetembro | Look @gigcouture |

view all 44 comments

fashionbysegovia 😍😍😍

giovaninapontess Que capa lindaaaaa

patlishak Acho@que foi a maquiagem mesmo @naybc_... Misturado com luz errada...

ivychuckchuck Esta capa está horrível.

stylebrasilien Na minha opinião, essa é a...

Add a comment...

@helenabordon on the cover of
Glamour Brazil.

Maria Hatzistefanis
Rodial.co.uk
@mrsrodial

"Lon/NY/LA ▪ Founder of @rodialskincare @nipandfab ▪ Guest Mentor of TV show #ProjectRunwayStartup @lifetimeTV."

BEAUTY ISN'T SKIN DEEP, BUT IT CERTAINLY STARTS THERE.

Luckily, that's Maria Hatzistefanis's specialty. The forty-five-year-old entrepreneur is the founder of England's leading skincare line Rodial. Her products are carried in high-end stores the world over—from Harrods to Saks Fifth Avenue to the New York City boutique Space NK—and are coveted by celebrities and models alike. Although Hatzistefanis is Greek by birth, decades living in London have given the beauty guru a British point of view. You know the type: elegant and refined, but with a sharp sense of humor.

SoHo, New York,
September 2015

" You are such an inspiration as a successful business woman. ♥ your Instagram page, you motivate me to want to work hard and be a great woman in business. "
—@lousaibel

"I got my MBA from Columbia University in New York," Hatzistefanis says. "After which, I felt a lot of pressure to go into banking or consulting. It can be incredibly difficult to pass up the money and security of a 'normal' job. It's a question every young entrepreneur and blogger must face: whether you can sacrifice comfort to start something of your own."

At first, Hatzistefanis took the path more traveled. She accepted a position in finance at London's Salomon Brothers. "But," she says, "there came a point where my job wasn't interesting or exciting anymore. I quit in 1999, and started Rodial skincare from the extra bedroom of my flat."

As with any startup, Rodial's first years were difficult. Given this was pre-Instagram, pre-Facebook, and even pre-MySpace, Hatzistefanis was left to promote the brand the old-fashioned way. "Things are different than when I started sixteen years ago," she says. "Back then, you had to do things the hard way, had to send physical product to publicists and pray they would give it to a celebrity. Had to pick up the phone and beg magazines for placements." Then, in 2005, she got her big break.

"I got a call in 2005 asking to provide Rodial products for the gift bags of an Oscar after-party," she says. "Soon, we were in the hands of Angelina Jolie, Jennifer Aniston, and Tom Cruise. That changed the game forever."

Twelve years later, Rodial is in thirty-five countries and two thousand stores. Hatzistefanis continues to expand her line—launching makeup in 2015—but her personal focus has shifted to digital media.

In the past few years, Hatzistefanis has relaunched the Rodial website five times. She pays close attention to emerging trends in user experience. She's also created her own YouTube, Twitter, and Instagram accounts to build a following for herself as an individual.

"The best thing I've ever done was to create the 'Mrs. Rodial' handles across social media to follow my life. I now have even more followers than Rodial."

★ HIT LIST ★

- Founded Rodial skincare in 1999.
- Has an MBA from Columbia University.
- Enlisted Kylie Jenner to launch Nip + Fab.
- Her first job was at *Seventeen* magazine.
- Maria is a mentor guest star on the show *Project Runway: Fashion Startup*, alongside four judges, including Rebecca Minkoff.

The largest push for Hatzistefanis's personal brand, Mrs. Rodial, came from Instagram—which has grown to over 420,000 followers.

"I'm 200 percent focused on Instagram," she explains. "In the modern age, visual communication is undeniably more important than verbal communication. You can say so many things with one picture, so I use Instagram as a way to channel my inner creativity. Everything on the Mrs. Rodial account, other than pictures *of* me, are ones I've taken myself."

But she isn't using social media to target Generation Z, like so many others are. She's not going to turn them away; her focus lies elsewhere.

"Everyone uses social to reach twelve- to twenty-two-year-olds," she says. "But what about that twenty-five-to-forty-five demographic? They're on all these platforms, too—but they're not being serviced."

Hatzistefanis lays awake strategizing ways of reaching this important demographic. "So many people think working for yourself means less work," she says. "That's crazy. When you're starting a company, you have to do everything yourself. Finance, accounting, Web design—you have to learn it all. People starting out should know it isn't glamorous. Glamour comes with time."

Crosby Street Hotel,
SoHo, New York,
September 2015

Crosby Street Hotel,
SoHo, September 2015

**" You're so lucky you enjoy your work so much,
you are doing something you love, you're
the boss and don't have to answer to anyone else. "**
—@clairehoare

@mrsrodial

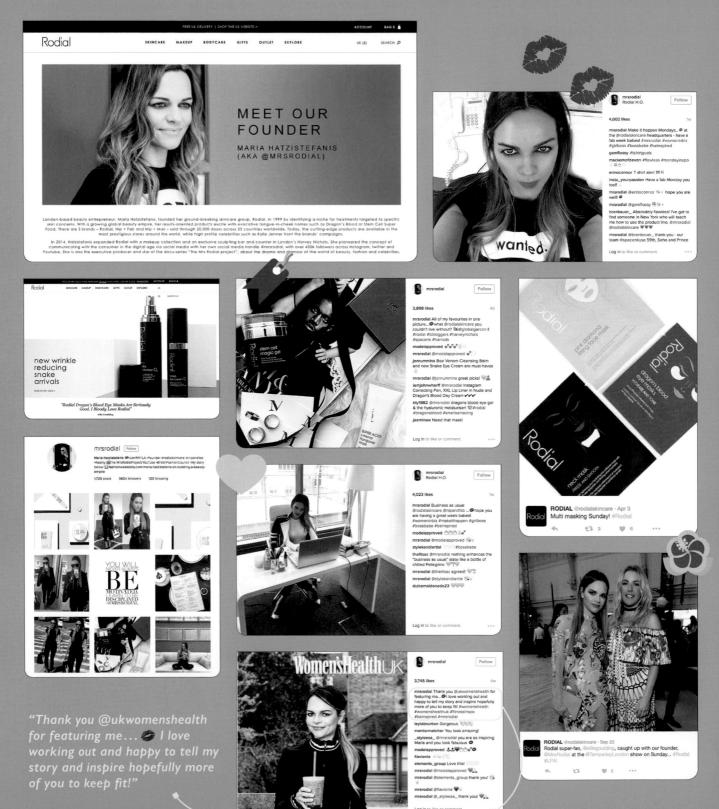

"Thank you @ukwomenshealth for featuring me... 💋 I love working out and happy to tell my story and inspire hopefully more of you to keep fit!"

"Hatzistefanis's huntress instincts for finding exotic ingredients has kept her in the spotlight, and has built up enough demand that in 2010 she decided to launch an offshoot brand, Nip & Fab, for the drugstore masses." —VANITY FAIR

"Speaking at the V&A museum... 💋 #MrsRodial #BeInspired #GirlBoss #BossBabe."

Barbie Ferreira

@barbienox
@boredbarbara

"✨ 🌹 🗝 model/bo$$ wit wilhelmina ny 💸 🌹 ✨ ."

ALMOST TWO MILLION PEOPLE HAVE WATCHED A YOUTUBE video interview with twenty-year-old model Barbie Ferreira. The thirty-second short—really more of a clip—is from Ferreira's 2016 campaign for Aerie. Why is this remarkable? Because unlike many successful models, Ferreira has a stunning curvy physique, and unlike other advertisements, Aerie's was 100 percent unretouched. Shocking? Maybe to outsiders, but to Ferreira and her some three hundred thousand Instagram followers, the images of her body in swimwear and lingerie were nothing out of the ordinary.

"When I started modeling, before I was signed to Wilhelmina, all my work was very real," Ferreira says of her appearances in fashion magazines and New York–centric zines while she was in her late teens. "No one ever Photoshopped me—we were really passionate about that, especially the artists I still work with like Petra Collins. She definitely never retouched me."

Hotel Hugo, New York,
March 2016

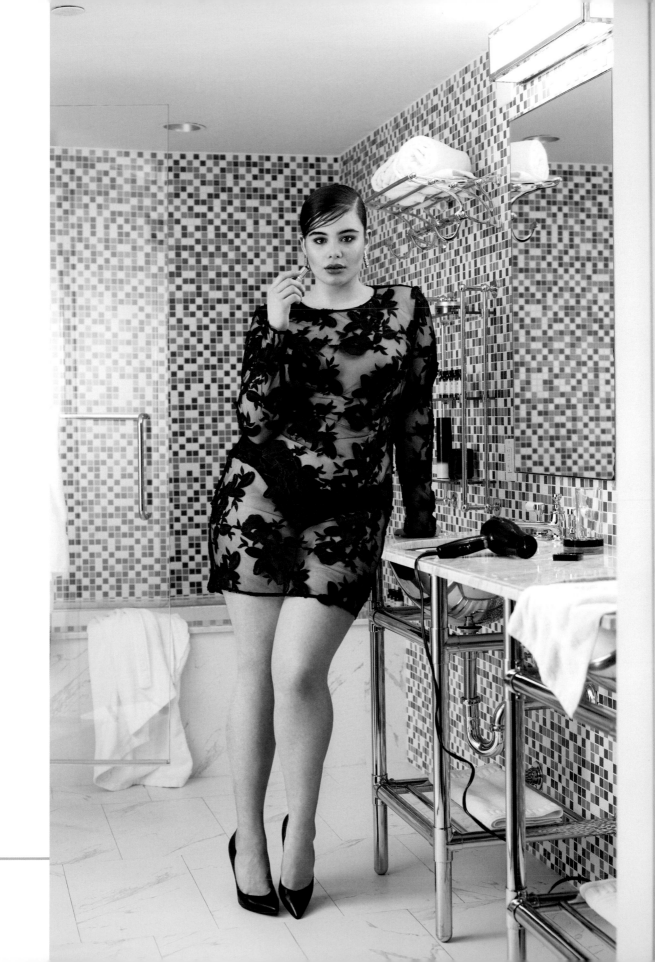

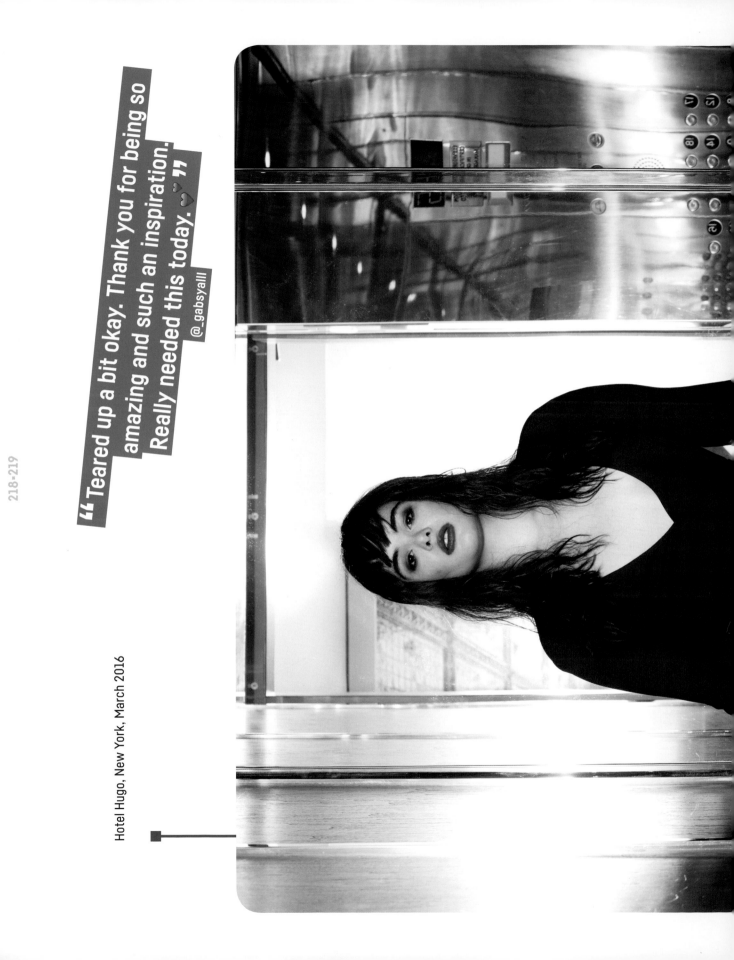

" Teared up a bit okay. Thank you for being so amazing and such an inspiration. Really needed this today. "
@_gabsyalll

Hotel Hugo, New York, March 2016

The Aerie campaign made the New York native into a star known the world over—"My mom would send me articles from places like Thailand and Costa Rica!" she exclaims—but Ferreira's international acclaim was a long time coming. As one of the youngest Digital Girls in this book, she's been gaining online traction for years.

"In terms of social media, I feel like I started off like any other high school student. I was blogging, too, before I had Instagram or anything like that—I think that also helped," she says, noting that her early Tumblr was a collage of her personal life, images that inspired her, and funny jokes. "I've always been on the Internet and I never, ever thought it would become a career. It's been a really pleasant surprise."

That surprise came in 2014, when Ferreira responded to an open call for American Apparel. She e-mailed a selfie to the brand and the next day a representative responded asking her to become one of its models. From there, she was introduced to Collins—who also moonlighted as an AA model—and began to rise through the ranks, appearing online in *Rookie* magazine and in an *ELLE* photoshoot lensed by Collins. By 2015, she was signed as a model at Wilhelmina.

"I never thought I would be a model just because I never thought I was tall enough, proportioned enough, or thin enough to be a straight-sized model, so it hadn't really crossed my mind," Ferreira says. "I always really loved acting. That was my number-one priority always as a kid. I used to have a commercial agent and was really focusing on studying Meisner technique and things like that. I went to classes three times a week after high school."

Still, modeling came calling. As Ferreira was first breaking through, she was labeled a "plus-size" or "curve" model—both terms fraught with negative connotations. "At first I was really neutral about it. I didn't think there was anything wrong with the word 'plus-size' I never

thought there were any bad connotations," Ferreira begins. "But the more time goes on, I realize that those words are just meant to put you in a box and limit you from all the jobs, all the progress you want because of your body. I call myself a 'model' and I don't say I only want to model for curvy girls. I want to model for every type of body or speak to every type of girl or person. Being confident in yourself is something that people of all shapes, sizes, and gender identities should aspire to."

Being a Digital Girl has helped Ferreira find that confidence herself. As an only child who moved from her native Queens, New York, to a suburb in New Jersey before high school, she took solace in online communities. "I have a single mom, I don't have any brothers or sisters, I don't have any cousins. My family is just me, my mom, my aunt, and my grandma, so I needed people that I could relate to and I wanted to talk to people who liked the same things as me," Ferreira says. "I 100 percent think the Internet has always been there for me. It was a very helpful part of my life."

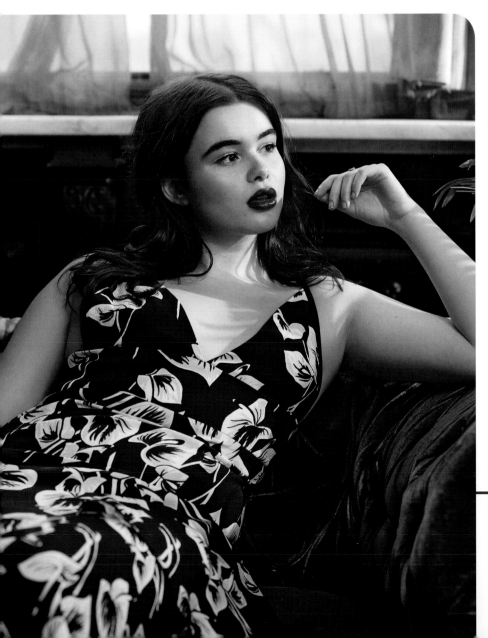

The Jane Hotel,
New York,
March 2016

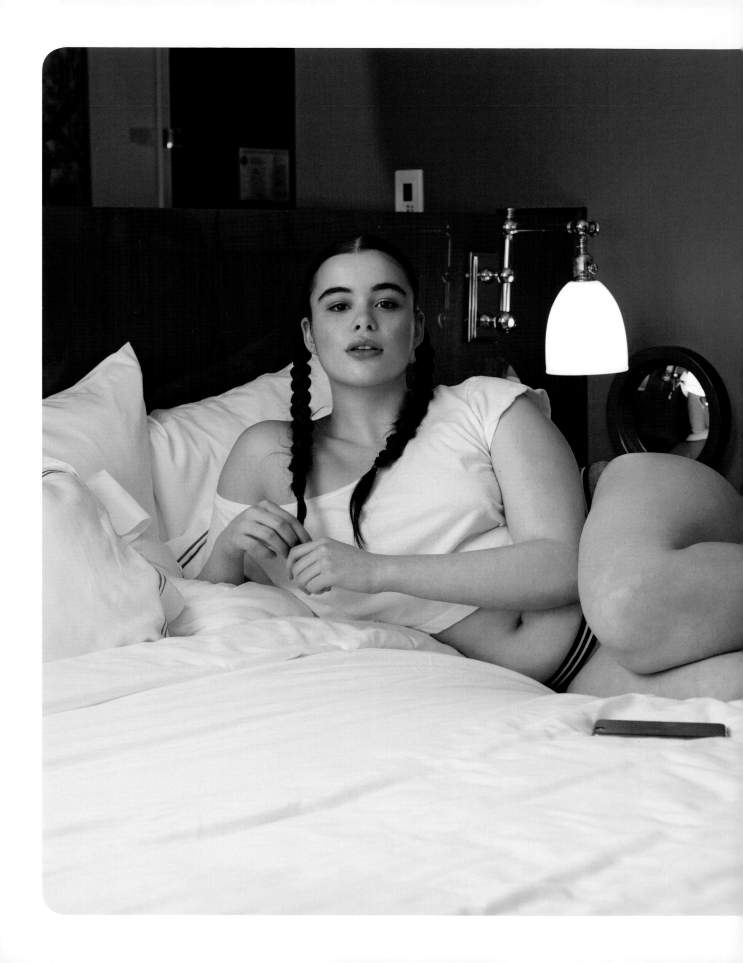

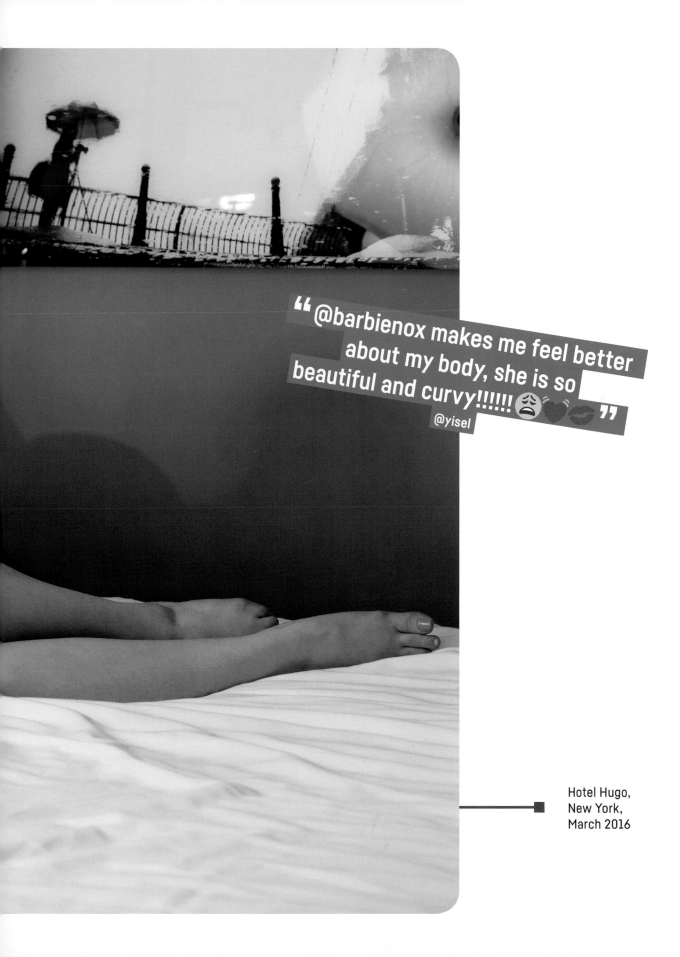

"@barbienox makes me feel better about my body, she is so beautiful and curvy!!!!!! 😩🖤💋"
@yisel

Hotel Hugo,
New York,
March 2016

@barbienox

BARBIE FERREIRA, 19

Model, Body Positivity Advocate & Self-Proclaimed Bo$$ @barbienox

barbienox

Follow

4,048 likes
5w

barbienox Under 20 in this bih. Check out @refinery29 's snap ♥♥ #thezlist
barbienoxfans ♥♥♥
jamiekrakower ♥♥♥
brooks.anna ♥♥♥
tanbarbie Just found you from that article!
linafirat same @tanbarbie
erinecunningham 🖤🖤🖤🖤🖤
erinecunningham #thezlist
melisskot You are killin' the game !! ♥♥ ♥♥
christianriverabjj Can I just marry you ? @barbienox
dandelionyewi love love love
katethegrate88 Today I discovered you through this snap and I am so glad I did! You are so beautiful and looking at you

Add a comment...

barbienox

Follow

12.7k likes
3w

barbienox I'm a very gigantic woman sometimes. what a strong group
view all 109 comments
kelsyarden Fuck, you're a goddess 😍
ondanuclear Please stop being so gorgeous I wanna die
annaballins I can't take a photo with Petra cuz I'm always shrek and she's Fiona (pre ogre)
zube.ii.da 😍😍😍😍
joilurrie._ @saschagantz not as fat as her stacks
josiemjharris @nadine_osman woah
bettypaige92 @swampspells
assilemavliss @saschagantz holy fuck ur albino
swampspells @bettypaige92 omg where can I find all of these outfits

Log in to like or comment.

burbie @boredbarbara · Sep 7
CONCEPT: FAT GIRLS IN WORKOUT CLOTHES ON BILLBOARDS. LIVING

231 1.1K

barbienox

Follow

12.9k likes
12w

barbienox COME N GET IT 👅👅👅
view all 59 comments
fakeassbitchjojo @graywhiteside
sandridingen Oh I really adore your vans they are so cute!
akbar_khadafi_khan I choose in mid very cute blonde hair
betterforliving 💚
babygirity420 Mom
alptbdr Marry meeee
xoxomoonie You in your Adidas lol @b.jorgette.r
b.jorgette.r @xoxomoonie yaaesss
jazvelez U guys r damn sexy

Add a comment...

barbienox

Follow

10.3k likes
7w

barbienox @its_meandyou x @bingbangnyc
mim.girl96 Love ya
erin4acre @goongurlsgo2hvn
couturesquemag Dream team
lomaho ILYSFM
bingbangnyc 💜💜💜💜💜💜💜
justinsofresh 💯
deathbyfalafel @kylleanneshea we need this jacket
johnjohn.exe This is definitely a @petrafcollins shot. Love it.
angiezadawgzki I miss these kind of shoots :/
aysenurcaki Bad bitch 💞 @bermoz
sabrinajeblaoui.photography 💕
goongurlsgo2hvn 💕💕 @erin4acre

Add a comment...

barbienox

Follow

12k likes
70w

barbienox last summer in @its_meandyou 🤙🤙
view all 277 comments
paolar4 @kathrivers 🙌🙌🙌
catacorb @camila.rojasamaya
tashamckim @acmackender like her a lot
sergiorozco14 Dios mio!
malody Mein body 11 @moodjay
dz_g123 @sev23inc порно актриса что ои
calt_me_maria @sev23inc @dz_gulshan бля ебанутые вы
dz_g123 @calt_me_maria пошла нах
albabvb @mariana_f20 @mariagli_82 @carmenloopez_
licool_c @cassanova.joe new girl crush
stephanie.mp3 her stomach is

Add a comment...

"Barbie will post photos celebrating her body, calling attention to the industry's double standards....and the fact that she's killing it regardless." —TEEN VOGUE

burbie
@boredbarbara
YA IM PRITTY BUT IM LOCO
📍 wilhelmina ny
🔗 instagram.com/barbienox
📅 Joined February 2012

TWEETS 7,238 · FOLLOWING 364 · FOLLOWERS 78.4K · LIKES 11.5K

Tweets | Tweets & replies | Media

burbie @boredbarbara · 2h
Queen

★ boy @FUCCI
Fenty Puma.

burbie Retweeted
Rembrandt Duran · 16h
Second verse of Best Friend by 50 Cent might be most romantic shit I ever heard in my life

[Verse 2]
While you in your bubble bath I'll come wash on your back
When you puttin your lotion I can help you with that
I sit and think of things to say that may make you smile
Or give you gifts from my heart to reflect my style

7 Followers you know

656 Photos and videos

Who to follow · Refresh · View all
GQ Magazine @GQMaga...
Eva Chen @evachen12
Leandra Medine @Leandra...

Find friends

Trends · Change
#NationalDrinkBeerDay
South Carolina 44.7K Tweets
Alec Baldwin 5,105 Tweets
#WednesdayWisdom
Gary Ginsberg 2,275 Tweets
#FENTYxPUMA

burbie
@boredbarbara

Lewks

RETWEETS 21 · LIKES 321

8:46 AM - 18 Sep 2016

📍 Paris, France

21 · 321

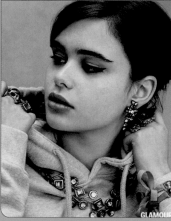

burbie @boredbarbara · Sep 8
121 · 899

barbienox · Follow
6,137 likes · 46w
barbienox Good morning
babycatzx Palm Springs is life
okhanor This would make a great painting
agalarova.aya Охуенна!
waldoethan Morning!
sweaterrpirogova @agalarova.aya о,рашка ёпта!
elmiraleonova АХАХАХАХ из рашки
solovey.3razboynik21221 РОССИЯ
sofi_burger Раииисяяя
__yuliyasergeyevna__ РОССИИИЯЯЯЯ !!!!!!!!!!!!!!!!!!1
misha_lemann ВСЕМ РОССИИ!!!!!
spookylyz Can we meeeeet
a.nnieb
Add a comment...

barbienox · Follow
13.7k likes · 11w
barbienox In the August issue of @glamourmag in a lil @vetements_official n fancy jewelry . Check it out !! There's a video too, I'll keep you guys posted 😊
view all 51 comments
shehabtakashi 😍😍
elpugo 👌👌
spookykierstyn DAMN B 👌
niaisasquare Too good
shehabtakashi 🙌
aracxlls MA YES WHATTHE FUCK
mannyshred Fly
bumblexo Ultimate brow goals
chloeducloser @wemaminaj
eliswnda love❣
christinalotr @shirinzaidi do it
the_golden_c This jewellery ❤❤❤
Add a comment...

barbienox · Follow
9,851 likes · 10w
barbienox Georgia o'keeffe x @petrafcollins x @tate live on @voguemagazine rn 😊
h0tgirlseatingpizza So beautiful
lunacrecient3 LOVELY
ashpalacios I LOVE
benjgrams 👑 So Pretty 👑
didisea Love 🙏
tatianaabell slay!!
glowormgirl Fav
omarrahmed YAAAAaaaasz @barbienox @petrafcollins 😍
sarahcullum Loveeee
lilafae Gorgeous
yasminmoonmoon
thisismayan 🌹
somekidfromthe90s Giving of vibes for
Add a comment...

On the cover of @idolmagazine

Featured in @glamourmag

Charlotte Groeneveld

TheFashionGuitar.com
@thefashionguitar

"Founder and editor TheFashionGuitar.com / mother in chief James and Stella / 🎤 ✈️ 🌐 /."

ON THE SECOND FLOOR OF A RED BRICK BROWNSTONE, fashion blogger Charlotte Groeneveld chats animatedly from behind a rack of clothing. Her conquest? A pair of bright-green, patent leather Valentino's that will go "perfectly" with today's outfit. As the founder of The Fashion Guitar, Groeneveld, who is Dutch, posts photos of her looks several days a week.

"The funny thing is that I never thought I would work in fashion," says the thirty-two-year-old. "I actually started my career in the financial industry, working in corporate communications. But then I was up for a job at a bank in London one day, and I didn't get it—some Harvard kid probably swooped in and stole it. It was the best thing that ever happened to me, because it led me to a temporary job in online marketing for ASOS—my introduction to fashion."

Groeneveld describes her love for fashion as "instant," inspiring the one-time banker to brainstorm a creative project of her own. The result: a personal style blog called The Fashion Guitar, which she launched in London in 2010.

With Stella and James outside their home,
West Village, New York, June 2015

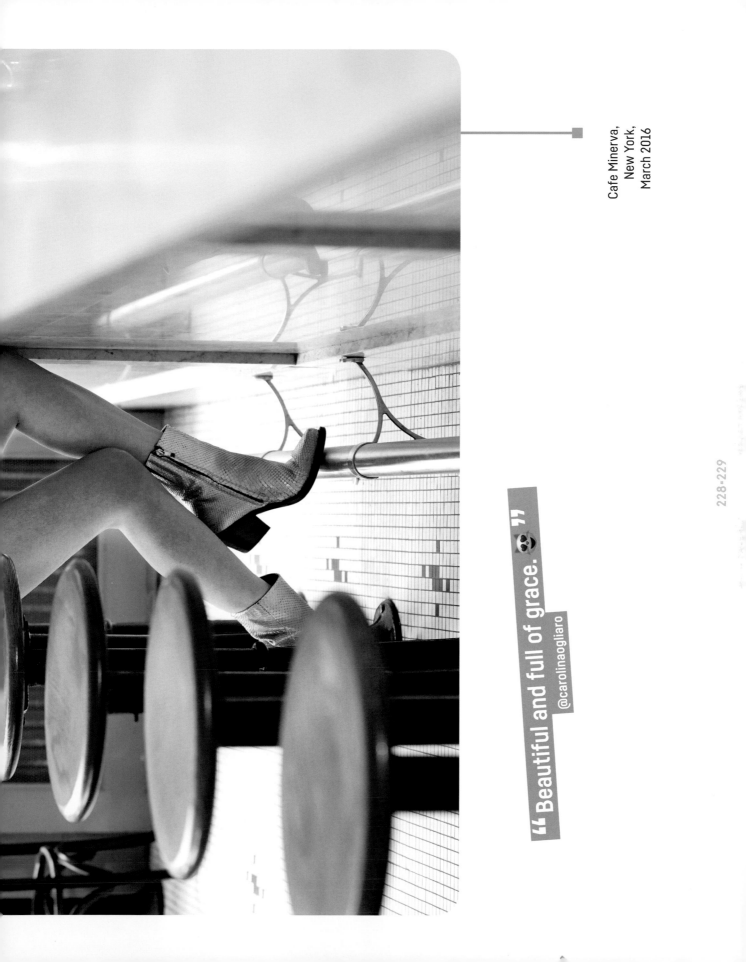

" Beautiful and full of grace. 💀 "

@carolinaogliaro

Cafe Minerva,
New York,
March 2016

"The Fashion Guitar took off almost immediately," she remembers. "Mostly because my job at ASOS had taught me how to master social media. Social media wasn't what we know now. It had just started to take serious forms. I never really focused on Facebook or Twitter, even though Facebook is still very popular in Europe. Instagram, however…I've got Instagram down to a science."

Like any Digital Girl, Groeneveld treats her Instagram as a thriving business of its own—something that could easily function without The Fashion Guitar website.

"I make sure to post every three hours," she says. "It doesn't matter if it's a holiday, weekend, whatever—I'm posting. I post often enough to be on people's minds, but not so often that it's annoying. I find that a lot of influencers overdo it with Instagram—over-posting is the number-one reason fans hit 'unfollow.'"

Outside
Proenza Schouler
Fall/Winter
2016–17 NYFW,
February 2016

Groeneveld's biggest challenge came in 2014, when her husband Thomas was offered a position with HSBC in New York City. While the opportunity to relocate with their children was certainly exciting, Groeneveld was tasked with raising two toddlers *and* restarting a fledgling business in a new country.

"I had built something in Europe," Groeneveld says. "I had a loyal following. And then, all of a sudden, I had to communicate with those fans from three thousand miles away, in a completely different time zone. It wasn't easy."

Cafe Minerva,
New York,
March 2016

One of the largest hurdles for Groeneveld—something fellow Digital Girl Chiara Ferragni also references—is the difference between European and

American fashion. A post that would be a slam dunk in London, or even Milan, might not translate to the more casual American audience.

"My style in London was a bit grungy," she says. "More leather jackets and jeans. London is a place where it feels that the weirder your outfit is, the more attention you'll get—especially during London Fashion Week. It's almost not even about fashion. New York is a completely different game. It's all about fashion, and about translating the latest trends into your personal style."

Groeneveld has found a way to thrive in New York City, incorporating American fashion without disenfranchising her European following—all the while staying true to her personal style.

"Europeans dress differently," she maintains. "People [in New York] are so on trend. The best thing I could do was to take inspiration from all the places in which I've lived—Holland, Singapore, England, and now America. And it's funny, because, over the past year, New York has become my favorite place for fashion."

Now that she's got New York—and two toddlers—under control, Groeneveld relishes the chance to breathe, and to look back on The Fashion Guitar's emerging years.

"It was always important to me to invest in the best," she remembers. "Whether that's a photographer, camera, lights. I've struggled with the amount of photos to share per look, but as it turns out, people always love to see more. Don't overdo it, of course, but if you have ten really cool shots, post ten really cool shots!"

★ HIT LIST ★

- Born in a small town in The Netherlands.

- Worked in the financial industry.

- Is a mother of two.

- Loves mixing high street and luxury fashion.

- Uses Glossier Boy brow to get those perfect arches.

- Calls Leandra Medine her style icon.

TheFashionGuitar.com

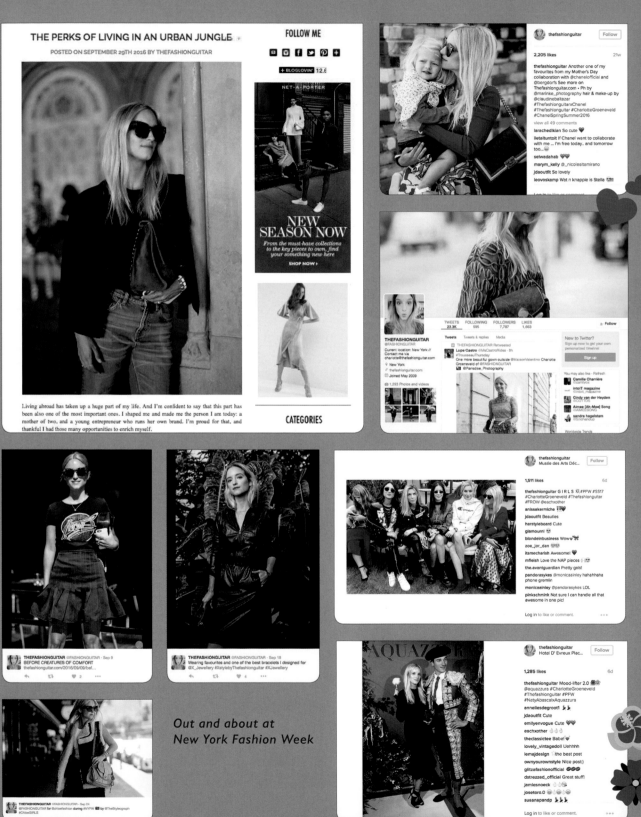

THE PERKS OF LIVING IN AN URBAN JUNGLE

POSTED ON SEPTEMBER 29TH 2016 BY THEFASHIONGUITAR

FOLLOW ME

+ BLOGLOVIN' 12.6

NET-A-PORTER

NEW SEASON NOW

From the must-have collections to the key pieces to own, find your something new here

SHOP NOW ›

Living abroad has taken up a huge part of my life. And I'm confident to say that this part has been also one of the most important ones. I shaped me and made me the person I am today: a mother of two, and a young entrepreneur who runs her own brand. I'm proud for that, and thankful I had those many opportunities to enrich myself.

CATEGORIES

Out and about at New York Fashion Week

A SHORT HISTORY OF HAIR

POSTED ON APRIL 4TH 2016 BY THEFASHIONGUITAR

Hair is a delicate matter. Once you screw it up, it's a long way back. I had my fair share of screw-ups, and looking back at my hair-history, I wonder how it's possible I still have hair on my head. No, I'm kidding, but I do admit that over time I learned more about my hair and how to treat it. So truthfully, I can't and I won't tell you anything about the history of hair in general – as the caption of this article might let you to believe – but what I will do is tell you a little more about the history of mine, and hopefully help you getting to your "perfect" hair sooner than I did…

See more

18 COMMENTS

DOWNTOWN CHIC

POSTED ON JUNE 22ND 2015 BY THEFASHIONGUITAR

Every now and then I've the opportunity to wear some amazing pieces from brands I love most. I've always desired wearing those brands, but never had the budget nor really the access to them. Working with the brands I love has always been one of the main goals of my blog. Building relationships with them, and create beautiful content together. Having that said, I also try to *never* forget that a perfect look should in my opinion has to have something affordable, and something desirable. That way we can go shopping, *and* keep something to dream about…

See more

29 COMMENTS

FASHION WEEK BEAUTY PREPARATIONS

POSTED ON SEPTEMBER 30TH 2015 BY THEFASHIONGUITAR

I can't believe Fashion Months is almost coming to an end. The last leg, Paris, is always the most exciting one for me, so I'm making sure that I arrive well rested and relaxed. Part of this process is treating my mind and body with care. Taking a little extra time putting on my day creme, maybe applying my favorite face serum with some extra care, and creating the most relaxing home environment.

See more

20 COMMENTS

"What sets The Fashion Guitar apart is her loyalty to the 'real-factor,' which shows up in her commitment to staying truly authentic." —VISUAL THERAPY

thefashionguitar — Follow

1,760 likes — 7w

thefashionguitar is the top distracting enough to not see the mess on my desk 😊 #CharlotteGroeneveld #Thefashionguitar #ThatsAmore #DolceandGabbana #Portofino

eastcostboho Super cute!!

amandastas You look adorable!

nadine_schmitt_ 🖤🖤🖤🖤

hi_itsgabby 🖤this!! Xx

thefashionguitar See you in NY during FW?! ❤️ @hi_itsgabby

nylon_threads Haha! So so cute 🖤

thebloomingbouquet Du süsse 😍🖤

lisa_mq 💚💚💚

sparklepiece 🖤🖤

summerofdiane Adorable top! 😍

violettedaily So cute!

Log in to like or comment.

thefashionguitar
Dream Downtown — Follow

2,716 likes — 3w

thefashionguitar Something blue 🤍 Celebrating #JimmyChoo20 with @jimmychoo and @netaporter last night in New York #Thefashionguitar #NYFW #CharlotteGroeneveld

livingnotes Prettiest girls! Charlotte, you look STUNNING!

tiendaredcarpet 🖤

guttaperca 😍👌

iam__vivi ♡♡

margauxduffort 👏👏👏Perfect 👌

rebecca_jon U have the best style Charlotte

sparklepiece 💚💚

natakar Two cuties !!

fieldsofharper Fab

cathy_elegant 🖤

dreamhotels

Log in to like or comment.

THEFASHIONGUITAR @FASHIONGUITAR · Sep 20

Proud of my new bracelet for @X_Jewellery in #SS16 favorite: lilac 🤍 #XstylebyThefashionguitar #XJewellery

"Proud of my new bracelet for @x_jewellery in #SS16 favorite: lilac."

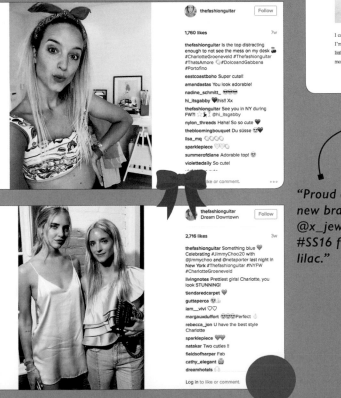

❤️ 1

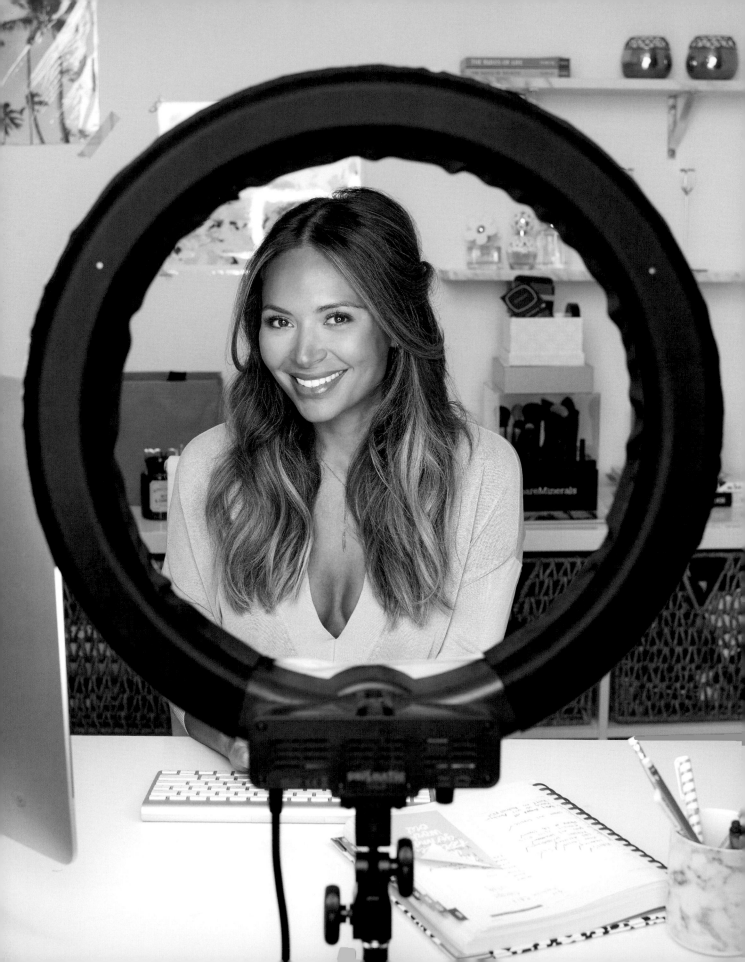

Marianna Hewitt

LifeWithMe.com
YouTube.com/MariannaHewitt
@marianna_hewitt

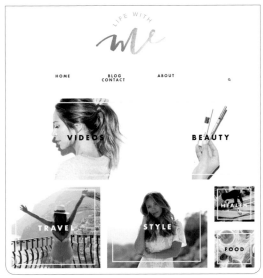

"Marianna Hewitt is a TV host turned lifestyle blogger sharing her personal style, beauty tips, and travel adventures. Her how-to video tutorials connect with viewers by giving them beauty coverage they can use all year round."

WHEN MARIANNA HEWITT—THE YOUTUBE STAR AND BLOGGER

behind Life With Me—flings open her door in West Hollywood, the first thing you notice is her size.

"I know," she says. "I'm *so* short. I'm just good at hiding it on camera, so people never expect it!"

At the age of thirty, Hewitt has spent a decade perfecting videos that always put her best foot forward. *Harper's Bazaar* even tapped Hewitt for a column.

Her studio, Beverly Hills, August 2015

Marina del Rey, California, April 2016

" Stunning!! You are such a big inspiration to many people because you are a girl boss! You have built yourself an empire @marianna_hewitt! Congrats you deserve it! "

@itsmishale

"Growing up in Ohio, I wanted to be a TV host," Hewitt explains. "I used to walk around my house with a video camera, interviewing my family. It wasn't a question that I would major in broadcast journalism at Kent University, and then I moved to Los Angeles right after."

Hewitt's first job? On-air talent for ModaMob, a fashion and beauty website that's now a subsidiary of AOL, which she scored in April 2013. Her beat was fashion news, which not only enabled Hewitt to hone her camera skills, but also led to a wonderfully hilarious reel interviewing stars on the red carpet. (Pro tip: it can still be found on the "About Me" page of her blog.)

"The idea of starting my own YouTube channel was daunting," Hewitt remembers. "Which is something I hope my fans understand—that I, just like them, was overwhelmed to start something of my own. I literally gave up."

Taking a different approach, she asked her bosses at ModaMob if they would allow her to contribute beauty content to the site. "I said, 'Let me do *one* video and I can prove it to you,'" Hewitt says. "So they let me do one on the perfect bun. It got a million views in a week."

"You're soooo fabulous! You inspire me everyday and I sincerely mean that. I really hope I can get to your level of content creating/creative work and design. @xchristinengo

★ HIT LIST ★

- Has five tattoos.
- Is a perennial morning person.
- Has a dog named Baby.
- Her favorite album is *Confessions* by Usher.
- Her favorite nail polish is Essie's Ballet Slipper. (She's worn it since December 2008.)
- Rarely wears prints or colors.

Marina del Rey,
California, April 2016

Aware of the rising talent in their midst, ModaMob reassigned her to DIY beauty content. It was a good launching pad, but in the end it wasn't the right fit.

"I did it for a while, and there are advantages to working for an established company," Hewitt says. "But the work will never truly be yours. You still have someone telling you what content you can and cannot create. If you want to be authentic to yourself, you need to work for yourself."

Hewitt quit her job in April of 2015, focusing instead on her personal brand.

"The hardest thing I've ever done was explaining to my seventy-year-old father that I was quitting my secure job to become a professional blogger," she says. "He couldn't see it as a career. The first moment he got it was when the *New York Times* wrote a story on the incredible power of digital influencers. They called me out specifically, referencing a Botkier bag I wore to Sundance. One day after I posted it, the bag sold out, and that was a language my dad understood."

So how has this blogger, and one who got a late entry in 2015 at that, arrived at a point where she can make or break a bag?

"I'm incredibly aware of my audience," Hewitt emphasizes. "And my audience varies drastically from platform to platform. I know, for example, that YouTube fans want me to look super glam. They want DIY beauty tutorials that can be replicated right away. My blog is better for outfit recommendations. And Instagram? The most important thing about Instagram is to post frequently, remembering that 64 percent of Instagram traffic comes from outside the United States. You need to post at all hours of the day, not just when you're awake."

Hewitt's best piece of advice is analog. It involves, of all things, an actual calendar.

"That first post is the *hardest* part," she says. "But you just have to do it. So you know what I did? I posted on Instagram that I was launching my blog on February 1, 2015. I forced myself into a date, and it was the best thing I've ever done."

"*Armed with serious determination (and her OG makeup brush), Marianna's next mission will be to build a women's network to help young girls find confidence and chase their dreams.*" —MARIE CLAIRE

At home,
Beverly Hills,
August 2015

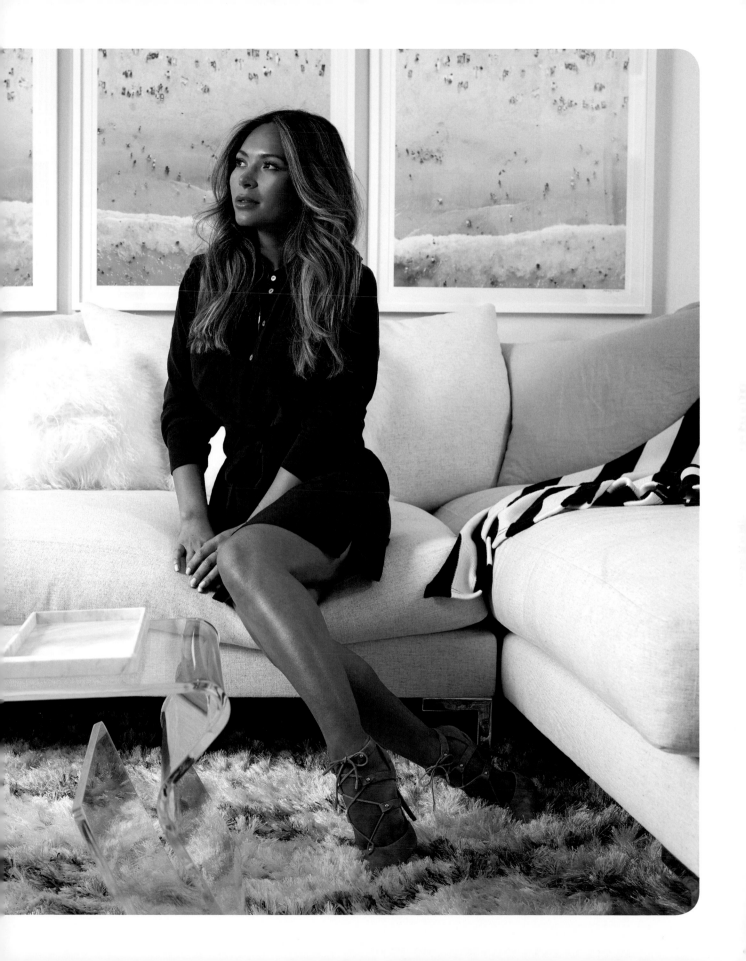

LifeWithMe.com

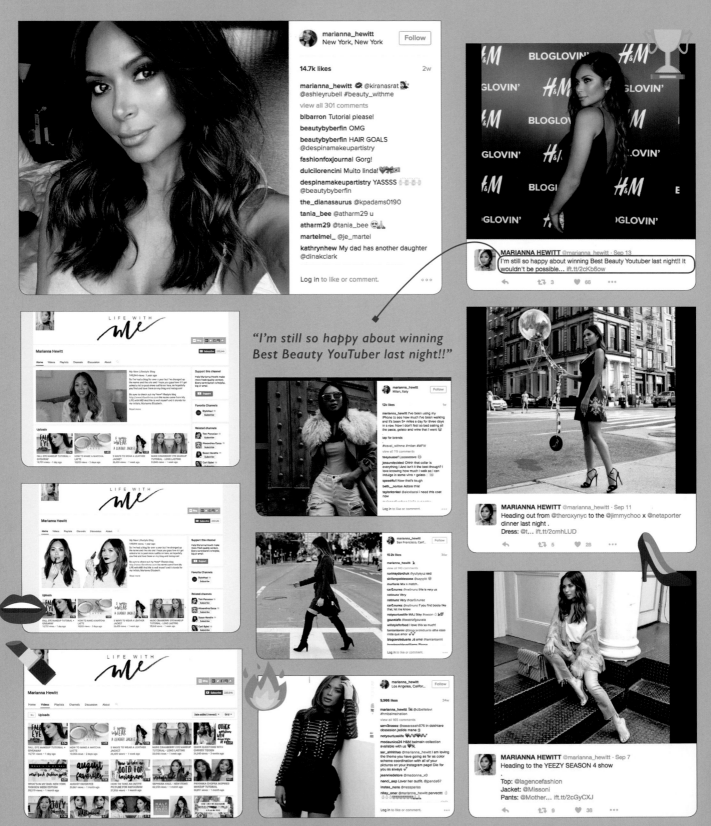

"I'm still so happy about winning Best Beauty YouTuber last night!!"

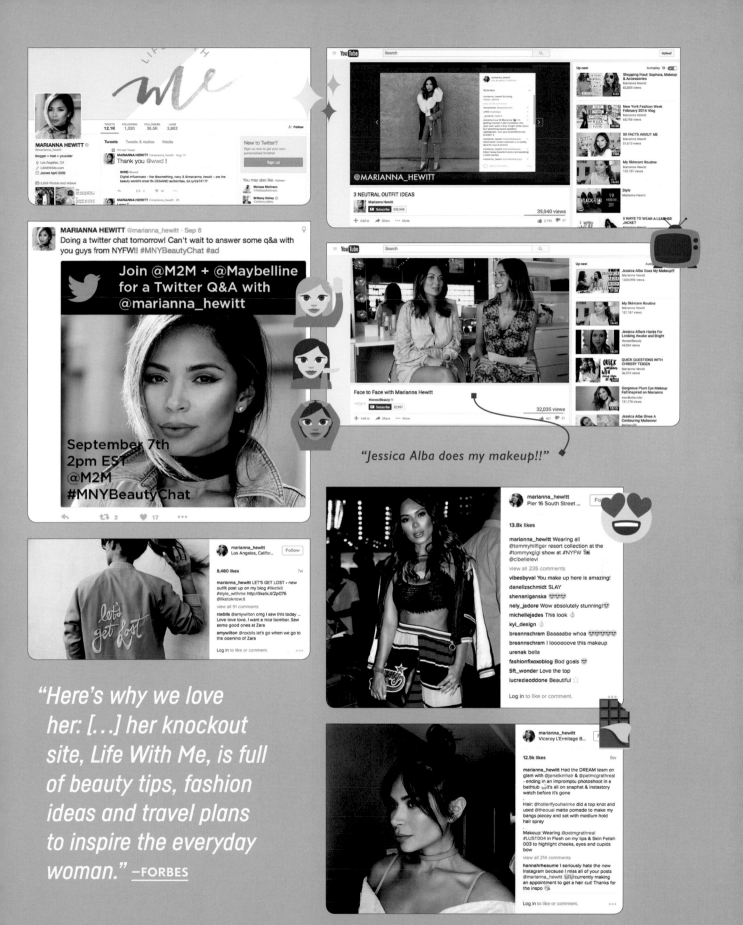

"Jessica Alba does my makeup!!"

"Here's why we love her: [...] her knockout site, Life With Me, is full of beauty tips, fashion ideas and travel plans to inspire the everyday woman." —FORBES

Vanessa Hong
TheHautePursuit.com
@thehautepursuit

" ✖ *Creative director, @thpshop.co*
✖ *founder, thehautepursuit.com.*"

IT'S RAINING OUTSIDE AS VANESSA HONG SHUFFLES THROUGH

suitcases in New York's Hudson Hotel. The thirty-two-year-old creative direc-
tor of The Haute Pursuit is flipping through piles of expertly folded clothing,
considering options for today's shoot. Chanel bags and faux fur stoles fly
through the air, making it clear this star is no traveling ingenue.

"I divide my time between Beijing, New York, and Toronto," she says, set-
tling on a cheeky menswear look. "Like many bloggers, I'm basically a nomad.
My boyfriend used to live in Beijing—and I have an office there—but my team
and my family are still in Canada."

The reason for her visiting Beijing transcends her love for her boyfriend,
who's since moved to Paris. Hong depends on the city—and her Asian heritage
as a whole—as inspiration for the Haute aesthetic.

Bryant Park,
New York,
May 2016

"Everything about Hong screams minimalistic architecturalism; much of her wardrobe is comprised of black, white, and gray pieces, sharp lines, and monochromatic ensembles." —WHO WHAT WEAR

Hudson Hotel,
New York, July 2015

"I've always had a knack for photography," Hong says. "And when I started the blog, photography was my biggest focus. I wanted to have this very distinct, very unique look. Just take my Instagram grid as an example—it's always consistent. It has a common theme of colors and emotions that run through a certain series of squares."

A visit to Hong's Instagram page does, in fact, affirm the consistency of her style. But the photo-sharing platform is only a piece of the Haute puzzle—a puzzle that extends beyond the realm of social media.

"I'm not just a blogger," Hong emphasizes. "I'm a designer, an entrepreneur. My goal is that anyone who touches my brand—whether on social media, the site, or the shop—can expect a certain aesthetic. As my business has grown and changed, I've worked to maintain a definitive theme that stretches to every corner of The Haute Pursuit."

Hong's unique vision attracts more than 560,000 followers around the world. And that's just on Instagram. The work can be exhausting, but Hong's reward came in 2014, with the launch of her clothing and objects collections on THPShop.co. Fast forward a few years, and Haute Pursuit–branded products include iPhone cases, faux fur jackets, and jewelry.

"I always dreamed of designing," Hong explains. "That was my focus, even before I started the blog. And then a few years ago, I realized that having such a huge following could create foot traffic—foot traffic that could lead to sales."

Her strategy is straightforward; it may sound borderline repetitive.

"My best piece of advice is to maintain a consistent aesthetic," she says. "Sure, my style has evolved over the years—but my gut has always stayed the same. I've built an aesthetic that people have come to know. Some people like it, others don't, but the people who like it, *really* like it."

So what's next for this globetrotting influencer? A denim line, and a bigger push into ready-to-wear. And a range of upscale office supplies, called THP Objects, that includes tech covers and stationery. Hong is also turning an eye to Snapchat.

"I think Instagram will continue to outshine Snapchat for a while longer," Hong says. "But in the tech world, everyone's always looking for the next big thing. The next big thing is probably Snapchat, because the moments on Snapchat are real. You can't edit. You can't do any post-production. What you Snap is what you get—and people crave reality. We're all just voyeurs at heart."

★ HIT LIST ★

- Splits her time between Beijing, Canada, and New York.
- Worked in biotech after college.
- Practices Vinyasa flow yoga.
- Turns off her phone every night.
- Loves wearing sneakers.
- Is a lifelong DIY-er.

TheHautePursuit.com

"Such a great time @yahoostyle
w/ @kristincav @mrjoezee :)."

"With her shaggy peroxide crop and architecture-inspired outfits, Vanessa Hong cuts a unique figure amid the oversaturated street-style set." —MATCHESFASHION.COM

"Another perfect photo of @thehautepursuit."

Retro Threads

September 19, 2016

I'm a modern girl with retro inclinations. Having lived many fashion lives before my current one, my wardrobe has literally gone through the decades. Fashion has always looked back, but I feel especially now, vintage is having a major moment. This is a simple outfit I wore the other day with a pair of values 'retro' staples: the perfect wide-leg jean (with a slight bell) and Adidas Gazelle. Oh and this Yang Li jacket. I found this at the last Decor Street Warehouse sale. It's become my go-to flexanse or you can tell, it's very glorious!)

Yang Li Leather Jacket, THPSHOP white tee, Citizens of Humanity Jeans, Adidas Gazelle Trainers, Kasbar Number Two

THP thpshop.co — Follow

1,222 likes — 27w

thpshop.co Venesse @thehautepursuit keeping it casual in the Evi knit dress // Online now #THPLAB
elisebakker_ I love it!!💕
thefashionfraction cool
parth_shah2012 Love that colour block tote, where is that from? @thpshop.co
a_ntipina Bag💕
richmuses Another perfect photo of @thehautepursuit
kellysinnott @amysinnott
prettylavishuk
thpshop.co @parth_shah2012 It's Celine :)

Add a comment...

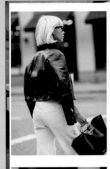

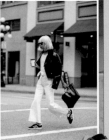

thehautepursuit — Follow
East Beijing Hotel

6,461 likes — 26w

thehautepursuit My essentials 🖤🖤🖤
view all 43 comments
fashionsensored Perfection 🙌🙌
carolinne.chagnon Perfect
stuartweitzman Love!
lucilrabarove Fabulous 🖤
thenomisniche And I love it all!! 🖤
luckyoetama Perfect! 🖤🖤
theseptlabel 🖤
evangeline.tee @aaronyongweihao
anntestyle Wishing you a lovely Monday 🙏Love, Ann
thegreyhanes Chic! 😍 amazing page, check us out for some great home interior inspos, you'll love it 🖤🙏
thestylesynapse Each piece is amazing. 🖤

Add a comment...

Utility Lace

Shop here

THP thpshop.co — Follow

2,167 likes — 2w

thpshop.co LAST CHANCE: our last Baby blue Boxy faux fur is on final sale (size S) // Grab this before it 😭😭😭
redhairtoni 😭😭😭
thpshop.co @niyoushah @luxewithlc Vanessa's shoes are from Zara
niyoushah @thpshop.co 😍😍😍
jwlzoz 🖤🖤🖤
fashionruellie Amazing 🖤🖤🖤
lifeonmoon 🖤
victoria231111 Hope it's NOT real fur... We shouldn't wear something that poor baby fox sacrifice its life for🙏
hansa.jeram 🖤
krembdelakremb L 🖤V E it!
urbanmei 🖤
mela.merkoffer Perfect 🙏

Add a comment...

The City Tote

Everyday Essential for the City dweller.

Shop Now

thehautepursuit — Follow
Central 中國， Hong...

7,466 likes — 5w

thehautepursuit Fun times at @maxmara event tonight 🎉🎉
view all 98 comments
doralluit 🖤🖤🖤🖤🖤🖤🖤
luluvelita 🖤🖤真漂亮我 不錯穿麻衣会死啊!!
tonyspeckman ✨
xoxoyoyomama Slay lady 👏
lillioopt Star light .. Star bright !!
velveteencockroach So bomb omg 💣💣💣
tthysdh @vsienclatanoe Oke bu noted...
leblogalexandra 🖤
lovetatum Brilliant! Like it!
luudesouss 🖤
officialoldboy nice one =)

Add a comment...

Tanya Jean-Baptiste

@clothesconscience
@tanya.jb

"Open mind, open closet, and ever evolving…
💋 *fashion assistant/stylist/blogger* 💄 *NYC."*

■

"OPEN MIND, OPEN CLOSET, AND EVER EVOLVING," IS TANYA

Jean-Baptiste's Instagram tagline. As the force behind @clothesconscience, an
Instagram account where she shares her daily outfits, fashion obsessions, beauty
looks, and life in Brooklyn with her thousands of fol-
lowers, the It girl's experiences are truly ever-changing.

Fort Greene Park,
Brooklyn, April 2016

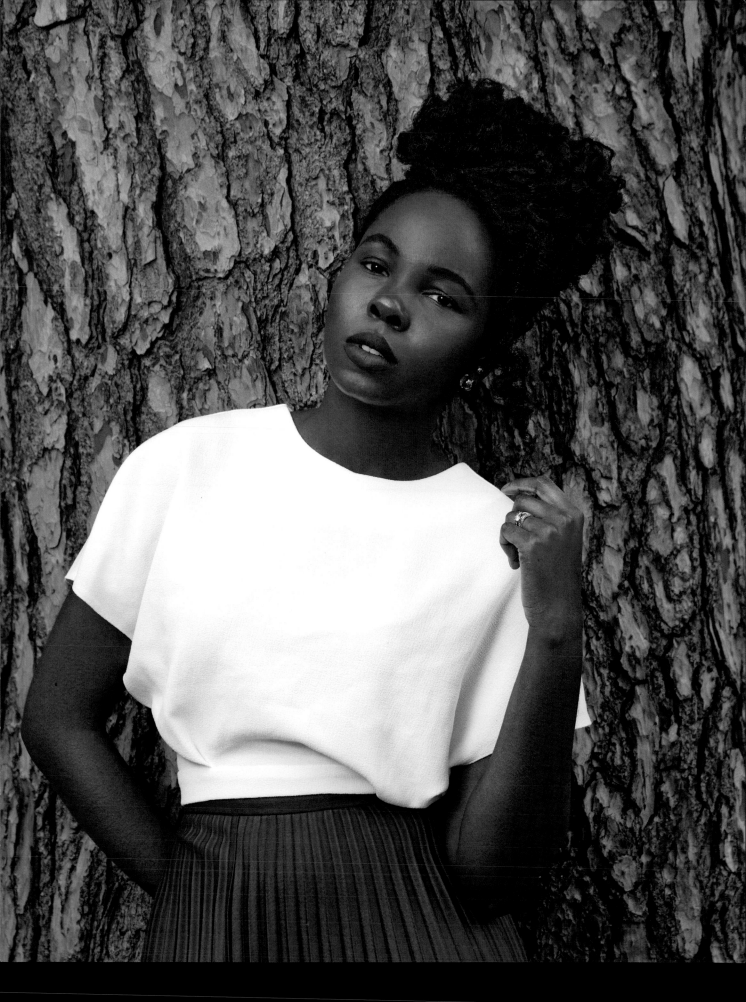

When she first joined the app about four years ago, it was a nascent platform, not the behemoth cottage industry of #OOTDs it is today. "I remember when Instagram came out, looking at other people's feeds and how they were able to express themselves," Jean-Baptiste says. It was seeing other Digital Girls thriving on Instagram that inspired the self-described shy girl to try it for herself.

"When I was thinking about my username, I wanted something that would represent me in a way that I'm pretty sure a lot of people don't see me. I put *clothes* and *conscience* together because I want my clothes to be the conversation piece and for people to see me as confident."

In fact, documenting her life and style through Instagram became something of an exercise in confidence-boosting for the social media star. "I've learned to appreciate all the things I thought were negative," she says. "I would have times before this where I would feel alone because my self-confidence was down or I was doubting my abilities to do something. I found through reading other people's stories that I was able to relate to them and vice versa. I feel like my Instagram has become an uplifting sisterhood for myself and my followers."

Today, she counts fourteen thousand followers in her sisterhood of cool girls. And fans who double tap on her page have become accustomed to her fresh, lively outfits and easy-to-replicate makeup tips.

"I feel like I'm relatable, an everyday girl," Jean-Baptiste says, when asked about her Instagram appeal. "Nothing that I wear is unattainable or something that a girl can't go to her local Zara or H&M and pick up. One day I might feel super girlie, the other super minimal. It really varies, and I'm finding that's OK."

Jean-Baptiste's realness doesn't just come through in her outfits, but in her approach to using social media in general. "I used to think, when I first started, I need to post three pictures a day and it needs to be an outfit post, a selfie, and something else for the third, but [that way] I feel like my page starts not to be genuine and it's not a true reflection of who I am," she notes. "If I don't post something for two days, I've learned to be OK with that."

At home,
Prospect Lefferts
Gardens, Brooklyn,
April 2016

"Incredible feed love!"
@beateskarlsson

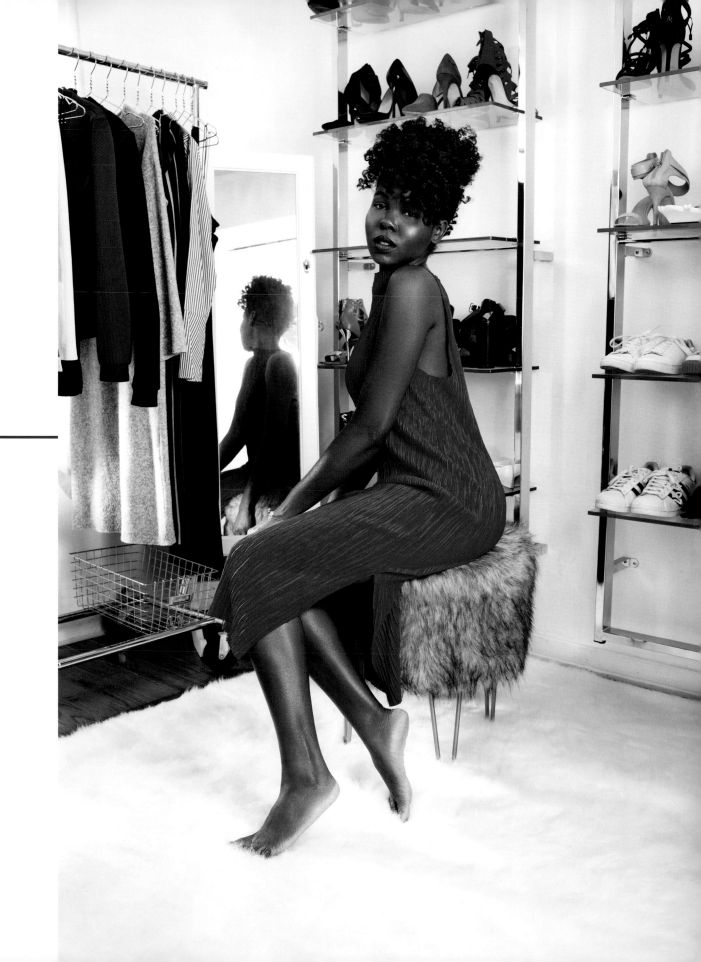

Walter's Restaurant,
Brooklyn, April 2016

"Very nice to see hair like mine. 😎😎"
@beateskarlsson

Her unfiltered relatability has propelled the Upstate New York native to great things. She was recently tapped by Curl Box to model for their products, becoming an advocate for African-American women seeking hair and beauty resources.

"I love sharing beauty tips, as well," she explains. "I learn things through YouTube and my girlfriends—I don't consider myself a professional, but I've learned enough that if a girl comments and asks me, I'm more than willing to share because that's how I learn myself."

At the moment, Instagram remains Jean-Baptiste's primary platform. Her rationale? Instant gratification. "It works well for me because we always have our phones in our hands—yes, we have Internet and can go to other pages, but I feel like the simplicity of the app and the ability to scroll and double tap makes it simple. I remember when I was redoing my bedroom in my apartment," she continues, "I was seeking opinions on furniture and within the hour I was able to decide between two coffee tables because people were engaging and responding," she says. "The fact that you're able to engage with your audience in real time is something that a lot of other platforms don't really offer."

★ HIT LIST ★

- Has modeled for Curl Box.
- Is a self-described introvert.
- Aspires to be a full-time stylist.

In the future, Jean-Baptiste hopes to parlay her strong sense of personal style into a career as a full-time fashion stylist. It's easy to imagine her message of self-acceptance working well with clientele. "I've learned that I don't have to be the loudest in the room, I don't have to be the flashiest," she says. "Being myself has gotten me pretty far."

@clothesconscience

TANYA JEAN-BAPTISTE

ASSISTED WORK MY WORK ABOUT

VOGUE JAPAN OCTOBER 2015 · VOGUE JAPAN DECEMBER 2015 · VOGUE JAPAN JUNE 2015

W MAGAZINE JULY 2015 · SAKS/ W MAGAZINE ART ISSUE 2015 · VOGUE JAPAN MAY 2015

GIA COPPOLA FOR FARFETCH 2014 · VOGUE JAPAN NOVEMBER 2015 · W MAGAZINE MARCH 2015

ClothesConscience

Home Hair and Beauty About

About

Thank you for stopping by. I hope you enjoy my perspective on all things fashion and beauty related. Catch me on instagram @ ClothesConscience

For business inquiries only: tjeanba1@gmail.com

Instagram

There was an error retrieving images from Instagram. An attempt will be remade in a few minutes.

Search

Follow Blog via Email

Enter your email address to follow this blog and receive notifications of new posts by email.

Join 675 other followers

Follow

Recent Posts

Military inspired
Rouge
Clean lines
Shades of grey
Military inspired

Archives

August 2016
July 2016

ClothesConscience

Home Hair and Beauty About

Open mind, open closet and ever evolving.

Military inspired 3
POSTED ON AUGUST 11, 2016

Clothed in dignity and strength.

All your struggles are not in vain. They will make you better equip to stay at the top once you get there.

Instagram

There was an error retrieving images from Instagram. An attempt will be remade in a few minutes.

Search

Follow Blog via Email

Enter your email address to follow this blog and receive notifications of new posts by email.

Join 675 other followers

Enter your email addr

Follow

Recent Posts

Military inspired

Rouge

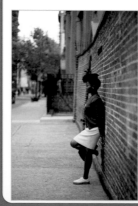

TANYA JEAN-BAPTISTE

ASSISTED WORK MY WORK ABOUT

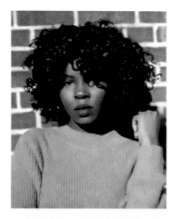

NYC Stylist

Contact: tjeanba1@gmail.com

Features:

ManRepeller

BeyondClassicallyBeautiful

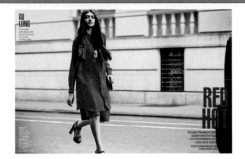

GO LONG

RED HOT

Back to Assisted work prev / next

FASHION LINE UP

clothesconscience

268 likes

clothesconscience I'm a summer baby. I like it ❄️❄️❄️My bottom lip starts to quiver in despair at the sense of the slightest chilly breeze. But this season I am really looking forward to Fall/Winter and all the yummy delicious layers that come with it.

enomistyle Me too, to all the above ;)
stephie_don_ Hahaha such a tanya visual description
imanijahaan in love 🖤
mmmengdi 😍
clothesconscience @enomistyle first time I'm excited for cold weather we will see how long this lasts 😂😂😂
clothesconscience You know me 😂😂😂 @stephie_don_
clothesconscience @imanijahaan 🖤🖤🖤
clothesconscience @mmmengdi 🖤

Add a comment...

"I may not be the loudest in the room but I'll get you talking."

clothesconscience Follow

359 likes 71w

clothesconscience Happy Memorial Day 🇺🇸
scantilyclassed Love
karonlwashington @_thegoldengirl_ love this look
thegoldengirl @karoncouture 👑👑👑
wooterleagues Nice!
justaves @meet_ekundayo
clothesconscience @trialsntresses @teamnatural_ @naturalhairstyles @naturalhairdoescare @4chairchicks
gvlden.ambitions @imani_murrayy

Add a comment...

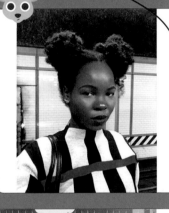

clothesconscience Follow

456 likes 4d

clothesconscience Mighty 😈

I may not be the loudest in the room but I'll get you talking.

veganzinga Oh I like this.
jessilrose Amazing 😍
snapcraquelpop Love! Where did you find the top?
gavingrymes Kawaii!I'm with @veganzinga
lyssa_sharee Can we talk about how you're matching the background...you look like a piece of art 😍
sooooseri0us #Life; give it
shaissodope What Stace said ! 😩😩😩 @sooooseri0us
dlyons3 You betta push thru Tanya!!! Yasss!

Add a comment...

clothesconscience Follow

267 likes 38w

clothesconscience 🖤 NYC street art
chichappenz 😍😍😍
vintageroyalty Hair!!!!!!!!! 🙌🏾🖤
mariamldn Love this picture. Your hair 😍 ettiket best!
clothesconscience Thank you @chichappenz @vintageroyalty @mariamldn
clothesconscience @ettiket 😍😍😍
ceesando slay

Add a comment...

clothesconscience Follow
Palace Of Versailles

138 likes 11w

clothesconscience 🖤🖤🖤
Creative people don't see things for what they are; they see them for what they can be

thee_shopaholic #Caption 😍
aworkingwardrobe Omg I have this exact same pic with this exact coat in Versailles. I legit thought this was my pic lol
clothesconscience @aworkingwardrobe 🙌🏾

Add a comment...

"Creative people don't see things for what they are; they see them for what they can be."

Yaris Sanchez
@yaris_sanchez

"I'll let you tell it."

■

"YOU CAN DO ANYTHING YOU PUT YOUR MIND TO. NO
definitions. No labels," says Yaris Sanchez, and in her case, the saying has certainly proved true. In her early twenties, she's had a string of successes as a music video girl, an empowered artist, and as a mother—and this is only the beginning of what's sure to be a fruitful career in the limelight. Still, she's trying to take it slow.

Chinatown, New York, May 2016

"One thing led to another on this path," she says. "Being that I was curvy, someone said I could work in music videos. I never thought of it as a career, I just thought it could be fun. The music video that I did that really made it all blow up was French Montana's 'Shot Caller.'" In the 2011 release, Sanchez plays the object of affection for the Moroccan-American rapper. "That was around the time Instagram came out, and I started traveling around the U.S. hosting events."

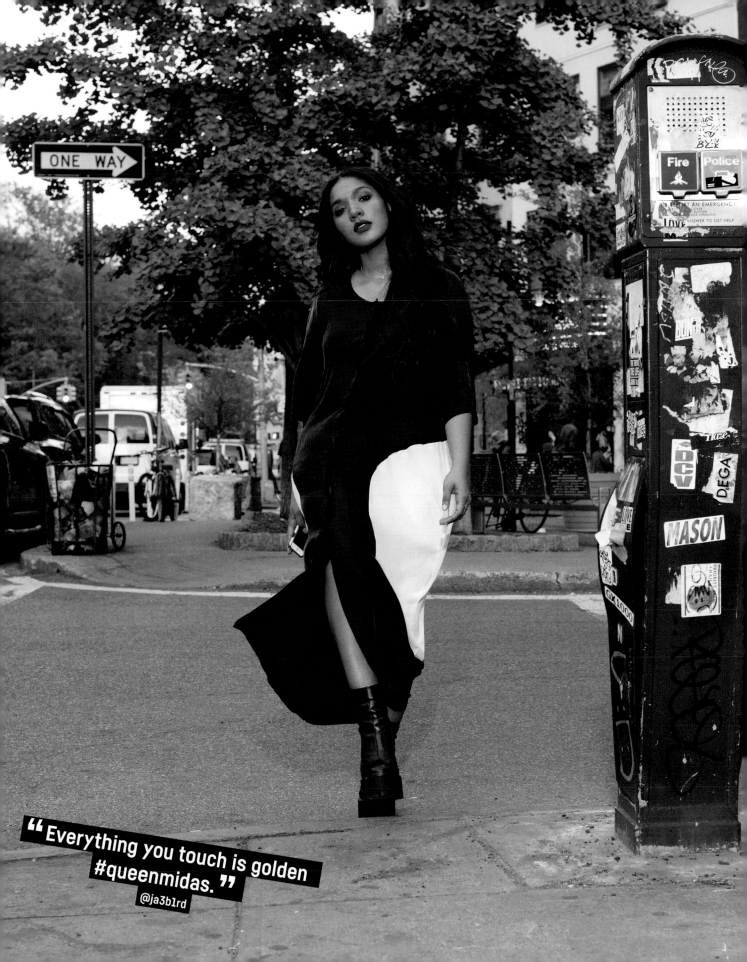

"Everything you touch is golden #queenmidas."
@ja3b1rd

"Yaris is truly the embodiment of someone who has defied all expectations." —GALORE

Chinatown, New York, May 2016

On Instagram, Sanchez posts less about rap videos and more about her art projects and #OOTDs. Her style is eclectic, meaning you'll find the New York native wearing everything from Victorian blouses to body-con dresses. "I love clothes and I love fashion. I look at myself like a mannequin. Wherever my eyes find beauty, I put it on. I don't care if it's going to look good," she says. "I graduated from the High School of Fashion Industries and I studied fashion design, so I was always into style and into clothes."

Translating her "anything goes" ethos to Instagram has been a concerted effort for the trendsetter. "My Instagram is really something that I cultivated over time," she explains. "I never had Facebook. Before Instagram came Twitter, and that's where I started my presence with followers and everything like that. I started realizing the power in it, and how important it is if you're an entrepreneur or trying to be self-made. That's when I started being a little more clever with what I do."

Along with outfit posts and snippets of her daily life, Sanchez now also shares pictures of her art. Recently, she celebrated her debut exhibition, *Never the Girl Next Door,* with photographer Raven B. Varona, which she believes turned the notion of the sexy, curvy pinup idea on its head.

"I got judged really badly, got called really awful things back when I first came on the scene," says Sanchez. "I never said anything. I never spoke up. I just let it be. But actually, if I just say my truth and what I really feel, that would probably touch a lot of girls who feel those things or who have circumstances they can't really control. If everything is out on the table, what can you really tell me about me that I don't know myself?"

Today, Sanchez uses her platform not only as a means of self-expression, but also to inspire others. "It's very liberating for sure. It makes me feel really confident and I think everyone should feel that way."

★ HIT LIST ★

- Starred in French Montana's "Shot Caller" video.

- Graduated from the High School of Fashion Industries in New York.

- Born in the Dominican Republic.

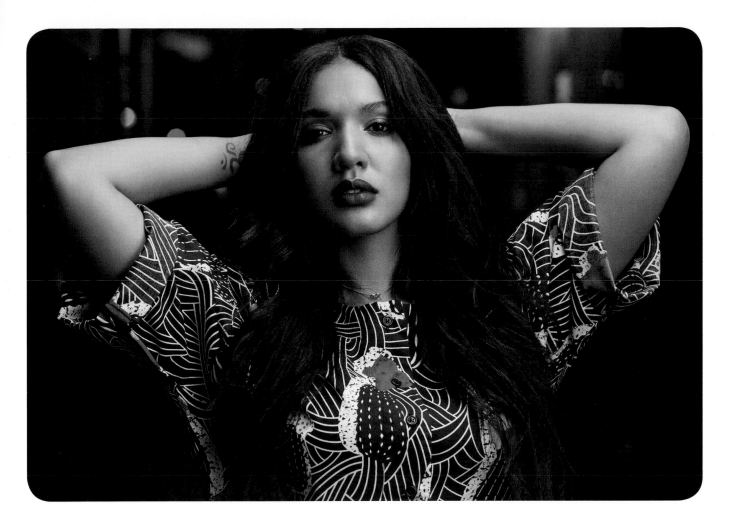

In the coming years, she hopes to translate that message into other projects, namely acting on the big screen. "Since I was little I always wanted to be an actress, really. My mom would take me on auditions for Nickelodeon and Disney Channel—it was always my dream and my mom really supported it."

Sanchez has recently begun taking acting courses in New York. "I would love to be in big motion pictures. I want to be a part of things that are meaningful and have a message. The good news is that being that I have this platform online, I can do what I want to do. I don't have to wait around for a casting agent or a casting call when I can actually put together a short film myself and debut that. At the end of the day, people are watching. If these things aren't coming to you, make them come to you by just doing it yourself."

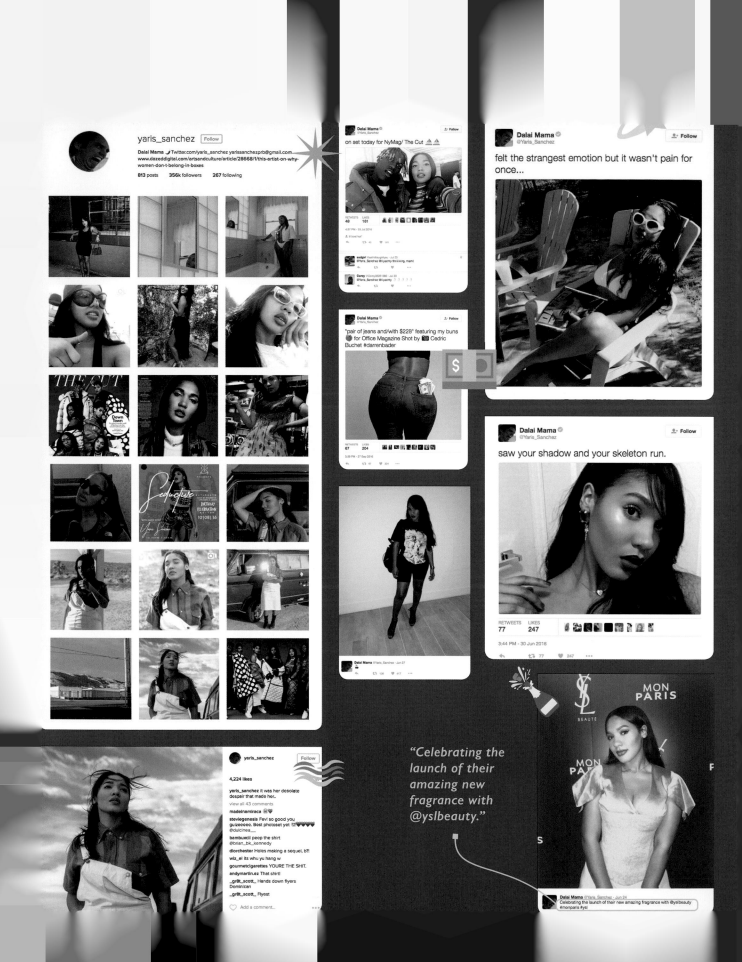

yaris_sanchez Follow

Dalai Mama 🦋 Twitter.com/yaris_sanchez yarissanchezprb@gmail.com
www.dazeddigital.com/artsandculture/article/28668/1/this-artist-on-why-
women-don-t-belong-in-boxes

813 posts **356k** followers **267** following

Dalai Mama ✓
@Yaris_Sanchez

on set today for NyMag/ The Cut ▲▲

Dalai Mama ✓
@Yaris_Sanchez

felt the strangest emotion but it wasn't pain for
once...

Dalai Mama ✓
@Yaris_Sanchez

"pair of jeans and/with $228" featuring my buns
📷 for Office Magazine Shot by 📷 Cedric
Buchet #darrenbader

RETWEETS LIKES
67 204

Dalai Mama ✓
@Yaris_Sanchez

saw your shadow and your skeleton run.

RETWEETS LIKES
77 247

3:44 PM - 30 Jun 2016

yaris_sanchez Follow

4,224 likes

yaris_sanchez it was her desolate
despair that made her..

view all 43 comments

madeinamiraca 🙌🖤
steviegenesis Fav! so good you
guizeeeee. Best photoset yet 💜💜💜💜
@dulcinea__
bambuxcii peep the shirt
@brian_bk_kennedy
dlorchester Holes making a sequel, b?!
wiz_el its whu yu hang w
gourmetcigarettes YOURE THE SHIT.
andymartin.ez That shirt!
_gr8t_scott_ Hands down flyers
Dominican
_gr8t_scott_ Flyest

Add a comment...

*"Celebrating the
launch of their
amazing new
fragrance with
@yslbeauty."*

MON PARIS
YSL BEAUTÉ

Dalai Mama @Yaris_Sanchez · Jun 24
Celebrating the launch of their new amazing fragrance with @yslbeauty
#monparis #ysl

yaris_sanchez · Follow

2,753 likes · 22w

ceezp 50 shades of yaris
sadesinferno ♥
_gr8t_scott_ Yes she's getting thick again
therealwileymane Lol
lumberjack___ Still on my
jonathanfortes__ Watch out she's gonna get all up in dat assss
paulalexander4 Cant believe joe budden hit that and i havent
yail_mad_yet 😂
jay_colossal @paulalexander4 this just ruined my day thanks
jonybravo88 @1989.champagne
tu_maleva Love u
right_above__ It "All up in errbody ass!" @yaris_sanchez 😂😂😂

Add a comment...

yaris_sanchez · Follow

4,736 likes · 26w

view all 53 comments
tjbst50 4 words: in... cred... a... ble
tangledupinblue89 @fadedredvelvet
dirtskirt @_joeygarcia_h
murchaia Great photo 😍
davisd @fnant_
ovohaii Yaris is hot!!!! @champagnepapi
mr_swift_cartay Fuck with me fuck all da rest hit me asap. Tonight
nuhbegowner
aysiaeliz GODDAMN GIRL. How do you find jeans tho?!
blacknregal Thissss
he_gabrizz For really tho @aysiaeliz 😂
jae.sav Still my favorite Dominican
damgoodbodies ♥♥
bcurls.michelle Obsessed

Add a comment...

Dalai Mama @Yaris_Sanchez · Jun 26
258 703

yaris_sanchez · Follow

4,730 likes · 27w

th_riller @jua_jua_ she's so cool!
moshockalocka @foxyjul looks like Twiggs
theuptowngrrl @dulcinea__ you rock
manialmeida Wow you are so gorgeous !
kingforever82 That's my love
kaidea Oh beautiful face 😍
dirtskirt @maddienielsen oooo
agirlcalledcleo @misssswaby uhhh I love her
stay_c3 @ressscue @marvelousss_
gyp5ysoul I LOVE this
z4ckmorris Bae
marrrtk @___saggee___ wth twin or nah lmaooooo
___saggee___ You sayin I look like her? @ib.mar

Add a comment...

"Comfortably nestled between a quirky sense of humor and laissez-faire aplomb, reside the duties of a mother, model, artist, theater, and film student." —DAZED

Torn from the pages of New York magazine.

THE CUT

Down Town
Six artists from the world of hip-hop wear this season's hottest jackets.

Photography by JESSIE ENGLISH
Lindsay Peoples

yaris_sanchez · Follow

2,091 likes · 6w

yaris_sanchez "It's like the greatest class picture ever" @nymag @thecut
saachasowavy 😂😂😂😂😂😂
ja3b9rd Everything you touch is golden #queenmidas
coreypeniiton Sexy babe
englishenglish Hahahah it's pretty senior high lol
diorchester You do the most random dope shit lol
julianwasasaint Mess with this heavy @savage_society
ferykah @josephdavis10
brandonaimengo This is epic
willgripforfood That's my friend @lilylightbourn
moodiguri @dopesta_danx2 coats
5evequise 'rap

Add a comment...

Lil Yachty

Yaris Sanchez

yaris_sanchez · Follow

3,460 likes · 6w

yaris_sanchez Sooooo thrilled to be a part of the September issue of @nymag for @thecut pick up a copy!!! ♥ "Sanchez got her start dabbling in music videos for artists like Rick Ross and French Montana, but the film student truly found empowerment once she took control of her own imagery. Her debut art exhibition of pinup photos inspired by Bettie Page, titled Never the Girl Next Door, cemented Sanchez's status as a modern woman who refuses to be boxed in." ♥ Thank you! @lrpeoples
Shot by: @englishenglish
Styled by: @lrpeoples
Hair: @staceyciceron
MUA: @samanthaimua
view all 57 comments
lowzabeth @reactinstyle I scrolled passed and thought this was you ♥

Add a comment...

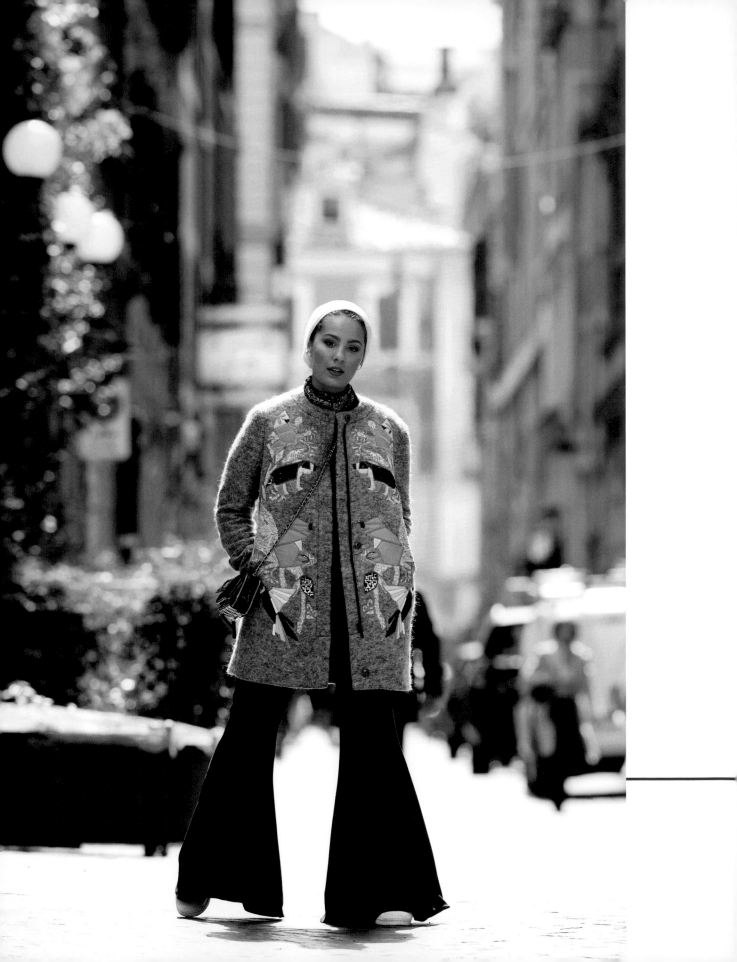

Ascia AKF
The-Hybrids.com
@ascia_akf

*"I blog fashion, wear turbans, and design things.
I tweet sporadically and am prone to becoming ghetto
without warning."*

Old City,
Rome, Italy,
March 2016

"I WAS INSPIRED TO START BLOGGING BECAUSE THERE WAS a gap in the market here for it. I was able to go online and see tons of gorgeous girls blogging from abroad, but could never adapt their outfits to fit my cultural needs without feeling some sense of frustration. I thought to myself, 'I could do this for my region. I could do this and represent an area that's overlooked in the fashion industry. I could do this and encourage other women to take ownership of their bodies, and their right to wear things on both sides of the fashion spectrum.'" So says Ascia AKF, the Muslim blogger who chronicles her outfits, travels, and relationship with her husband, Ahmad, on her blog The Hybrids and corresponding social media channels. Since launching her blog, Ascia has amassed nearly two million Instagram followers and sixty thousand YouTube subscribers, all of whom tune in for daily digests from the life of one of Kuwait's most stylish women.

"I never set out to be a 'hijab' blogger," she explains. "I set out to be a modesty blogger in a world where that was ill-represented and even misunderstood across *every* cultural or religious background. The Hybrids as a brand is not exclusive to me. It's a place where hybrids of all kinds can come and gain better understanding about what they like and how they might like to dress or how they define modesty for themselves. So the long and the short of my personal style is modest, but comfortable."

While The Hybrids might have started out as a showcase for Ascia's ever-evolving style and a place for her to explore her heritage—she's half Caucasian-American and half Kuwaiti—it's since become much more. She shares the platform with her husband, and together they make an unbeatable team who share personal stories, as well as funny anecdotes across their many platforms. "We enjoy spending the time together creating content—and not many men in the Middle East were prepared, in my humble opinion, for a man to encourage his wife to be in the public eye *and* do it with her. It was refreshing," Ascia explains. "Again though, Arab couples are so much more than what the media lets on about us. We aren't oppressed by marriage the way I feel it's portrayed and that was a big factor that sparked our vlog life. Giving people an insight into what goes on in our day to day, which is often incredibly banal, was another way we felt more connected to the people that have given us the gift of their audience."

So what does go on in the daily life of Ascia, Ahmad, and their two young children? Lots of traveling, lots of stylish outfits, and lots of fun-filled free time. Some of The Hybrids' most watched YouTube vlogs are the ones where they're just hanging out, driving, singing in the car, and challenging each other to parlor-style games.

"I'm not very good with rules, but with blogging staying active is the key. We try to have three types of content up a day across any social media platform.

★ HIT LIST ★

- Runs her blog with her husband, Ahmad.

- Her half Caucasian–American and half-Kuwaiti background inspired the name of her blog.

- Is a fan of *RuPaul's Drag Race*.

- Has her septum pierced.

- Is a mother of two.

"An expert at deftly layering clothes, Ascia AKF's look is more of a citizen of the world. She combines high low fashion in a way that is not only accessible, but transcends age, ethnicity, and even gender." —HIJABILIFE.COM

When we had our son this became so much harder," Ascia admits. "A baby doesn't care if you need to put makeup on and take an outfit photo! So we had to become slightly less obsessed with rules and slightly happier with ourselves if we felt like awful bloggers but good parents." It was her journey into motherhood that inspired Ascia to start her own business outside of The Hybrids, Desert Baby Kuwait, which sells baby slings and accessories.

As this Digital Girl continues to forge her own path, she's also ready to dole out some tips to those who want to follow her lead and break down boundaries. "My advice to girls wanting to do what we in social media do is: grow

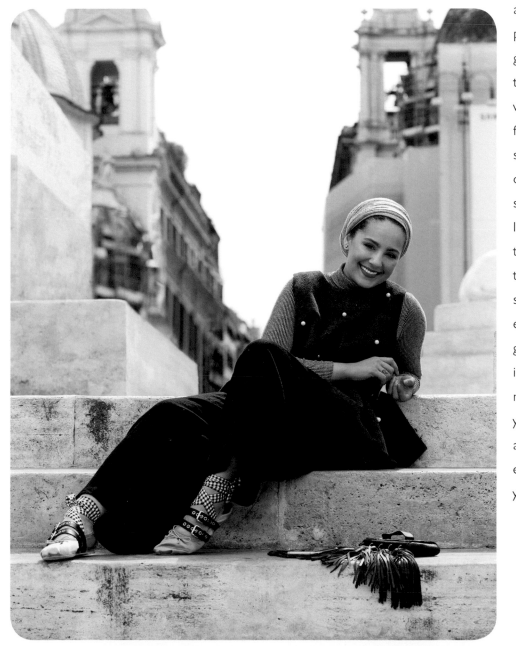

a thick skin to people's negativity, but grow a thick skin to too much positivity as well. Both can be bad for you, one for your self-esteem and the other for an elevated sense of self-worth. It sounds harsh, but that's the reality. Try to find that sweet spot where you take everything with a grain of salt and realize that this is social media. It's a job that you can be passionate about, but followers will never define your worth."

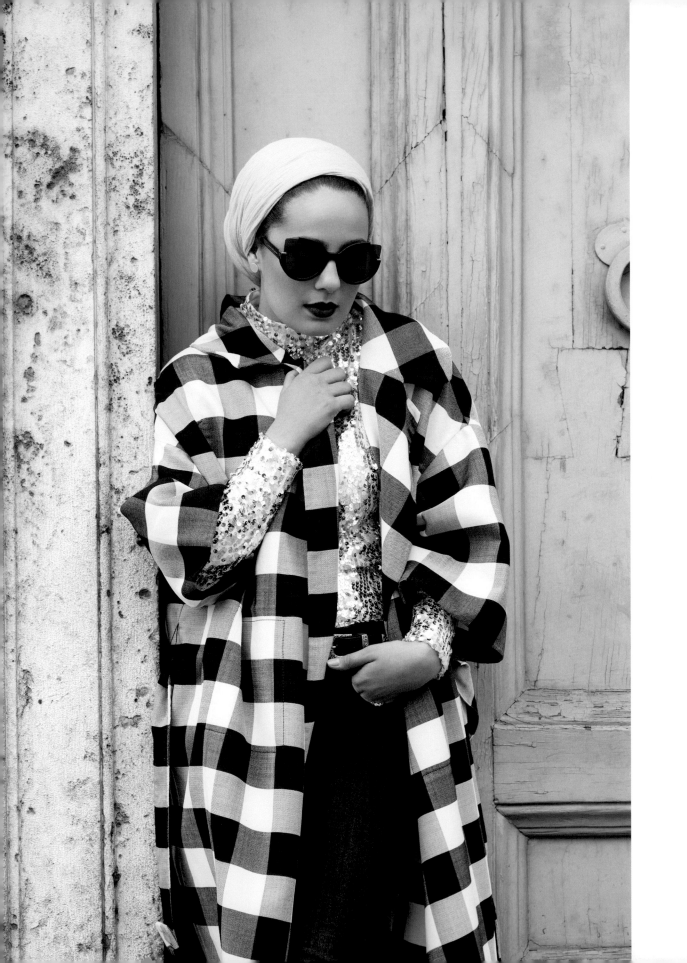

"You are a wonderful lady. GREAT mother POWERFUL entrepreneur and AMAZING fashionable girl 👠 🖤 go ahead DO whatever you are doing you are just PERFECT 🖤!"
@coach_zeez.k

@ascia_akf

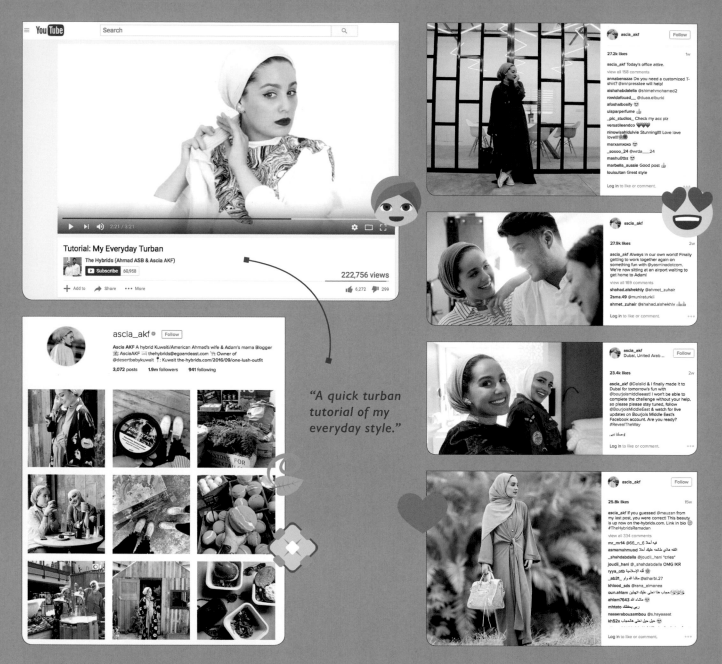

"A quick turban tutorial of my everyday style."

"With over 1.5 million followers on Instagram, the turban wearing Ascia pioneered the personal style blog wave in the region and has since garnered a reputation of being one of the most influential fashion voices [...] and one of the most open and honest as well." —STYLE.COM ARABIA

"Looks so laid back and yet so chic! Love."

THE HYBRIDS'
NEW VIDEOS EVERY WEEK

The Hybrids (Ahmad ASB & Ascia AKF)

Home Videos Playlists Channels Discussion About

The Hybrids: 7 Second Challenge!

0:11 / 8:35

The Hybrids: 7 Second Challenge!
67,353 views · 4 months ago

The one where we dare each other to do some really silly things in front of a camera. Apparently Ahmad likes eagles?

SHOP OUR STYLE

Ascia:

Ascia T-Shirt: https://api.shopstyle.com/a...
Read more

The Hybrids Vlog

11:07	11:43	17:16	9:51
VLOG: New York City, Tom Ford & A Meet Up!	The Hybrids Vlog: S1E1	The Hybrids Vlog: S1E2	The Hybrids Vlog: S01E03
The Hybrids (Ahmad & Ascia AKF) 20,274 views · 1 month ago	The Hybrids (Ahmad & Ascia AKF) 156,729 views · 1 year ago	The Hybrids (Ahmad & Ascia AKF) 251,438 views · 1 year ago	The Hybrids (Ahmad & Ascia AKF) 115,792 views · 1 year ago

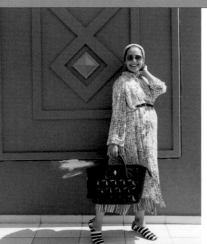

ascia_akf Follow

23.5k likes 2w

ascia_akf Sank castles • outfit @rivafashionme (you can shop Riva online now! Worldwide delivery🐚)

view all 201 comments

noha_makeupartist اوه رباي انتي حامل؟؟؟ ماشاالله

hishersq8 So adorable🖤

n_algarni32 @sh_2213

woodbase.store الى عشاق القهوه ، ليكون لقهوتك طعم مميز دمجنا لك الحب مع القهوه ب قاعدات اكواب (خشبيه ملونه من اختيارك) زوروربي وتجدون الكثير غير ذلك احرف ، خشبيه وممضنه باحجام مختلفه والكثير من الخشبيات الانيقه

empoweredbymodesty Looks so laid back and yet so chic! Love.

lamnim 👍🖤

7xhd الحين اسيا لو تتكلم عربي وتكتب عربي افضل

ruba_boutique بنات الرياض عندنا افضل الملابس، واقل الاسعار

Log in to like or comment.

ascia_akf Follow

23.8k likes 6d

ascia_akf Today I squeezed my pregnant self into all things black & white because #31Weeks of gestating this little one is too exhausting to think about color coordination #LetsBeHonest (this look up now on the blog! Link in my bio! 🌐)

view all 98 comments

mryam.aish Tjanneeeen wallaaaa, miss you!

reemalshwalsh 😍😍😍

aoosheealdeebane تحفة الشنطه يا عسسسسل

umusana U look so cool Masha Allah, I think ur pregnant with baby girl 💚😍

_cinderella990 حامل ؟

miss.myra.v What!! You're expecting again?! Awe, yay!! Congrats!

ladyangel.photo 💚💚

eaasz_7 الله يسهلك ولي 💚💚قريت الولاده 💚💚

Log in to like or comment.

THE HYBRIDS'

HOME AHMAD ⌄ ASCIA ⌄ VIDEO ⌄

The Hybrids Vlog: S01E03

VIDEO

The Hybrids Vlog: S1E3

ASCIA AKF · JUNE 17, 2015 · ♡ 0 · 🔲 · 👁 435 VIEWS

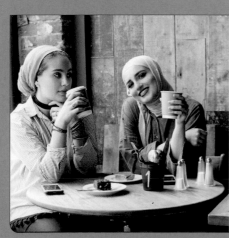

ascia_akf Follow
Storm Fish Restaurant

29.8k likes 2w

ascia_akf Coffee break after the factory visit with the number 1 travel buddy @dalalld ✔️ now off to the airport & back to my boys!

قهوة بعد جولة المصنع مع دلال! الحين رايحه المطار عشان ارجع الكويت، واید ولهت على احمد واثم

view all 170 comments

mahoe___55 حياكم ضيوفي يوميتي مع اهلي 💚 بسلاي والسلفر اسيا💚

b1_mj I love you ascia

in0u_ @mar.17 تحننن 😍

dina_w210 اسيا احلا بس دلال هوت اكثر

turkishboutiquekw8 بنات تقضلو عندي اجمل الموديلات التركيه حياكم

manahildw @afifashamsi

noufnn اكرها على جنبها تلمزح كليير مع طليعتها وعقربه

neebbo @rehab.alaa

Log in to like or comment.

THE HYBRIDS'

HOME AHMAD ⌄ ASCIA ⌄ VIDEO ⌄

LIFESTYLE BEAUTY EVENTS LIFESTYLE OUTFIT TRAVEL

LIFESTYLE
THE ONE WITH THE NEW BLOG
ASCIA AKF · MAY 1, 2015
The Hybrids! If you're reading this then you already see how bomb-diggidity our...
♡ 0 ♥ 4

VIDEO
MY EVERYDAY TURBAN
ASCIA AKF · OCTOBER 14, 2015
A quick turban tutorial of my everyday style. And the lipstick I'm wearing (before anyone asks!) is NYX Liquid Suede in Amethyst, and the shirt is from Lillaiya...
♡ 0 ♥ 4

VIDEO
THE HYBRIDS VLOG: S1E3
ASCIA AKF · JUNE 17, 2015
Season 1, Episode 3 of our vlogging life. The most confusing vlog of all time...
♡ 0 ♥ 4

VIDEO
THE HYBRIDS Q&A
ASCIA AKF · SEPTEMBER 28, 2014
The one where Ahmad & Ascia answer a bunch of questions, thus wasting 10 minutes of your life. We're so sorry...
♡ 0 ♥ 4

LATEST POSTS

THE ONE THAT KEPT IT SIMPLE
ASCIA AKF · BORED...

THE ONE WITH POWER
ASCIA AKF · ...

THE ONE WITH THE REGGO PINAFORE
ASCIA AKF · 2 MONTHS AGO

THE ONE WITH THE LUSH OUTFIT
ASCIA AKF · 2 MONTHS AGO

Acknowledgments

The making of *DIGIT@L GIRLS* was an absolute team effort and I could have never done it without the help of many people.

First and foremost, I want to thank my wife, Christiane Mack, for all of her support and guidance throughout the making of this book. Your love and belief in me gave me the strength and courage to take on, and more importantly, complete *DIGIT@L GIRLS*.

Thank you to my creative team, the tireless efforts of my editor Nicole Phelps, Steff Yotka my writer, designer Shawn Dahl, and also my studio manager Alvia Urdaneta.

And the people in the industry who were so gracious with their time and advice; my publisher at Rizzoli Charles Miers, Associate Publisher Anthony Petrillose, and Editor Gisela Aguilar. Also Caroline Wolff at *W* magazine, Alexandra Macon and Helena Suric at *Vogue*, Eva Chen at Instagram, and Misha Nonoo for her great words. Also, Vicky Yang at The Society, Justine Grimaldi-Maiorino at Utopia, Kristen Reeve and Timothy Priano at ABTP.

And to my team who was so essential in creating the looks for all the beautiful women in *DIGIT@L GIRLS*; Kiyoshi Maeda, Laura de Leon, Joshua Ristaino, Eric Vosburg, Bennett Grey, Gina Kleinschmidt, Leigh Gill, and Carrie Beene at CarrieNYC.

And to Rachelle Hruska and Sean MacPherson for generously providing us space in which to shoot at the incredible Jane Hotel, also my great friend Derek Sanders whose beautiful restaurant La Esquina provided such a wonderful back-drop and tasty tacos for our crew.

And to my old friends, Carl Saytor and Amy Shapiro at Lux Lab, and John Manno; your support has been instrumental to my success for so many years now, and I truly value your friendship.

First published in the United States of America in 2017 by
Rizzoli International Publications Inc.
300 Park Avenue South
New York, NY 10010
www.rizzoliusa.com

Publisher: Charles Miers
Associate Publisher: Anthony Petrillose
Editor: Gisela Aguilar
Proofreader: Victorine Lamothe
Production Manager: Rebecca Ambrose
Design Coordinator: Kayleigh Jankowski

Distributed in the U.S. trade by Random House, New York.

Printed in China.

ISBN: 978-0-8478-5885-9
Library of Congress Control Number: 2016958873

2017 2018 2019 2020 10 9 8 7 6 5 4 3 2 1

Emoji art by EmojiOne

Design by Shawn Dahl, dahlimama inc